Adirondack
Prints and Printmakers

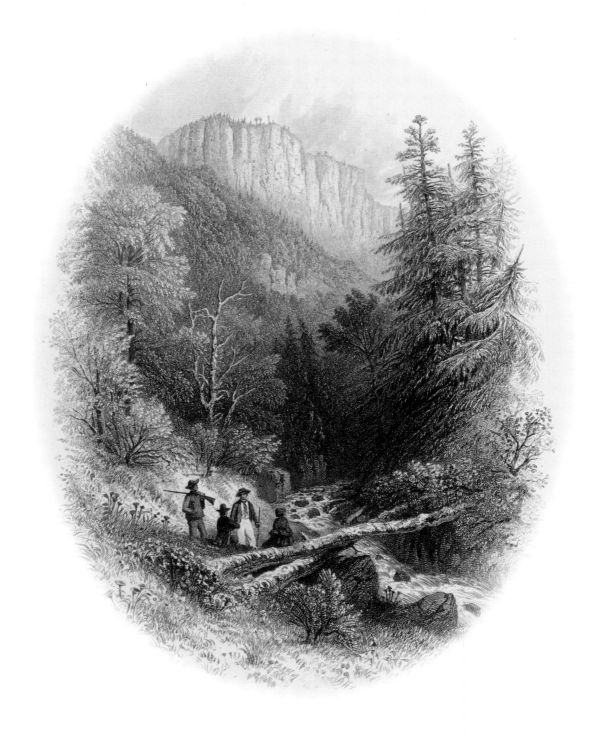

Adirondack

Prints and Printmakers

THE CALL OF THE WILD

EDITED BY CAROLINE MASTIN WELSH

The Adirondack Museum / Syracuse University Press

Editor: Alice Wolf Gilborn
Designer: Pelican Street Studio

The paper used in this publication meets the minimum requirements of American National Standard for
Information Sciences—Permanence of Paper for Printed Library Materials, ANSI Z39.48-1984. ∞ ™

Library of Congress Cataloging-in-Publication Data

Adirondack prints and printmakers : the call of the wild / edited by Caroline Mastin Welsh.
 p. cm.
 Collected papers from the twenty-third North American Print Conference, Adirondack
Museum, Blue Mountain Lake, N.Y., Aug., 1995.
 Includes bibliographical references and index.
 ISBN 0-8156-0519-6 (cloth : alk. paper)
 1. Adirondack Mountains Region (N.Y.)—In art—Congresses. 2. Prints, American—New York
(State)—Adirondack Mountains Region—Congresses. 3. Regionalism in art—New York (State)—
Adirondack Mountains Region. I. Welsh, Caroline Mastin. II. North American Print Conference
(23rd : 1995 : Adirondack Museum)
NE954.2.A34 1998
769.9747'5—dc21 97-39201

Manufactured in the United States of America

To Peter and Jamie

Contents

◉ *Illustrations*

Foreword

THE ADIRONDACK MUSEUM is a large regional museum of history and art located in the center of the Adirondack Park in upstate New York. Since 1957 the museum has presented the history of the Adirondack region through exhibitions, public programs, and publications. Over the years these publications have made it possible for the museum to reach out to an audience far beyond Blue Mountain Lake. Through them the museum has acted as a catalyst for scholarship on the Adirondack region by introducing scholars to our collections and by presenting their research and insights to new audiences.

In 1995 the museum was fortunate to have had the opportunity to host the North American Print Conference and to provide a forum for scholarship on the legacy of print images of the Adirondacks. The Adirondack Museum's collections are especially rich in these materials, and so it was with enthusiasm that we brought together scholars to share their research with each other and with the public. The work presented at this conference explored the significance of prints of the Adirondacks from a variety of historic and aesthetic perspectives and, in particular, focused attention on the cultural role that prints have played in introducing the region to a national and international audience.

The conference was a great success. We are especially pleased now to bring the work of these scholars to new audiences through a publication for people interested in history and visual art, and in the complex and fascinating region that has captured the imaginations of Americans since its earliest exploration.

I would like to express my thanks to Syracuse University Press for collaborating with the Adirondack Museum to bring this project to fruition. Thanks go to the many scholars whose work informs these pages. In particular, I would like to acknowledge the key role that the staff of the Adirondack Museum played in the success of the project, including museum librarian Jerry Pepper, a conference contributor, and editor Alice Gilborn, whose dedication to the printed word has been behind so many museum publications. Special acknowledgment and thanks go to Chief Curator

Caroline Welsh. Without her energy and dedication to the project in her multiple roles as conference chair, contributor, and editor of these proceedings, this publication would never have seen the light of day.

JACQUELINE F. DAY
Director

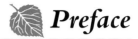

REGIONAL COLLECTIONS of prints offer important opportunities for study. Not only do they illustrate aspects of daily life in a particular area, but they also mirror attitudes and values in the larger arena of American culture and art. In August 1995, the North American Print Conference held its twenty-third meeting at the Adirondack Museum overlooking Blue Mountain Lake in the approximate center of the Adirondacks. Focusing on printed images of the Adirondacks, the nine papers prepared for this Conference explored the cultural significance of regional images and the roles that they played to document Adirondack people, places, and pastimes. They examined changing attitudes toward the natural world and wilderness aesthetics, as well as the development of the Adirondacks as a mecca for tourists. Individual artists, from the very well known to the artist little known except for his works in the Adirondack Museum Collection, were also discussed for their contributions to knowledge of the region. By its analysis of prints depicting the Adirondacks, it is hoped that this volume will contribute to the understanding of and the scholarship of American historical prints in general. Much of the discussion which follows is published here for the first time.

The Adirondack Museum, chartered in 1955 and opened in 1957, is a regional museum of history and art which interprets the material culture and social history of a six million acre region in upstate New York defined by the Adirondack Park and its close environs. The museum opened its doors with nine buildings and a few exhibits; at present, twenty-three buildings house diverse exhibits and a collection of objects numbering close to one hundred thousand. Within the walls of the Adirondack Museum are tools dating from the nineteenth and twentieth centuries which harvested trees and earth-bound minerals and ores; vehicles which transported people and goods on land and water; objects from hearth and home; the equipage of sport and recreation. There are also artifacts which picture the past: thousands of documents from the region, historic photographs and works of art including paintings, prints, and drawings. Prints were among the first acquisitions of the museum. Two lithographs were collected in 1955, followed by three etchings by John Henry Hill in 1957. Twenty-two etchings by Arpad Gerster were given in 1958. The Bufford lithographs from

Ebenezer Emmons's Natural History Survey of the State of New York (1838) came in 1961, followed by the Bartlett views of Lake George. The Currier and Ives lithographs after Tait arrived in 1964 and hundreds more in the intervening years.

The publication of these conference papers is really two different projects—the conference and the proceedings. The twenty-third North American Print Conference would never have taken place without the initial inspiration of Georgia Barnhill of the American Antiquarian Society or the support of Adirondack Museum Director Jacqueline Day. Syracuse University cosponsored the conference and provided unforgettable housing for conference registrants at the Minnowbrook Conference Center. We are particularly indebted to David Tatham who served as our liaison with the university as well as an advisor to the project. The Ecology and Environment Center of Blue Mountain Lake graciously provided housing for the speakers. Nearly everyone on the staff of the Adirondack Museum played some role in the conference itself. Collectively and individually, they carried out the hundreds of tasks essential to organizing and hosting such a meeting with grace and efficiency. We could not have succeeded without their time, effort, and ideas.

The greatest credit for this publication goes, of course, to the authors themselves who worked very hard researching and presenting their lectures and revising papers for publication. For each individual's scholarly contribution and for his or her patience and cooperation during the preparation of the final manuscript, I am especially grateful. Critical for the production of the book were the editorial efforts of Alice Wolf Gilborn. Alice assiduously read and re-read the manuscripts with an eye for detail and consistency, often a monumental task with multiple authors. Ilona Selzer-Kelting cheerfully volunteered her time to perform hours of painstaking corrections on the word processor. Curatorial Assistant Karen Joyce provided much needed clerical assistance for both the conference and the book. The good humor and productivity of these three colleagues were invaluable to me. The book's graceful design by Pelican Street Studio and the efforts of Executive Editor Cynthia Maude-Gambler to see the publication come to fruition are much appreciated.

Finally, it was through two gifts that the good ideas and hard work of all these people have found permanent form in *Adirondack Prints and Printmakers: The Call of the Wild*. We are deeply grateful for the personal generosity of Anne H. and John K. Howat and for the grant from the International Fine Print Dealers Association, without either of which there would be no book.

CAROLINE MASTIN WELSH
Chief Curator and Curator of Art
The Adirondack Museum

GEORGIA B. BARNHILL is the Andrew W. Mellon Curator of Graphic Arts at the American Antiquarian Society. She has written and lectured widely on book illustrations and prints. She is the author of *American Broadsides* (1971); editor of *Prints of New England,* a volume of essays based on lectures presented at the 1976 North American Print Conference; and author of *Wild Impressions: The Adirondacks on Paper* (1995).

WARDER H. CADBURY, retired Professor of Philosophy at the State University of New York at Albany, has had a long interest in the history of Adirondack art and literature. His publications include *Arthur Fitzwilliam Tait: Artist in the Adirondacks* (1986), written with Henry F. Marsh; the introduction to the centennial reprinting of William H. H. Murray's *Adventures in the Wilderness* (1970); and the introductory essay for another Adirondack classic—John Todd's *Long Lake* (1983). The recipient of several fellowships for research, Professor Cadbury also served as a research associate at the Adirondack Museum for some twenty-five years.

NANCY FINLAY is a Print Specialist at The New York Public Library. Her interests range from the prints of the French Romantic artist Eugene Delacroix to the graphic arts of the turn-of-the-century Arts and Crafts movement. Her publications include *Pride of Place: American Views from the Leonard L. Milberg Collection* (with Dale Roylance, 1983) and *Artists of the Book in Boston, 1890–1910* (1985). She has contributed to *Double Vision: Perspectives on Gender and the Visual Arts* (1995), and *Inspiring Reform: Boston's Arts and Crafts Movement, 1890–1930* (1997). She is currently working on the American book illustrator F. O. C. Darley and the landscape drawings of Edward Lear.

JEROLD PEPPER is librarian at the Adirondack Museum where he has been answering the public's questions about the Adirondacks since 1982. He has written and lectured widely on Adirondack subjects.

JANICE SIMON is Associate Professor of American Art at the Lamar Dodd School of Art at the University of Georgia, Athens. She has written on the antebellum art periodical *The Crayon,* the World's Columbian Exposition, the forest interior in American art and culture, and America's image of the pirate. Her most recent publications include *Crosscurrents in American Impressionism at the Turn of the Century* (1996), coedited with Donald Keyes, and entries for *American Paintings in the Detroit Institute of Arts* (1997).

DAVID TATHAM is Professor of Fine Arts at Syracuse University. He is the author of many articles, reviews, exhibition catalogs and books concerning nineteenth-century American graphic arts and painting. He has published widely on the work of Winslow Homer, including a series of articles on Homer's Adirondack paintings as well as a book entitled *Winslow Homer in the Adirondacks* (1996).

ROSEMARIE L. TOVELL is the associate curator of Canadian Prints and Drawings at the National Gallery of Canada. She has worked on many exhibitions and written numerous publications including *Reflections in a Quiet Pool: The Prints of David Milne* (1980), *An Engraver's Pilgrimage, James Smillie in Quebec 1821–1830,* coauthored with Mary Allodi (1989,) and *Berczy,* General Editor (1991). Her most recent publication, *A New Class of Art: The Artist's Print in Canadian Art, 1877–1920* (1996), won the award for outstanding publication from the American Historical Print Collectors Society.

PHILIP J. WEIMERSKIRCH is the Special Collections Librarian at The Providence Public Library. Dr. Weimerskirch has worked for medical and specialized libraries. His interests range from the history of books and printing to natural history books and prints to the beginnings of lithography in America. He has published and lectured on these subjects.

CAROLINE MASTIN WELSH is the Chief Curator at the Adirondack Museum, Blue Mountain Lake, New York. As Curator of Art at the museum she has directed and contributed to the cataloguing and publication of the painting and print collections; has published and lectured on the subject of Adirondack art and artists; curated exhibits on Adirondack art; and is working on a directory of Adirondack artists.

Introduction

CAROLINE M. WELSH

> Few fully understand what the Adirondack wilderness really is. It is a mystery even to those who have crossed and recrossed it by boats along its avenues, the lakes; and on foot through its vast and silent recesses.
>
> VERPLANCK COLVIN, 1874[1]

VERPLANCK COLVIN "crossed and recrossed" the Adirondacks with missionary zeal in his twenty-five year effort to conduct a comprehensive survey of the Adirondacks. His annual reports, published from 1872 to 1896, contained scientific minutiae about flora and fauna as well as incredibly detailed geographical and topographical data. They were accompanied by descriptions of Colvin's arduous and often perilous adventures to gather the data. They also included lithographs drawn by Colvin and published by the Albany firm of Weed and Parsons. "Lake Tear of the Clouds," the highest source of the Hudson River, and prints of myriad remote and wondrous sites, were among the first images ever made of the wilderness territory in northern New York State named "Adirondacks" by Ebenezer Emmons, New York State Geologist, in 1837. The Adirondacks, first characterized as a "Dismal Wilderness" and then a "Sportman's Paradise," has challenged cartographers, scientists, sportsmen, travelers, and artists to try to define it since the late eighteenth century.

Appleton's Journal on Saturday, September 21, 1872, published a short article and a wood engraving entitled "Our Artist in the Adirondacks." The article describes the experiences of an unknown but presumably typical artist:

> "Our artist in the Adirondacks" has contrived to tell his own story, in his graphic way, with the pencil, and an explanation by the pen is therefore hardly necessary. We see [the artist], as he starts for the forest paradise, cheerful and jaunty, in anticipation

OUR ARTIST IN THE ADIRONDACKS.

of the sport and the sketches that await him. We get a glimpse of the natives as they are seen [along] the way, and of an exotic, in the shape of one of "Murray's fools," as the believers in the Rev. Mr. Murray's book about the Adirondacks are popularly called.[2] Next we see our artist loaded with the "traps" of travel, making his toilsome way across one of the "carries," which are such an interruption and such a contrast to the luxurious boat-travel of the wilderness. In the center of the picture we have "Mother Johnson," famous for flapjacks and for portly proportions, who presides over the little hostelry at Raquette Falls, the "carry" around which is one of the hardest in the usual route of the traveller. Near by is her daughter, the belle of the Raquette, appropriately name Sylvia. "Lysander" is a noted guide . . . ! The "black flies" are the great insect-pest of the wilderness, against which the easiest protection is a veil enveloping the head. The rest of the sketches explain themselves.[3]

Prints pictured the Adirondacks for thousands of people. Fortunately for the wilderness, not everyone came to experience it firsthand. Many of those who did not come formed ideas about the north woods by reading guidebooks authored by Joel T. Headley, William H. H. Murray, Seneca Ray Stoddard, and others. Illustrated with wood engravings, these books depicted the lay of the land, what took place there, and the nature of its human and animal residents. Prints published in the contemporary popular press like *Appleton's Journal* and *Harper's Weekly* served a variety of purposes. They lured tourists to the region and then ridiculed road conditions and accommodations in the Adirondacks. They informed the public about events like the American Canoe Association meets and issues like endangered species. Artist-printmakers also illustrated the major geologic and topographic surveys of New York State.

Artists who came to the Adirondacks to paint the scenery frequently reproduced it in prints. Lithographs after original paintings disseminated affordable fine art to a broad middle class and thus exemplified a pervasive nineteenth-century faith that art could enrich the life of everyone. Nineteenth-century painters like Arthur Fitzwilliam Tait speeded the acceptance of lithography by having their works chromolithographed. Wood engravings after paintings appeared in fine art publications such as *The Aldine* in the 1870s and William Cullen Bryant's *Picturesque America* of 1874. Currier and Ives and others published scenes of hunting, fishing, camping, and winter activities and at the same time promoted the allure of the Adirondacks to sportsmen.

The first persons to depict the Adirondacks in visual forms were map makers and delineators of military fortifications and battle plans. Eighteenth-century maps noted the militarily strategic

nature of the Hudson and Champlain valleys and documented settlements. Nineteenth-century maps charted development and use of land for recreation and commerce. Jerold Pepper tracks, through historical maps of the region, the history of settlement and development of the Adirondacks from Samuel de Champlain, in 1609 the first European to record seeing the mountains, to the 1973 *Adirondack Park Land Use Master Plan.* Maps serve as both document and work of art. Cartographic and calligraphic details provide information as well as reveal the evolution of attitudes toward and the value of the Adirondack wilderness over nearly four hundred years.

Other Europeans, like the Swedish botanist Peter Kalm, who visited Lake Champlain in 1749, made careful drawings of the region's flora and fauna long before the region had a name. French naturalist Charles Alexander Lesueur sketched Whitehall and Lake George in 1816. Jacques Gérard Milbert not only collected natural history specimens between 1815 and 1818 but also made innumerable drawings of the Adirondack region and other places in New York State. His wash drawings of the Hudson River were transformed into lithographs in Paris and published in three volumes for a European audience. Twenty watercolor sketches by English artist William Guy Wall of the region north and west of Lake George were published as aquatints in *The Hudson River Port Folio* (1821–25). Philip Weimerskirch traces the history of the production of Milbert's *Itinéraire pittoresque du fleuve Hudson* and Wall's *Hudson River Port Folio* and, for the first time in the literature on either work, compares and contrasts the treatment of the same subject by the two books. Weimerskirch reveals details about the artists at work, their orientation and choice of views, and who originated the idea for the *Hudson River Port Folio.* His treatment enhances the significance of two of the earliest, most ambitious, and most beautiful publications of American scenery in the Adirondacks.

Early nineteenth-century geological and zoological surveys employed artists to illustrate volumes designed to document and catalog the largely unexplored wilderness. Charles Cromwell Ingham (1796–1863) accompanied New York State Geologist Ebenezer Emmons as he surveyed the "cluster of mountains in the neighborhood of the Upper Hudson and Ausable Rivers, [which he named] the *Adirondack group.*"[4] Ingham's painting *The Great Adirondack Pass, Painted on the Spot* in 1837 captures on canvas the awe-inspiring natural wonders of the region's interior. This painting was reproduced as a lithograph in Emmons's *New York State Geological Report for 1837.* Georgia Barnhill discusses the extent and variety of prints that illustrated the Adirondacks in late eighteenth- and nineteenth-century books and periodicals as well as the importance of the role of publishers in the commission and selection of the images seen by vast and diverse audiences.

As William M. Ivins, Jr., stated in *Prints and Visual Communication,* prints are "exactly repeatable pictorial statements [that make] the accepted report of an event more important than the event, for

what we think about and act upon is the symbolic report and not the concrete event itself."[5] Prints reported Adirondack topography, flora and fauna, recreational opportunities, livelihoods, hostelries, events, and issues in gazetteers, guidebooks, and picture books and appeared in the popular press. Juxtaposed with explanatory text, prints defined the Adirondacks and ultimately helped in the protection of the region by disseminating images that prompted legislative action to conserve the wilderness.

Separately published images joined books and periodicals to picture the Adirondacks. After the Civil War, Louis Prang's determination to manufacture affordable reproductions of paintings in order to provide livelihoods for American artists, as well as to educate and develop a taste for the aesthetic in the American public, bore fruit in the chromolithograph. By 1876 Prang had published more than one hundred reproductions of works of art as chromolithographs. A number of them were paintings of the Adirondacks by such artists as Arthur Fitzwilliam Tait, James M. Hart, and Hermann Fuechsel. Warder Cadbury examines another aspect of Prang's work: half-chromo album cards of landscape views known as gems of American scenery. Amongst this oeuvre are the three dozen or so small prints of Adirondack scenes by an artist named Robert D. Wilkie. These little-known and rarely seen works provide another clue to understanding the relationship of artist and publisher in the late nineteenth century as well as to the popularity of printed scenic images in Victorian America.

It was not until the mid-1800s that artists arrived in any numbers in the Adirondacks. By 1850 most prominent artists had been to the Catskills and the White Mountains and had exhibited paintings of these subjects at the National Academy of Design. These two mountain areas were more easily reached from the artistic centers of New York, Albany, and Boston, while the Adirondacks's more rugged terrain and greater distance made the region less accessible. Improved transportation and wider knowledge about the region—partly gained by paintings and prints visualizing it—opened the area to artists after 1850. Inspired by the the drama of the landscape, the purity of the light, and the grandeur of its rugged wildness, artists produced a substantial body of paintings, drawings, and watercolors of the Adirondacks as the century progressed. Many were reproduced as prints or chromolithographs by publishers who recognized that the magnetism of the region for artists was shared by the population at large, particularly city dwellers who yearned for simpler ways of life in the face of growing urban industrialization.

No other wilderness region of the country has served America's artists for so long or with so many subjects as the Adirondacks. *The Aldine,* according to Janice Simon, published more images of the Adirondacks and more Adirondack references than it did for any other mountainous area in America. Between 1871 and 1877, this subscription magazine published original wood engravings of extraordinary quality, descriptions of American scenery, poetry, and prose, as well as critical re-

views of American and European literature and art. Its primary intellectual focus was America's sylvan landscape. As Janice Simon argues, *The Aldine,* more than other nineteenth-century magazines or art periodicals, revealed a compendium of American perceptions about the country's forested lands after the Civil War. Whether pictured as a source of lumber, of artistic inspiration, or as a destination for tourists, America's forests—particularly those in the Adirondacks—were a laboratory for evolving ideas about the natural environment and its role in American national culture.

Artists of great national and international stature, artists of less renown, and artists known only by the works in the collection of the Adirondack Museum made prints depicting the Adirondack landscape. John Henry Hill, called the "Hermit of Phantom Island," continued three centuries of celebrating Lake George in image and word. The third generation artist in his family, John Henry Hill's artistic antecedents are detailed by Nancy Finlay who also documents, in Hill's own words, his daily life on Phantom Island in Lake George, his working and marketing methods, and the sites that he drew, etched, and painted as recorded in the diary he kept between 1870 and 1874. This diary provides a poignant personal counterpoint and context to his works of art.

Although David Tatham has written widely on Winslow Homer's paintings and his long artistic association with the Adirondacks, this volume publishes his study of Homer's six Adirondack prints for the first time. Five wood engravings produced in the 1870s, while he was in Minerva, New York, represent Homer's important contribution to the history of Adirondack prints. These images were published in illustrated weekly magazines and document in rich detail Adirondack trappers and hunters at work, loggers felling trees, boys fishing, and everyday life. Although these prints are minor works by a great artist, Tatham shows how much they enrich the graphic record of the Adirondack region.

The essay on the etchings of Dr. Arpad Gerster publishes the work of an avocational artist. Gerster's etchings represent the only images, in some cases, of remote Adirondack sites. Accompanied by Gerster's highly literate diary entries, these etchings and words are not only a personal response to wilderness but also record intimate views of Adirondack scenery seldom seen by contemporary tourists. Like the readers of *The Aldine* and the artists who graced its pages, Gerster found inspiration and repose in the forest interior.

The mystique of the Adirondacks continued in the twentieth century. It reached across our northern border to captivate Canadian artist David Milne and to inspire him to invent his own print process—the multiple plate color drypoint. Rosemarie Tovell observes that the drypoint process facilitated the communication of Milne's excited response to the region's beauty. Philosophically rooted in the nineteenth-century's predilection for inspiration from the natural

world, Milne was artistically committed to the twentieth century and Modernist art and aesthetics. Like Thoreau, Milne immersed himself in nature and developed a new art in the Adirondacks during the 1920s when he frequented Dart's Lake, Big Moose, and Lake Placid.

The abiding inspiration of the Adirondack forest interior, its lakes and mountains, have provided artist and printmaker with subject matter for nearly three hundred years. These essays taken together underscore the importance of the wilderness landscape in American art and culture and substantiate the role that prints have played to document, promote, and celebrate the Adirondacks.

Adirondack
Prints and Printmakers

When Men and Mountains Meet
Mapping the Adirondacks

JEROLD PEPPER

SAMUEL DE CHAMPLAIN was the first European to record seeing the Adirondack Mountains. On June 26, 1609, Champlain, with a small contingent of French volunteers, set off up the St. Lawrence. At the mouth of the Richelieu River, they were met by sixty Ottawa warriors, and together they moved down river prepared to do battle with the Iroquois. For seventeen days the Indian war party traveled south down the Richelieu and the west shore of Lake Champlain.

Around ten o'clock on the evening of July 29, Champlain's party spotted about two hundred Iroquois warriors. Both sides were intent on fighting, but neither wished to fight at night. The Iroquois landed and erected a strong barricade on the shore of the lake near Ticonderoga. The Algonquins spent the night on the lake, with their boats tied together.

At dawn the Algonquins landed and the Iroquois came out of their fort. The Algonquins began to run toward the enemy; as they neared the Iroquois, they parted ranks in the center, and Champlain advanced some twenty paces ahead of the rest. They continued to move forward until Champlain was within fifty feet of the enemy. The Iroquois, astonished to see an armor-clad Frenchman, stood motionless for a time. Then, Champlain raised his arquebus and aimed toward the three leaders. When he fired, two of the headmen fell dead and another was mortally wounded. The Iroquois lost courage and fled into the woods, pursued by Champlain and his companions.[1]

In the narratives of his voyages published in 1632, Champlain described seeing mountains to the east and south of the lake. The eastern mountains were certainly the Green Mountains, and the ones lying to the south were probably the Adirondacks.[2] In a map accompanying the narratives, the outlines of Lakes Champlain and Ontario and the St. Lawrence and Richelieu Rivers are familiar. The central Adirondacks, though, are illustrated by numerous Indian villages which probably never existed there.[3]

Champlain's brief encounter set a pattern for diplomacy and warfare that continued largely un-

changed for the next two centuries, the Algonquins siding with the French and the Iroquois with the British. The Lake Champlain basin war route became the most bitterly contested strategic corridor in the world. In the process it became well known to Europeans and Americans. At the same time, the central Adirondack Mountains remained a place of mystery and imagination.

The climax of the conflict set into motion by Champlain in 1609 occurred during the French and Indian War, a global war that thrust the Champlain Valley onto the center of the world stage. People thirsted for information from the battle fronts. In 1755 Samuel Blodgett, a Boston engraver, produced *Perspective Plan of the Battle Fought near Lake George on the 8th September 1755*. It was the first geographic representation of a battle plan produced in America.[4] The print contained an insert of a map of the area between Lake George and New York Harbor, the line of march an invading French army would probably take to win control of North America.

On the other side of the Atlantic, the British public was equally engrossed in events unfolding in North America. The year 1757 was a low point for the British-American war effort. Braddock's army had been destroyed at Ft. Duquesne in Pennsylvania, an attack against the French stronghold at Louisbourg had been a dismal failure, Fort Oswego fell, and Fort William Henry at Lake George was captured and its garrison massacred. Panicky settlers from the countryside streamed into Albany and Schenectady. In that year Richard William Seal, a London engraver and draftsman, produced a *New and Accurate Map of the Present War in North America,* which was published in London's fashionable *Universal Magazine.* Lacking any more knowledge of the topography of the interior mountains than Champlain had, Seal extended the Hudson and Oswegatchie Rivers into an area he labeled "Parts but little known."[5]

During the French and Indian War, the gulf in knowledge of the topography of the Lake Champlain–Lake George corridor and the Adirondack Mountains continued to grow. In 1762 William Brassier produced *A Survey of Lake Champlain Including Lake George, Crown Point, and St. John.* The survey contained a high degree of precise topographical information, including soundings for the lakes. During the American Revolution, in which the region would continue to be a key strategic area, Brassier's map became a standard piece of equipment for the British army. It was included in the *American Military Atlas,* which was sometimes called the "Holster Atlas" because it was carried by British officers in their holsters.[6]

In 1742 John Bartram, pioneer American botanist, traveled extensively on the eastern seaboard from northern New York to Florida to examine the country's flora and fauna. During part of his trip, he was accompanied by Lewis Evans, one of America's most prominent eighteenth-century cartographers. Evans used the geographic information acquired during that trip to produce *A General Map*

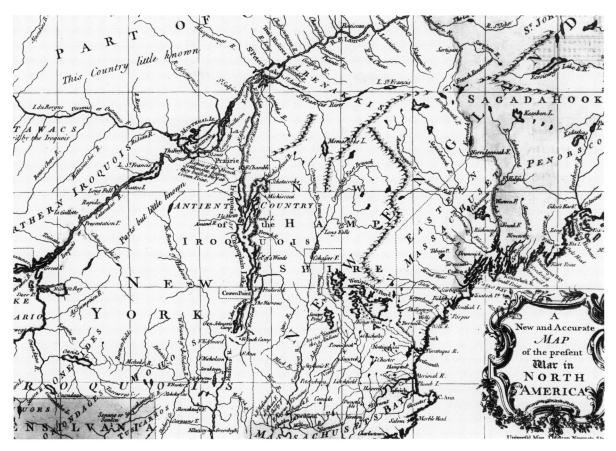

1.1. Published in London during a low point in British-American fortunes in the French and Indian War, R. W. Seals's *A New and Accurate Map of the Present War in North America* labeled the Adirondack Mountains "Parts but little known."

of the Middle North American Colonies in America published in Philadelphia in 1755.[7] He labeled the Adirondacks "Couxaxrage," an Iroquois term Evans translated as "beaver hunting ground." The map also included the comment, "This country by reason of mountains, swamps, and drowned lands is impassible and uninhabited."

In 1776 Evans produced an edition of his map in conjunction with Thomas Pownall, a royal

administrator and governor. On this map Evans simply covered the Adirondacks with a key to locations in the Champlain Valley, epitomizing the gulf in knowledge concerning the two regions.

The first hard knowledge of the Adirondack interior was acquired through the Totten and Crossfield Purchase in 1772. Joseph Totten and Stephen Crossfield, two New York City shipwrights acting on behalf of a group of investors, obtained a patent, or license, from the British governor of New York to acquire 800,000 acres, including most of what is now Hamilton County and parts of Essex, Warren, and Herkimer Counties. After some negotiations under the auspices of Sir William Johnson, the investors were able to purchase the Mohawk claim to the land for less than three cents per acre. The fees to royal officials for the transactions totaled nearly $40,000. The next step was to produce a survey.

In the spring of 1772, survey parties were organized under the supervision of Ebenezer Jessup, an Albany surveyor and investor in Adirondack real estate and a close friend of William Johnson. They traveled up the Sacandaga River to the Hudson near North Creek and began laying out the lines of fifty square townships containing 25,000 acres each. Using only compass and chain, they moved gradually northward until they came to what was to be the northern boundary of the Purchase, a line running east and west from a well-recognized survey point on the shores of Lake Champlain, described as a rock in a bay ten miles north of Crown Point. This east–west line was never run by the survey. One hundred years later, when the line was actually extended to Lake Champlain, it did not come to the rock ten miles north of Crown Point. Instead it ran through Westport, ten miles further north, adding 700,000 acres to the Totten and Crossfield Purchase and bringing its actual total to 1,150,000 acres.[8]

Totten, Crossfield, Jessup, and William Johnson all took the British side during the Revolution, and the ownership of the land reverted to the new state government. The Totten and Crossfield Purchase became a permanent fixture on Adirondack maps, including its faulty northern line, which kept the boundaries of several Adirondack counties in dispute until well into the twentieth century. Although the survey produced the first record of Adirondack topographical features such as Raquette and Indian Lakes, their shapes remained a matter of conjecture; they were often misplaced, and they were generally not labeled. The survey also included faulty information—Jessup connected the headwaters of the unknown Raquette River with the Hudson.[9]

Cartographers soon borrowed from the Jessup survey, making his errors their own. In 1776 Claude Joseph Sauthier collaborated with London engraver William Fadden to produce *A Map of the Province of New York*. The map, commissioned by William Tryon, the royal governor of New York, was probably an attempt to clarify conflicting land claims, particularly in the region that is now Vermont where armed rebellion against New York officials had broken out.

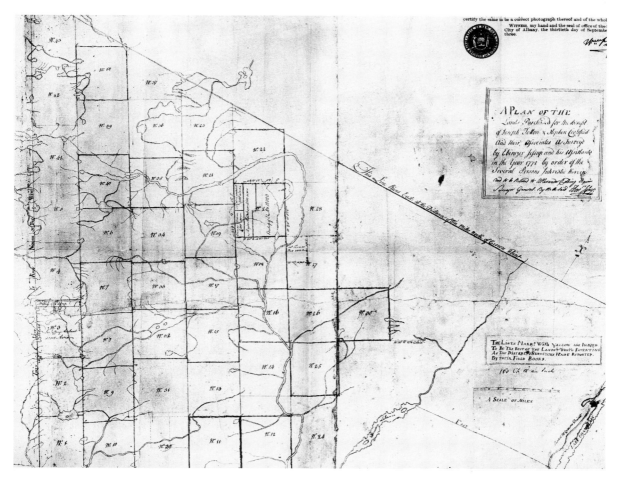

1.2. Ebenezer Jessup's failure, in 1772, to run the northern line of the Totten and Crossfield Purchase to a point on a rock on the shore of Lake Champlain ten miles north of Crown Point added 700,000 acres to the 1,150,000 acre tract.

Sauthier's dependence on Totten and Crossfield is obvious; the triangular survey is the only information about the Adirondack Mountains contained on his map. A closer look reveals that some additional information had become known in the four years since Jessup first ran his lines. Sauthier notes "A Very Remarkable Mountain" that is certainly Gore Mountain outside of North Creek. Indian Lake is situated in the correct location, as is the junction between the Hudson and Indian

Rivers in Township 16, and the Hudson River extends as far as present-day Newcomb in Essex County. Beyond Newcomb, though, instead of turning eastward toward Mt. Marcy, the Hudson extends south-westward toward Raquette Lake, duplicating Jessup's confusion concerning the Upper Hudson and Raquette River watersheds.

The errors in Jessup's survey soon became apparent. In 1792 Alexander Macomb, a New York City merchant, paid eight cents per acre for 4,500,000 acres of North Country land. Macomb hired Charles Brodhead, a Mohawk Valley surveyor, to survey the tract, which extended from Totten and Crossfield's northern boundary to the St. Lawrence River. Brodhead and his crew first tried to locate Jessup's northern line and, of course, found no trace of it. They were able to locate the northwestern corner of Jessup's survey, and Brodhead resorted to running his township lines south and east from the river and the shore of Lake Ontario to points on Totten and Crossfield's hypothetical northern line.[10]

Northern New York remained a strategic border region, and tensions between the United States and the British in Canada ran high. In 1812 Amos Lay published the second edition of his *Map of the Northern Part of the State of New York,* perhaps to provide a more accurate map in case war broke out.[11] An 1801 version of the map produced jointly with Arthur Stansbury had been the first published map exclusively devoted to northern New York State.[12]

In 1810 the New York State Legislature, also anticipating trouble on its northern frontier, authorized the construction of two "military" roads connecting the Mohawk Valley and Lake Champlain with the St. Lawrence River. The crude north-south route, variously called the Albany, Russell, or Fish House Road, after a fishing camp William Johnson kept on the Sacandaga River, shows up on the map.[13]

In 1818 New York State Geographer John Eddy produced *The State of New York with Parts of the Adjacent States* to help promote DeWitt Clinton's plan for the Erie Canal.[14] The map contains a wealth of information about the Adirondacks. The general locations of the headwaters of all the major Adirondack rivers are correctly identified, although their specific sources remain undiscovered.

The Eddy map also includes some errors: Forked Lake is depicted as part of Long Lake; Raquette and Blue Mountain Lakes are confused or missing, but they are correctly linked to the Raquette River watershed. The interior of the mountains, though, retained a dark, sinister aura of the unknown. Eddy covered the southwestern part of the Adirondacks with a label, "A wild barren tract extends hereabouts the property of the state, covered with almost impenetrable Bogs, Marshes, and Ponds, and the uplands with Rocks & evergreens."[15]

Although the geographical details of the Adirondack Mountains were coming into focus in the first decades of the nineteenth century, the region still remained mysterious. In much the same way as cartographers labeled the unknown parts of the western United States as the Great American

1.3. In the early decades of the nineteenth century, New York's northern mountains remained mysterious and sinister. This 1823 map, published by Carey and Lea, labeled the Adirondacks a "Wild Unsettled Country."

Desert, an 1823 map of New York State, from an atlas published by Carey and Lea in Philadelphia, notes the Adirondacks as "a Wild Unsettled country."[16]

In 1836 the New York State Legislature, in an effort to identify and publicize the state's resources and promote development, "authorized an accurate and complete geological survey of this state, which shall be accompanied with proper maps and diagrams, and furnish a full and scientific description of its rocks, soils and minerals, and of its botanical and zoological productions."[17] Ebenezer

Emmons, a physican and professor of natural history at Williams College, was appointed to supervise the work of the survey's second district, including the unnamed Adirondack Mountains.

The following summer Emmons lead a party up what proved to be the highest mountain in the state, which he named Mount Marcy in honor of Governor William Marcy.[18] In an 1838 report on the survey's progress Emmons wrote:

> The cluster of mountains in the neighborhood of the Upper Hudson and Ausable rivers, I proposed to call the Adirondack Group, a name by which a well-known tribe of Indians who once hunted here may be commemorated.
>
> It appears from historical records that the Adirondacks or Algonquins, in early times, held all the country north of the Mohawk south of Lower Canada, and east of the St. Lawrence River . . . but were finally expelled by the superior force of the Agoneseah or Five Nations.[19]

A *Geological Map of the State of New York,* published by the state in 1842, compiles much of the information learned of the Adirondacks through the work of Emmons and the Natural History Survey. Most of the lakes and rivers in the region are correctly configured and located, and many are named.[20]

In terms of promoting development, at least in the Adirondacks, the Natural History Survey did have an effect. In the spirit of an era that invented terms like hokum and bunkum, the region became a focal point for promoters and speculators, each with their own scheme for making a fortune. None of them was very successful.

In 1848 a group of investors sought and received a charter from the state to build a railroad from Saratoga Springs, where connections could be made to Albany and to Sackets Harbor on Lake Ontario. The route was selected from several different plans considered by the state for a railroad across the mountains. The goal of the project, as shown on a map of the road compiled in 1853, was to compete with the New York Central Railroad's recently consolidated route from the east coast to the Great Lakes.

The proposed route ran northward from Saratoga Springs, meeting the Hudson River at its confluence with the Sacandaga and continuing up the Hudson through Warren and into Hamilton County. The survey then called for the railroad to turn westward running along the bed of the Indian, Cedar, and Rock Rivers along the south shore of Blue Mountain Lake, labeled Lake Emmons on the survey map, and Raquette Lake, and finally, along the Fulton Chain through Herkimer County and on to Carthage and Lake Ontario.[21] Despite a provision in the charter permitting the

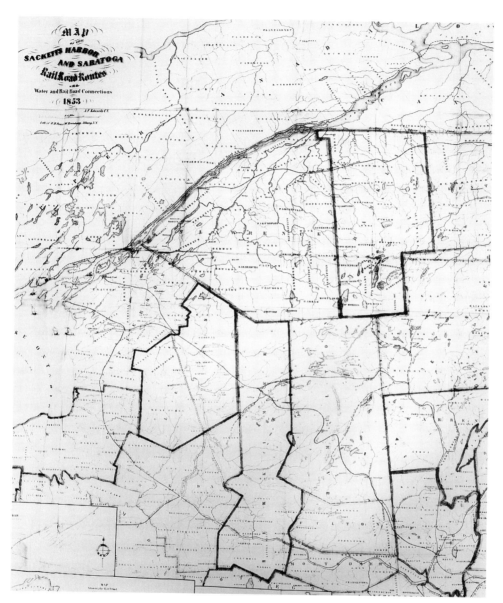

1.4. In 1863 Dr. Thomas Clark Durant, a vice president of the Union Pacific Railroad, acquired the Sacket's [*sic*] Harbor and Saratoga Railroad, along with the rights to purchase one million acres of Adirondack land tax-free for twenty years.

railroad to purchase up to 250,000 acres of state land in the Adirondacks at a nickel an acre and a ten-year abatement from all property taxes, the company was unable to raise the necessary capital to begin construction.

In 1863 the Sacket's [sic] Harbor and Saratoga Railroad Company was reorganized and renamed The Adirondack Company. The company was now controlled by Dr. Thomas Clark Durant. Dr. Durant, a vice president of the Union Pacific during its race to build the transcontinental railroad, accumulated one of the great fortunes in nineteenth-century America. The bounty provisions of the Sacket's Harbor and Saratoga Railroad were extended to the new company. In addition, the legislature exempted the Adirondack Company's land, up to one million acres, from taxation for twenty years. The terms of the law gave the company four and one-half years to lay track from Saratoga Springs to the border of Essex County.

By 1869 the company had fulfilled its part of the bargain, laying sixty miles of track from Saratoga to North River, although its actual terminus was in North Creek. The Adirondack Company's railroad, or the Adirondack Railway, as it was now called, would never lay additional track. The cost of constructing the sixty mile line was $3,000,000; in exchange, the Adirondack Company gained control of 658,261 acres of Adirondack land covered by a twenty-year exemption from all property taxes.[22]

In 1874 Dr. Durant summoned his son William West Durant home from an expedition in Egypt to manage the family's Adirondack lands. Born in Brooklyn in 1850, William had been educated in England and Germany and had not been back to the United States in thirteen years.[23] Accustomed to refinement, Durant modeled his Adirondack developments after the baronial hunting estates of European aristocracy. In the process he developed a unique regional architectural style now known as the Adirondack Great Camp. He also lost the family fortune.

The American economy exploded in the decades following the Civil War, and the industrialists, financiers, and railroad magnates who flourished during this era amassed great wealth. William West Durant's Adirondack developments provided an opportunity for these people to acquire vast private holdings enclosing wilderness lakes, ponds, and rivers.

Owners of the Great Camps would visit for a few months, weeks, or sometimes only a few days. For the rest of the year the camps—actually small isolated villages—were residences for the caretaker staff. In addition to residential quarters, the Great Camps were supported by outbuildings for maintaining the complex, its visitors, and staff. They were self-sufficient and often included working farms, greenhouses, ice houses, and even a chapel. Finally, the Great Camps required complex networks for underground water supply, waste collection systems, and eventually electric power lines. They were lavishly expensive to build and maintain.[24]

In 1883 the railroad's exemption on property taxes expired, putting great pressure on Durant's cash flow. In July, 1889, he sold his share of the Adirondack Railway to the Delaware and Hudson. By 1897 Durant was forced to sell the *Utowana,* his two hundred-foot ocean-going yacht. He began selling off large tracts of undeveloped land to the state and to several large timber operators. He turned to his millionaire friends for help, particularly Collis P. Huntington. Huntington's death in 1900 sealed Durant's fate. By 1904, awash in a sea of lawsuits, including one brought by his sister, Durant lost control of his Adirondack empire.[25]

In 1845, three years before the Sacket's Harbor and Saratoga Railroad Company received its charter from the state, Farrand N. Benedict, a professor of mathematics at Burlington College in Vermont, purchased most of Township 40, containing Raquette Lake. The following year a group of businessmen from Essex County petitioned the state to underwrite the construction of a railroad and steamboat route running across the Adirondacks from Lake Champlain to the Black River Canal in Oneida County. Professor Benedict was listed as civil engineer on the petition, and he came up with an elaborate boat and rail network, beginning in Port Kent, which was served by the Lake Champlain steamboats and was a popular jumping off point for travelers coming into the mountains.

Benedict's plan called for a railroad to be built through the Ausable River Valley to Miller's Creek in the vicinity of what is now the Village of Saranac Lake. From there, passengers would board a steamboat, and dams on the Raquette would raise the water level so that boats could pass down the river from Lower Saranac to Raquette Lake. Connecting boats would travel to Tupper Lake and down the Eckford Chain. The boats would continue down John Brown's Tract Flow, the Fulton Chain of Lakes, and the Moose River. Somewhere above the fork of the Moose, passengers would disembark from the steamboats and board another railroad that connected with the Black River feeder canal.[26] The promoters, however, found little enthusiasm in the state government for underwriting Benedict's complicated plan.[27]

Benedict tried again. In 1874 the state Canal Commissioners undertook a survey to determine the use of the headwaters of the upper Hudson and Raquette Rivers for transporting logs. Once again, Benedict was put in charge of the survey.

This time Benedict advocated a simpler plan to divert the headwaters of the Raquette into the Hudson River. A one-and-one-half-mile long canal between Long Lake and Catlin Lake in Newcomb would shunt water from Blue Mountain Lake, Utowana Lake, Eagle Lake, Raquette Lake, Forked Lake, and Long Lake into the upper Hudson.[28] Excavations, which are still visible from the air, were actually begun on the Long Lake side of the canal, but powerful lumber interests on the lower Raquette eventually foiled Benedict's plan.[29] By the 1880s his land had been sold for

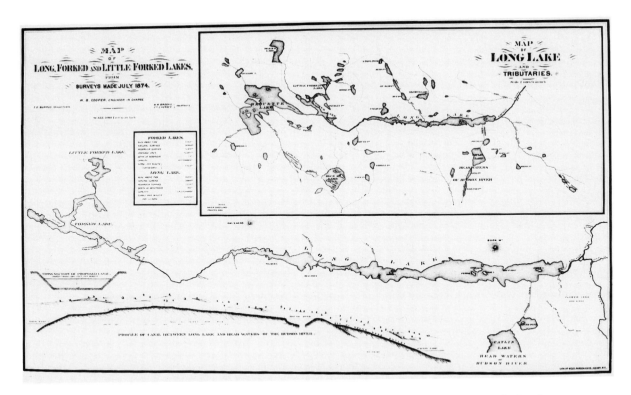

1.5. Work began on Farrand Benedict's canal linking Long Lake and Catlin Lake and diverting the headwaters of the Raquette River to the Hudson, but the plan failed to gain support from the state.

taxes. Benedict, like Durant and many others, was unable to overcome the difficulties of development in the Adirondacks. The collapse of Durant's and Benedict's land empires left such a legacy of legal chaos that it remains impossible to obtain title insurance for deeds in certain parts of the village of Raquette Lake.[30] On the other hand, their projects expanded the knowledge of Adirondack topography and resources and brought the region to the attention of a wider public.

By the middle of the nineteenth century, Americans had acquired wealth and leisure time, and recreational travel became acceptable and popular among the upper and professional classes. Some of the new tourists sought aesthetic, spiritual, or educational self-improvement, while others went simply for recreation. The accounts of Adirondack travelers began showing up in newspapers and in a wide range of popular magazines. The July 1859 issue of *Harper's New Monthly Magazine* con-

tained an article by Thomas Bangs Thorpe about a hunting trip to the Adirondacks. The article was accompanied by a map of his route entitled *A Visit to "John Brown's Tract."*

In the summer of 1860, Dr. William Watson Ely, a Rochester physician and amateur draftsman, traveled with a group of friends across the Adirondack Mountains from Boonville to Port Kent. Ely described Adirondack roads as "execrably bad," but he found the mountain scenery inspiring. Ely wrote a series of articles for the travel section of a Rochester area weekly newspaper, *Moore's Rural New-*

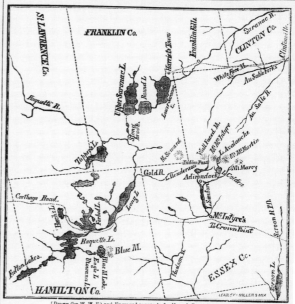

SEPT. 8. MOORE'S RURAL NEW-YORKER.

Spice from New Books.

Traces of Past Life.

PLEASANT, both to eye and mind, is an old garden wall, dark with age, gray with lichens green with mosses of beautiful hues and fairy elegance of form; a wall shutting in some sequestered home, far from "the din of murmurous cities vast;" a home where, as we fondly, foolishly think, Life must needs throb placidly, and all its tragedies and pettinesses be unknown. As we pass alongside this wall, the sight of the overhanging branches suggests an image of some charming nook; or our thoughts wander about the wall itself, calling up the years during which it has been warmed by the sun, chilled by the night airs and the dews, and dashed against by the wild winds of March, all of which have made it quite another wall from what it was when the trowel first settled its bricks. The old wall has a past, a life, a story; as Wordsworth finely says of the mountain, it is "familiar with forgotten years." Not only are there obvious traces of age in the crumbling mortar and the battered brick, but there are traces, not obvious except to the inner eye, left by every ray of light, every raindrop, every gust. Nothing perishes. In the wondrous metamorphosis momently going on everywhere in the universe, there is *change*, but no *loss*.

If a garden wall can lead our vagabond thoughts into such speculations as these, surely it may also furnish us with matter for our Studies in Animal Life. Those patches of moss must be colonies. Suppose we examine them. I pull away a small bit, which is so dry that the dust crumbles at a touch; this may be wrapped in a piece of paper—dirt and all—and carried home. Get the microscope ready, and now attend.

I moisten a fragment of this moss with distilled water. Any water will do as well, but the use of distilled water prevents your supposing that the animals you are about to watch were brought in it, and were not already in the moss. I now squeeze the bit between my fingers, and a drop of the contained water—somewhat turbid with dirt —falls on the glass slide, which we may now put on the microscope stage. A rapid survey assures us that there is no animal visible. The moss is squeezed again, and this time little yellowish bodies of an irregular oval are noticeable among the particles of dust and moss. Watch one of

THE TRAVELER.

A TRIP TO THE WILDERNESS.—III.

BY W. W. ELY, M. D.

THE lakes, which constitute so striking a feature of the New York Wilderness, are not only its chief attraction to the tourist, but, without them, this vast region would be, for all practical purposes, inaccessible. They are so numerous, of such nearly uniform elevation, and so related to the rivers which flow in widely different directions from the common center, that the exploration of the territory becomes not simply possible, but expeditious and pleasant. The traveler is not, therefore, obliged to wend his way through gloomy, trackless forests, but is transported from lake to lake, amid the most delightful mountain scenery, penetrating no further into woods than to cross a "carrying place," or to avail himself of a suitable camping ground during his sojourn in the neighborhood of an eligible hunting or fishing region. Any description from the pen of a tourist, of the territory in question, must accordingly relate more particularly to the scenery of which these interesting bodies of water form so large a proportion, and to the incidents from which they cannot be wholly disconnected.

By reference to the map given at the head of this page—which the enterprising "RURAL" has caused to be engraved for the purpose—a correct idea may be obtained of the relations which the principal lakes bear to each other, connecting the extreme points of the wilderness by navigable waters from the Brown Tract lakes on the southwest to the Saranac lake on the northeast.

Having already referred to the first of the series, or the Fulton lakes, we find in the northern part of Hamilton county that peculiarly shaped lake, the Raquette, whose size, central position and advantages as a rendezvous for sportsmen, invest it with special interest. This lake has an elevation of 1,731 feet above tide water, and is one of the head waters of the river

[Drawn (by W. W. E.) and Engraved expressly for Moore's Rural New-Yorker.]

MAP OF ROUTES THROUGH THE NEW YORK WILDERNESS.

from its wooded summit, (if you climb a tree to witness it,) well rewards the labor. The wilderness extends as far as the eye can see, and the number of visible lakes excites your astonishment. The elevated waters of the Blue Mountain lake flow with the Raquette streams to the St. Lawrence, while less than a mile south the head waters of the Hudson begin their course in a direction nearly opposite.

On the border of the Eagle lake is the neat and convenient residence of Mr. E. Z. C. JUDSON.

the Raquette, we were at this time a dozen, including four guides. These, acting in the capacity of cooks, were not long in furnishing an ample supper of venison, of which we ate right heartily, notwithstanding the precept against "late suppers," and were soon after ranged along the floor of the cabin, thankful for having found such nice *hotel* quarters in the wilderness. At an early hour the next day we were ready to renew our journey, and passing down Cold River to resume the navigation of the Raquette, we met several

1.6. Dr. William Watson Ely, a Rochester physician and amateur draftsman, produced Adirondack maps first published in the August and September 1860 issues of *Moore's Rural New-Yorker.*

Yorker, which published them in their August and September issues. In an effort to guide future visitors to the region, Dr. Ely created several maps of his route that were published along with his articles.

Alfred Billings Street, a lawyer from Monticello, New York, moved to Albany in 1839 when he was twenty-eight years old. He turned to literary pursuits, and, in 1842, he was named New York State Librarian. Street wrote *Woods and Waters; or, the Saranac and Racket* [sic] in 1860. Part hunting stories, part guidebook, part verse, the book contained the first published map of what would soon become a very popular Adirondack tourist route through the Saranac Lakes and the Raquette River to Long Lake.[31]

Unlike Street, Ely, and Thorpe, Edwin A. Merritt was a trained surveyor. From Potsdam, New York, Merritt also had a considerable amount of firsthand experience surveying the neighboring Adirondack Mountains. By the 1850s, Potsdam, located on the Raquette River, had become a major milling center for logs cut in the northern woods. Hunting and fishing, which had once been necessities of rural American life, had become for some, by mid-century, recreational activities. The existing maps of the mountains were inadequate for guiding sportsmen unfamiliar with the local geography.

Merritt saw an opportunity, and in 1860, he produced the first true guide to the Adirondack Mountains. The folio, *Maps of the Racket* [sic] *River and Its Headwaters,* contained a twelve page descriptive guide and two accompanying maps of the Raquette River.[32] The narrative section contains descriptions of routes, distances between various points along the river, portages, hotels and other way stations, and sources for supplies, as well as a list of guides from various towns along the river.

The first of Merritt's two maps, *Map of the Head Waters of the Racket* [sic] *River,* covers the region from Blue Mountain and Raquette Lakes to upper Long Lake. With extraordinary detail Merritt's maps include information about hunting and fishing and the location of roads, portages, and habitations. His knowledge of the region is evident and his enthusiasm obvious in the label for the region north of Long Lake, which reads "Fine Sporting Territory."

Merritt's second map of the river, *Map of the Racket* [sic] *River Between Stark's Falls and Tupper's Lake,* is equally detailed and locates the "Great Windfall of 1845," no small obstacle for hunters crossing the mountains on foot. Merritt's two-map guide is clearly the first true Adirondack map produced specifically for visitors to the region.[33]

In 1865, in another clear indication of the growing market for information concerning the Adirondacks, New York City map publisher Henry H. Lloyd produced a *New Map of Northern New York Including the Adirondack Region.* Although Lloyd's map contains little more than previously published geographical information about the Adirondacks, Lloyd adopted color and size formats that would become standard among Adirondack tourist maps, and the map came packaged to fold in and out of a map-sized folio made of book board.

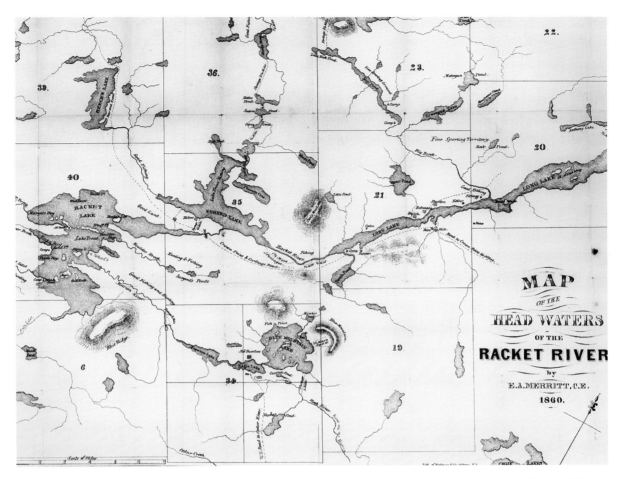

1.7. Edwin A. Merritt, a surveyor from Potsdam, New York, had on-the-ground experience that provided a high level of detailed information for his 1860 *Maps of the Racket [sic] River and Its Headwaters,* the first published guide to the Adirondack Mountains.

Edwin Merritt's 1860 guide to the Raquette River ended with a note that he was preparing a "map covering the entire Forest," which he predicted would be ready for sale by January 1, 1861. Perhaps the Civil War or financial problems intervened, but the map *Wilderness of New York and a Sketch of the Border Settlements,* published in Albany by state printer Weed, Parsons, and Company, did not come out until 1867.

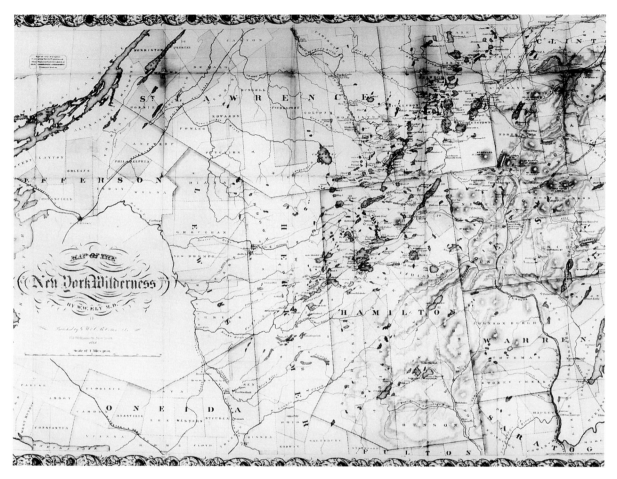

1.8. In 1867 Dr. Ely produced the first edition of *Map of the New York Wilderness*, the most successful nineteenth-century Adirondack tourist map.

Surprisingly, Merritt is listed on the map as assistant to Homer de Lois Sweet, a Syracuse surveyor and poet whose book, *Twilight Hours in the Adirondacks*, would be published in 1870.[34] A wall map consisting of thirty-six ten-by-ten-inch sections, and having a scale of one inch equal to two miles, Merritt's 1867 map contains a remarkable amount of accurate and detailed information. Clearly intended for the regional visitor, the map includes geographic and topographic material, along with

the names and locations of portages, hotels, and habitations. The map also notes the location of sites of interest such as John Brown's grave, as well as the nearest telegraph to New York City.

In 1867, the same year that Merritt came out with his wall map, Dr. Ely produced the first edition of what was to become the most successful and widely copied Adirondack tourist map, *Map of the New York Wilderness* published by George W. and Charles B. Colton of New York City. The Ely map did not possess the level of detail and accuracy of Merritt's map. On the other hand, Ely did copy the successful color, size, and foldout format of Henry Lloyd's 1860 map. *Map of the New York Wilderness* became the standard map for nineteenth-century tourists to the Adirondacks. During the following decades it appeared in many editions in the popular Adirondack guidebooks produced by Winslow Watson, Edwin Wallace, and Seneca Ray Stoddard.[35]

In 1869 a man with the unlikely name of William Henry Harrison Murray set off a tourist boom in the Adirondacks. Murray, a Congregational minister from Connecticut, had taken several hunting and fishing trips to the Adirondacks and, like Ely, had written about them in his local newspaper. In 1869 they were compiled in a book called *Adventures in the Wilderness; or, Camp Life in the Adirondacks.* Published on April Fool's Day, it became a best seller, going through ten editions by the end of the summer.

The Delaware and Hudson Railroad gave free copies to the purchasers of round-trip tickets to Whitehall on Lake Champlain, which became mobbed with tourists who quickly became known as "Murray's Fools." The tourist edition of Murray's book, provided by the railroad, contained one of Dr. Ely's maps.[36]

Seneca Ray Stoddard, born in Wilton in Saratoga County in 1843, understood the market unleashed by Murray's book. An 1867 newspaper advertisement listed Stoddard photographs of Glens Falls, Saratoga Springs, Lake George, Lake Champlain, and Ticonderoga for sale at local bookstores and hotels. In 1873 Stoddard published his first guidebook, *Lake George Illustrated.* Four thousand copies were sold that summer. The next year Stoddard published the "bible" of Adirondack guidebooks, *The Adirondacks Illustrated,* which he revised annually until 1915.

A guidebook was incomplete without a map, and in 1874 Stoddard added a *Map of the New York Wilderness.* Bearing his name, it was actually a copy of Dr. Ely's 1867 Adirondack map. In 1880 Stoddard published a completely new map entitled *Map of the Adirondack Wilderness* using a distinctive circular format that allowed him to show "air-line" distances from Mt. Marcy. The 1880 map included information about hotels, railroads, steamboats, trails, and carries. Like the guidebook, Stoddard would issue a new edition of his map each year.[37]

Verplanck Colvin was born in Albany in 1847. From a prominent Hudson Valley family, Colvin

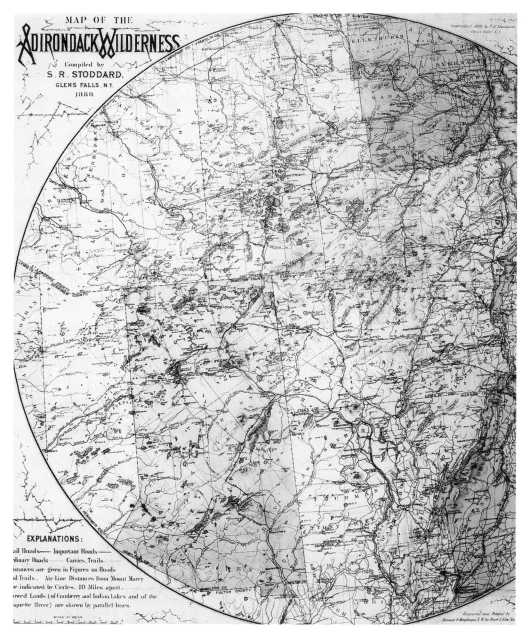

1.9. Seneca Ray Stoddard produced his *Map of the Adirondack Wilderness* in 1880 to include in his highly successful guidebook *The Adirondacks Illustrated*.

left a promising career in his father's law office to explore and map the Adirondack Mountains. In 1872 Colvin convinced the state legislature to appropriate $10,000 "to aid in completing a survey of the Adirondack wilderness of New York, and a map thereof." Colvin, who was twenty-five years old, was appointed superintendent of the Adirondack Survey.

Colvin began his fieldwork in the Champlain Valley, where existing base lines provided key points of reference. He and his party carried scientific instruments that he had bought with his own money. Taking measurements from dawn to dusk, Colvin pushed his men unmercifully from peak to peak in all sorts of weather. Some of his men quit when he prohibited alcoholic beverages in the survey camps. In addition to fighting their way through miles of uncharted wilderness in the harshest weather, the survey crew had to ward off bear attacks on their camps. Colvin's innovations helped push the work forward, and he took out a patent for a portable boat he devised for use in the survey.

In the survey's first report published in 1873, Colvin announced the discovery of "the summit water of the state, and the loftiest known and true high source of the Hudson River," which he named Lake Tear of the Clouds.[38]

Verplanck Colvin never produced a map of the Adirondacks. Instead, his achievement lay in publicizing the mountains through the survey's reports, published between 1873 and 1899, and in the speeches he made to groups throughout the state. The survey's reports are not only crammed with facts, but read like adventure stories, imparting a sense of mystery and grandeur.[39] They also were illustrated with views of remote sites not previously depicted, which Colvin drew and the Albany firm of Weed and Parsons lithographed.

Between 1871 and 1879 over one-half million acres of Adirondack land reverted to state ownership. Much of the land, which had been sold off during the great land sales of the late eighteenth and early nineteenth centuries, went to timber operators who cut the softwoods that could be driven down the rivers. They then let the title revert back to the state for taxes.[40]

This amounted to a state subsidy for the timbermen. The practice produced a lively speculative market in Adirondack land, and in 1879, B. C. Butler compiled *The New York Wilderness Hamilton County and Adjoining Territory,* a wall map published by Weed and Parsons, which claimed to sort out the Adirondack land ownership confusion.[41] The problem of state ownership of large tracts of land became so acute in some Adirondack towns that, in 1871, the state began the unique practice of paying local property taxes on its Adirondack lands to help support the local governments in the region.[42]

The Erie Canal opened in 1825 transforming New York City into the busiest port in the United States. By the middle of the nineteenth century the state's extensive canal system was not only an important part of New York's commercial network, but also a counter to the railroad's growing mo-

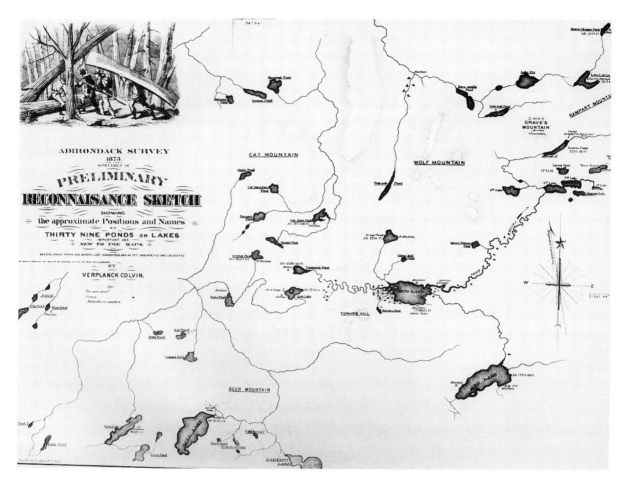

1.10. Although the Adirondack Survey never produced a complete map of the Adirondacks, Verplanck Colvin's achievement lay in publicizing the mountains through the survey's reports, which read like adventure stories.

nopoly over transportation. Unfortunately, the canal system was vulnerable to winter weather and periodic droughts that made the canals impassable.

A supply of high quality drinking water was also considered crucial to the future growth of the state's cities.[43] In 1862 the state engineer, William B. Taylor, surveyed the capacity of western Adirondack lakes to supply water to the Black River Canal.[44] One part of the plan, a dam on the Beaver River at

Stillwater, was actually built, and the construction of dams on Adirondack waterways remained a contentious political issue until a constitutional amendment in 1954 largely prohibited them.[45]

By the 1880s New York City business groups began supporting the protection of Adirondack forests, and the New York Board of Trade and Transportation lobbied the legislature to protect New York's watersheds by purchasing Adirondack land. In 1884 the legislature appointed Charles S. Sargent, a Harvard professor and director of the Arnold Arboretum, to head a commission to study the problem of Adirondack forests. Verplanck Colvin was named the commission's secretary. In January 1885 the group made its report. Among other things, they recommended that all state-owned lands in the Adirondack and Catskill counties be known as the Forest Preserve, and "The lands now or hereafter constituting the Forest Preserve shall be forever kept as wild forest lands."

On May 15, 1885, Governor David B. Hill signed Sargent's bill into law, linking the powerfully evocative phrase, "forever wild," with the preservation of the Adirondacks. The law prohibited the sale of state-owned forest preserve land, but it said nothing about the timber. It also established a three-member Forest Commission to manage the preserve. The commissioners published a map with their first report in an effort to take stock of their new domain. The map listed state-owned land and forest lands.[46]

The commissioners soon realized that a state preserve scattered over twelve Adirondack counties was unmanageable. In 1891 they issued a special report to the legislature on the establishment of an Adirondack Park to consolidate future state land purchases within a smaller geographic area. State-owned parcels outside the park would be sold or exchanged for land within the "Blue Line," which delineated the proposed park's boundaries on the map accompanying the report. The commissioners also called on the state "to acquire and hold the territory in one grand, unbroken domain." In other words, they recommended that the state buy all large, private landholdings within the proposed Adirondack Park. The commissioners estimated that the cost would be between $3,000,000 and $3,500,000.[47]

On May 20, 1892, Governor Roswell P. Flower signed the Adirondack Park Act. The area within the Blue Line consisted of 2,807,760 acres, of which 551,093 belonged to New York State. In 1893 the Forest Commission published a wall map titled *Map of the Adirondack Forest and Adjoining Territory* . . . compiled by John Koetteritz, the state forester. The map was produced to enable the state to take stock of its Adirondack lands and to reduce timber poaching. Like the 1879 map by B. C. Butler that it resembled, Koetteritz's map stressed information about Adirondack land ownership, and state-owned, Forest Preserve land was colored in red ink. Koetteritz's map was the first of a series, sometimes called the plat maps, which the state continues to publish.

The map also contained the first published record of the actual boundaries of the new Adirondack

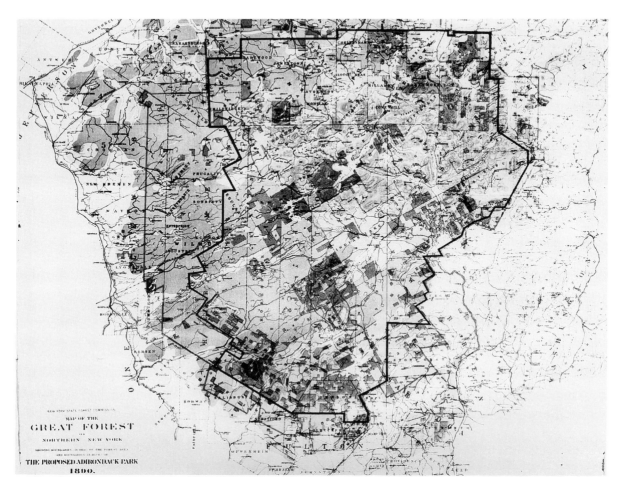

1.11. A map accompanying a New York State Forest Commission report on the establishment of an Adirondack Park delineated the proposed park in blue ink, originating the tradition of the Blue Line.

Park as they were fixed by the legislature the year before. The park's boundary was marked in blue ink following the precedent started by the Forest Commissioners' 1890 map. The Blue Line, as the park's boundaries have become known, has been drawn in blue ink on most subsequent Adirondack maps.[48]

In 1894 a New York State Constitutional Convention meeting in Albany added the "forever

wild" protection of the Forest Preserve to the state's constitution. Article fourteen supplemented the existing restriction on the sale of state-owned Adirondack land, with a prohibition on the removal of its timber. The "forever wild" clause is unique; it gives the state-owned portion of the Adirondack Park constitutional protection that cannot be undone by a governor or legislature. Only the people of New York, voting in a statewide referendum, can make exception to the blanket of protection thrown over the Forest Preserve in 1894.

During the later decades of the nineteenth century, the Adirondacks became a fashionable tourist destination. Victorian men of letters such as Mark Twain and Robert Louis Stevenson, and politicians like Grover Cleveland and Rutherford B. Hayes, took well-publicized trips to the region. Travel in the region was confined to a row in a guideboat or a tramp through the woods, to the rigid schedule of a steamboat or railroad journey, or to the hazards of a horse-drawn wagon ride over the region's bone-jarring roads. These factors imposed a leisurely pace on tourism, and only a small segment of the American public could afford the weeks or months required to vacation at Adirondack resorts.

Travel by automobile captured the public's fancy in the first decades of the twentieth century. Fifteen million Model T Fords were built and sold in the United States between 1908 and 1927. The automobile opened the Adirondacks to middle-class Americans. By the First World War, macadam surfaced roads connected most Adirondack tourist destinations with the rest of the state, and, as a 1910 *AutoRoad Map of the Adirondacks* by S. R. Stoddard shows, motorists could buy gasoline and get repairs in towns like Long Lake and Newcomb.

By the 1920s the New York State Conservation Commission was actively promoting Adirondack tourism. Private groups such as the Adirondack Mountain Club were organized to help build public interest in recreation in the region. In 1932 the Winter Olympic Games held in Lake Placid symbolized the growth of the Adirondacks as a center for outdoor sports. Some tourists purchased land for second homes. Subdivisions increased the number of individual land owners in the park and drove up the price of land, vastly complicating the state's plan to buy park land.

Liberated from the necessity of staying at large hotels, automobile tourists roamed wherever the road led them. Their need for services created new business opportunities for Adirondackers who previously had worked for the large resorts. Billboards advertising gas stations, diners, stores, and camp grounds soon became so prolific that they were eyesores and traffic hazards. In 1924 the state legislature authorized the Conservation Commissioner to regulate signs in the Adirondack Park. During the first year, state forest rangers removed nearly 1,500 signs from Adirondack roadsides.[49]

In 1959, after several years of debate, voters approved a referendum allowing the construction of the Northway, a 175-mile highway between Albany and the Canadian border, with over ninety miles

running through the Adirondack Park. Many people feared that the new highway would subject the park to a development boom similar to the one changing the character of neighboring Vermont.

A group led by Laurence Rockefeller proposed, in 1967, that a National Park be carved out of the Adirondack Park. Governor Nelson Rockefeller, responding to public concern about pressures on the Adirondacks, appointed a commission to study the park.[50]

On December 15, 1970, the Temporary Study Commission on the Future of the Adirondacks delivered its report to him. It contained 181 recommendations. For over a year, the legislature considered legislation based on the Commission's recommendations. On June 7, 1972, just before adjournment, the legislature finally acted, establishing an independent Park Agency with general power over land use in the Adirondack Park. In May 1973 the legislature adopted the *Adirondack Park Land Use Master Plan*.

The plan divides private land in the park into six categories that determine acceptable levels of development. The least restrictive category, hamlet, requires half-acre building lots, while the most restrictive designation, resource management, limits density to one structure per 42.6 acres of land. Although it hoped to enlist local support, the legislature imposed the restrictions in the Land Use Master Plan from the top down. Not surprisingly, the Adirondack Park Agency and the Land Use Master Plan provoked bitter resentment in many Adirondack communities.

As seen in satellite images from space, the Adirondack Mountains exert the same powerful sense of mystery as they did when Champlain first saw them nearly four hundred years ago. The Adirondacks are as much an idea as a place. A dismal wilderness, a huckster's boondoggle, a rich man's fantasy, a recreational playground, a "forever wild" wilderness park; Americans have invented and reinvented the region. Perhaps no other form of creative impulse has so faithfully captured our own constantly evolving reactions toward the mountains as have the region's maps. Part expression of human imagination, part utilitarian document, maps are simultaneously works of art and artifactual evidence of the powerful hold the Adirondacks have over our imagination.

William Blake, the seventeenth-century English engraver and mystic, understood the strange pull of the mountains well when he wrote:

Great things are done when
Men and mountains meet—
These are not done by
Jostling in the Street.[51]

Two Great Illustrated Books about the Hudson River

William Guy Wall's *Hudson River Port Folio* and Jacques Gérard Milbert's *Itinéraire pittoresque du fleuve Hudson*

PHILIP J. WEIMERSKIRCH

SOME OF THE EARLIEST views of the Adirondacks appear in two books about the Hudson River, William Guy Wall's *Hudson River Port Folio,*[1] a large oblong folio with twenty hand-colored aquatints, and Jacques Gérard Milbert's three-volume *Itinéraire pittoresque du fleuve Hudson* with an atlas of fifty-four black and white lithographs.[2] Both were published in the 1820s, one in New York and one in Paris. Though they were published thousands of miles apart, there are some interesting connections between the two works. They are the earliest books that are entirely, or largely, about the Hudson River, and they contain some of the finest illustrations of American scenery ever published.

Milbert, a French artist, first visited America in 1815; Wall, an Irish artist, came to America in 1818. Both settled in New York City, and both eventually returned to their own countries. Wall painted mostly in watercolors but also worked in oils. His *Hudson River Port Folio* is based on his watercolors of the Hudson River and its environs. Milbert, who had studied in Paris with the landscape painter Pierre-Henri Valenciennes, executed his Hudson River views as wash drawings in sketchbooks. The atlas of lithographs for his *Itinéraire pittoresque du fleuve Hudson* is based largely, though not entirely, on these drawings.

The author gratefully acknowledges the help cheerfully and generously given by, among others, Billie Aul, Georgia B. Barnhill, Katherine Blood, William Diebold, Robert Emlen, Nancy Finlay, Harry Katz, Paul Mercer, Carol Miller, Sally Pierce, and Wendy Shadwell. Also, the author wishes to thank the New York State Library for providing him with a research residency, which greatly facilitated his work.

Although much has been written about William Guy Wall and the *Hudson River Port Folio,* little has been written about Milbert and his work. The extensive literature on the Hudson River School frequently refers to Wall as a pioneer and to his book as the first to draw attention to the picturesque beauty of the Hudson River Valley. Milbert was probably the first artist to decide to publish a book of the Hudson River Valley scenery, but because his book appeared in France a few years after Wall's book was published in the United States, few scholars have taken notice of it. Milbert's *Itinéraire* was, however, translated into English and published by the Gregg Press in 1968 with facsimiles of the lithographs.[3] The *Hudson River Port Folio* has never been reproduced in facsimile in its entirety, but undated facsimiles of some of the plates have been issued, probably in the 1950s. Furthermore, its illustrations frequently are reproduced in books and articles about American landscape painting and the Hudson River School. Despite the fact that both books treated the same subject at nearly the same time, no one seems to have compared them.

The plates in Wall's *Port Folio* are arranged from north to south, that is, from the town of Luzerne, about eleven miles west of Glens Falls, to New York City. Six of these plates are views of the scenery between Luzerne and Glens Falls, and two other plates are views of places a few miles beyond Glens Falls. Thus many of the views in this book are of the Adirondacks and vicinity. The plates in Milbert's *Itinéraire* are arranged in the opposite direction. This work is not just about the Hudson River, but also about places as far west as Niagara Falls and as far south as the Natural Bridge of Virginia. Twenty-nine of the lithographs are Hudson River views, and of these, eight are views of places between Luzerne and Glens Falls, and two of scenes a short distance beyond Glens Falls. There is a view of Lake George with the town of Caldwell (later renamed Lake George Village) and one of the town of Whitehall, which is east of the Adirondack Mountains near the southern tip of Lake Champlain. The mills on the Black River are in the town of Brownville, New York, a few miles northwest of Watertown, which is west of the Adirondack Mountains.

Although Wall's *Hudson River Port Folio* was the first of these two works to be published, Milbert probably made many sketches of Hudson River scenery before Wall made his first trip up the Hudson. Milbert traveled up the Hudson by steamboat in the summer of 1816 and was so impressed with the scenery that he traveled along the river on foot and made the drawings that he brought back to France. By the summer of 1820, when Wall made his first trip up the Hudson, Milbert had probably made several such drawing trips and very likely had filled several sketchbooks. Both Milbert and John Rubens Smith, Wall's teacher, operated drawing academies in New York so they were undoubtedly acquainted. It would be interesting to know if Milbert's sketches influenced Wall or if the success of Wall's book led Milbert to produce a book of his own.

Philip J. Weimerskirch

A separately printed prospectus for *The Hudson River Port Folio* is in the Library Company of Philadelphia. Probably written by John Agg, who also wrote the descriptions of the plates, it announced that:

THE HUDSON RIVER PORT-FOLIO, CONTAINING TWENTY-FOUR VIEWS ON THE NORTH RIVER, SELECTED BY W.G. WALL, DURING A TOUR IN THE SUMMER OF 1820, AND PAINTED BY HIM IN HIS BEST MANNER, AND WITH A FAITHFUL ATTENTION TO NATURE. TO BE ENGRAVED BY J.R. SMITH, IN AQUATINT, IN A MANNER PECULIARLY ADAPTED TO REPRESENT HIGHLY FINISHED DRAWINGS. THE LETTER-PRESS DESCRIPTIONS BY J. AGG, ESQ.

J.R. Smith was the artist and teacher John Rubens Smith; J. Agg was John Agg, a British poet and novelist who worked for a time in Washington, D.C., as a newspaper reporter and editor. His descriptions were limited to one page for each plate. The concluding paragraph of the prospectus states that:

It is proposed to publish "THE HUDSON RIVER PORT-FOLIO" by subscription, in six numbers, each number to contain four engravings of the size of twenty-one inches by fourteen, and carefully coloured under the immediate inspection of Mr. Wall, and accompanied by a letter-press description, written by Mr. Agg, who accompanied the artist during his tour. Wherever the subject will permit, this literary accompaniment will be enriched with historical narrative, so that the scene and chronicle of glorious achievement will be transmitted, side by side, to posterity.

This is followed by four lines of "conditions":

This work will be printed on paper expressly made for the purpose, and on which neither labour nor expense has been spared to render it equal to any European. The Series will be complete in six numbers: each number to contain four views; coloured from nature, under the immediate direction of Mr. Wall; and delivered to subscribers at sixteen dollars per number; payable on delivery.

The text of the prospectus appeared, with negligible changes, in the Philadelphia newspaper *The Aurora* on October 16, 1821, and it was slightly over one-half a column long. The same advertisement appeared on the 17th and 18th but not on the 19th. Then on October 20 it appeared again

with the name of the engraver given as I. Hill rather than J. R. Smith. I. Hill was John Hill, a Philadelphia printmaker, about whom more is to follow. John Rubens Smith was evidently relieved of his duties at this time, since he worked on the first four aquatints, leaving two unfinished. Hill finished these two aquatints, reworked the other two aquatints Smith had started, and made the other sixteen aquatints himself. From then on the notice appeared in *The Aurora* almost daily for months. The sixth number of the *Port Folio* was never issued, so there were only five parts each with four aquatints. The book has no title page, probably because the publishers intended to include one with the sixth number. The first number came out at the end of 1821, the fifth number in 1825.

John Rubens Smith was born in London in 1775, the son of John Raphael Smith, a prominent engraver of mezzotints.[4] He studied with his father and exhibited many portraits at the Royal Academy between 1796 and 1811. In 1802 he made a brief tour of America, to which he emigrated in 1809, settling in Boston where he established a drawing academy. In 1814 he moved his academy to Brooklyn, New York; in 1816 he moved it to a room in the American Academy of Art in New York City, the use of which was granted to him for his services as the Academy's keeper and librarian. William Guy Wall, who came to New York in 1818, was a frequent exhibitor at the Academy. Smith lived in Brooklyn until 1827, when he moved back to Boston. He later returned to New York and died there in 1849.

John Hill was born in London in 1770 and learned engraving there.[5] He came to Philadelphia in 1816, where he made the aquatints for Joshua Shaw's *Picturesque Views of American Scenery,* which was published by Mathew Carey in 1820. It was the first large-format color-plate book printed in America, and it was also one of the first American books illustrated with aquatints. It included a view of the Hudson River and may well have served as the model for the *Port Folio.* There were certainly many possible British models, including Boydell's book on the river Thames. The only earlier American books of city or landscape views were William Birch and Sons' *The City of Philadelphia,* 1800, and *The Country Seats of the United States of North America,* 1808, but both of these works contained comparatively small uncolored engravings. In the late eighteenth century Edward Savage and George Isham Parkyns both proposed publishing a volume of aquatint views of American cities and scenery, but neither of these projects came to fruition.

At any rate, John Hill's work on *American Scenery* led to his being hired by Henry J. Megarey of New York to finish the *Hudson River Port Folio.* He worked on it for well over five years, and it was his finest achievement. Ultimately Hill retired to a farm near West Nyack, New York, and died there in 1850.

William Guy Wall was born in Dublin, Ireland, in 1792, married there in 1812, and came to New York in 1818, arriving on September 1.[6] He had studied art before coming to America and continued

his art education in New York under John Rubens Smith. In the summer of 1820 Wall and John Agg, and possibly John Rubens Smith and others as well, made a trip up the Hudson River, and it was on this trip that Wall did the paintings that were reproduced in the *Hudson River Port Folio*. Wall stayed in New York for nine more years. He then moved to Newport, Rhode Island, then to New Haven, Connecticut, then to Brooklyn, New York, before returning to Ireland. He came back to America in 1856 and lived in Newburgh, New York, until at least July 1862. Shortly afterwards he returned to Ireland. After 1864 nothing more is known of him.

Recently, new information about John Rubens Smith and his connection with the *Hudson River Port Folio* has become available through a large archive of Smith's watercolors, pencil drawings, and prints, as well as some work by his pupils and some miscellaneous prints and drawings that were probably used for teaching purposes, acquired by the Library of Congress. The collection contains several plates from the *Hudson River Port Folio,* a proof with manuscript notes for one of the plates, a preliminary drawing for one plate, and a pencil sketch for another plate. In addition there are a number of Hudson River views that had never been published. One of them, "View on the Hudson near West Point," done in ink and watercolor, was "drawn in company with Mr. Vanderlyn who was dozing on the Soldiers graves near the gate to Lord's Tavern."[7] The drawing is undated, but it does show that the painter John Vanderlyn accompanied Smith on one trip up the Hudson.

An unpublished biography in the Department of Prints and Photographs of the New York Public Library reveals more about Smith and the *Hudson River Port Folio*. The biography was written in 1930 by a descendant, Edward S. Smith, and it says in part:

> He [John Rubens Smith] drew a number of views in and around New York and up the Hudson River from 1818 to 1828. Among them were: New York, from the Heights of Brooklyn, 1825, engraved by J. E. Nagle, Troy, from Mount Ida, Hadley Falls and Jessup's Landing. The last three were aquatinted and engraved by J. R. Smith after paintings by W. G. Wall and used in Wall's Hudson River Portfolio.
>
> In one of J. R. Smith's portfolio's [sic] . . . is a rather crude water-color painting of New York City from Jersey Shore, by W. G. Wall, inscribed in pencil, in John Rubens Smith's handwriting, referring to the picture: "Wall's style of painting before he came to me. In a year after I got him engaged to Megarey to paint subjects for the Hudson River Portfolio—In return he gratefully tried to ruin me—Ingratitude [sic] J.R.S."
>
> From information gathered from William Earl Smith, who was closer and longer associated with his father than were his brothers, I am able to state that the

Hudson River Portfolio was J. R. Smith's original idea and project, for the accomplishment of which he travelled up the Hudson River and to adjacent tributary locations, when he could be spared from his pupils, making sketches for the portfolio, at considerable outlay and expense, and when travelling was slow and tedious. Wall, a promising pupil, had assisted Smith in making the sketches and had been entrusted with responsibility in part of the work of developing them, but he betrayed the trust and issued the Hudson River Portfolio in his own name. Much bitterness and a law suit followed, as per traditional information, but a record of the case I have been unable to trace in New York court records.[8]

As this account was written one hundred years after the event, and as it was seemingly handed down in the family by oral tradition, it may not be wholly accurate. Also, John Rubens Smith had a reputation for being quarrelsome and critical of his fellow artists, so he may have distorted the facts to suit his purposes. One wonders why, if Smith intended to do a book of Hudson River views, he did not get Megarey to publish his own drawings instead of having him commission Wall to make paintings of Hudson River scenery? Smith's claim that Wall tried to ruin him in business probably relates to the fact that he was ousted by Megarey, and very likely Wall told Megarey that Smith was doing inferior work. Richard J. Koke, the author of a long article on John Hill in *The New-York Historical Society Quarterly* for January 1959, believed Smith did not possess the skill to make good aquatints.[9] Hill's account books in the New-York Historical Society note that Hill charged Megarey ninety dollars a plate for the sixteen he did himself and fifty dollars apiece for finishing and reworking Smith's plates. Hill must have put a great deal of effort into finishing and reworking these plates. Even so, in Koke's opinion, he was not able to bring them up to the level of his own work. The New York Public Library has two uncolored aquatints pulled from the plates that Smith worked on, and Koke thought that they were relatively crude and vapid.[10]

The first plate in the *Port Folio* is a view of "Little Falls at Luzerne," now called Rockwell's Falls. The plates were not issued in the order in which they were numbered, so the first plate in the book was actually the second plate of the third part with four plates that subscribers received. Koke was able to sort all this out from Hill's account books. Hill engraved this first plate entirely by himself, finished it on December 20, 1822, and, in March 1823, billed Megarey for printing one hundred impressions. In 1825 he billed Megarey for printing seventy more.

Plate two, "Junction of the Sacandaga and Hudson Rivers," is the second plate of the first number and was begun by Smith and finished by Hill. The first state of the plate is inscribed, "Printed by

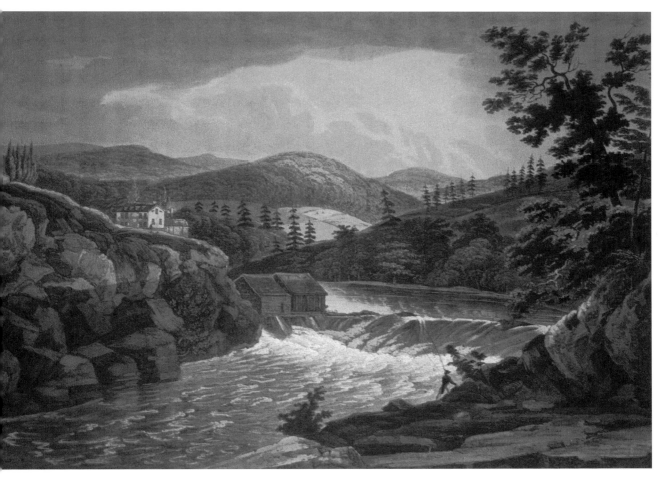

2.1. "Little Falls at Luzerne." Plate no. 1 in the *Hudson River Port Folio*. Hand-colored aquatint engraved by John Hill after a painting by William Guy Wall. Courtesy of the New York State Library.

Rollinson, Painted by W. G. Wall, Finished by I. Hill." There is no mention of John Rubens Smith. Rollinson could have been either Charles or William Rollinson. Hill did not engrave the lettering on the plates. Some of the lettering is known to have been done by Robert Tiller of New York, and he may well have done all of it. The second state bears the additional words, "and transferred to G.

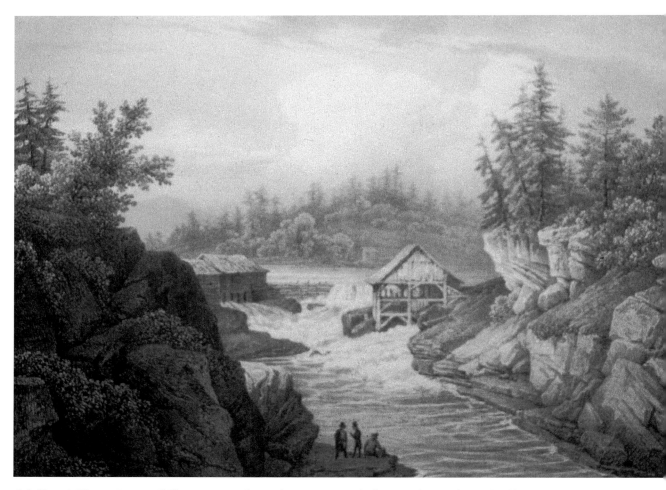

2.2. "Saw-Mill near Luzerne." Plate no. 25 in the *Itinéraire pittoresque du fleuve Hudson*. Lithographed by Bichebois after a drawing by Jacques Gérard Milbert. Note that the wooden building just right of center is missing in plate no. 1 in the *Hudson River Port Folio*. Wall's painting was done closer to the falls, and he may have painted the scene from this building. Courtesy of the New York State Library.

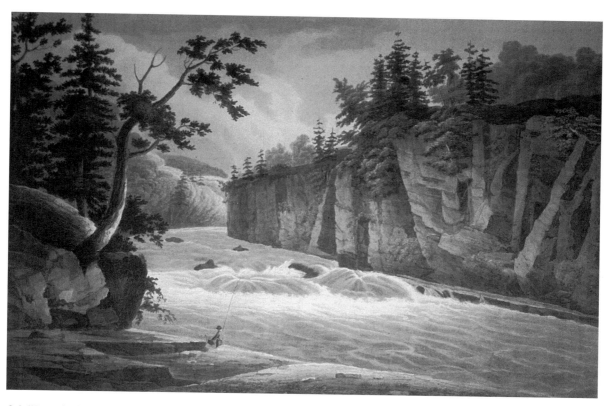

2.3. "Rapids above Hadley's Falls." Plate no. 4 in the *Hudson River Port Folio*. Hand-colored aquatint engraved by John Hill after a painting by William Guy Wall. Courtesy of the New York State Library.

& C. & H. Carvill." This was in 1828 when the Carvill's reissued the book. The Library of Congress has an original sketch for this plate and an uncolored proof.

Plate three, "View near Jessup's Landing," depicts the town of Corinth a few miles south of Luzerne. It is the first plate in the first number and so was begun by Smith. The first state says that it was "Engraved by I. R. Smith," but in the second state these words have been replaced by "Finished by I. Hill." Hill finished it in November 1821.

Plate four shows the "Rapids above Hadley's Falls," about one and one-half miles east and a little south of Jessup's Landing. It is the first plate in the third number and so was done entirely by Hill.

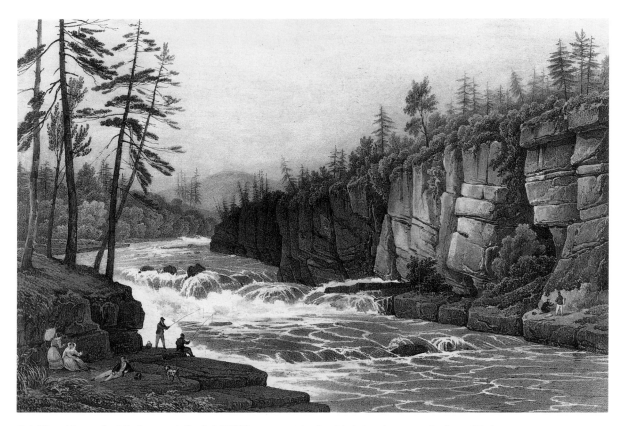

2.4. "Rapids on the Hudson at Adley's [*sic*]." Plate no. 28 in the *Itinéraire pittoresque du fleuve Hudson*. Lithographed by Bichebois after a drawing by Jacques Gérard Milbert; figures added by Victor Adam. The Adirondack Museum 78.49.1.

He completed the plate in October 1822 and sent it to Megarey who added the lettering. It was then returned to Hill, who put some finishing touches on it and printed two hundred impressions. In 1825 he was to print seventy more.

Plate five, "Hadley Falls," is the fourth plate of the first number. The first state indicates that it was "Engraved by I. R. Smith." In the second state the words "Finished by I. Hill" have been added. The third state is the same as the second but the names of the Carvills have been added. Edward Nygren considers this plate one of the most spectacular and romantic in the series and says the com-

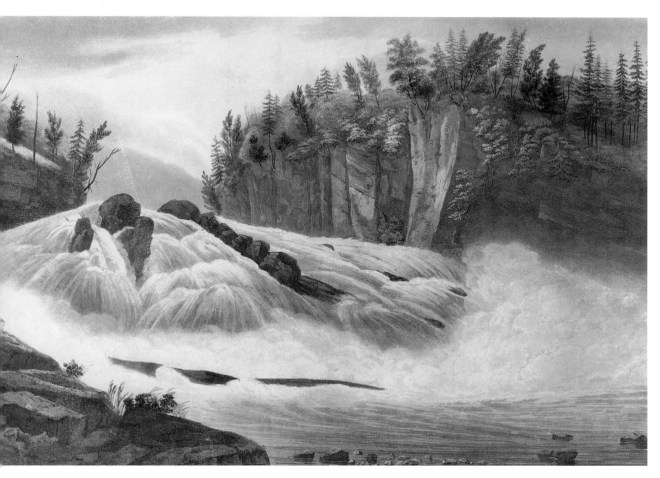

2.5. "Hadley Falls." Plate no. 5 in the *Hudson River Port Folio.* Hand-colored aquatint begun by John Rubens Smith and finished by John Hill from a painting by William Guy Wall. The Adirondack Museum 75.169.2.

position recalls depictions of Welsh waterfalls. He added that "By introducing well-dressed figures, Wall emphasizes the attraction of the falls to dedicated tourists in pursuit of the picturesque."[11]

Plate six, "Glens Falls," is the second plate of the second number. Hill did this one entirely by himself and finished it in March 1822. His wife, Ann, printed two hundred impressions in July, and his daughter, Caroline, helped color the plates.

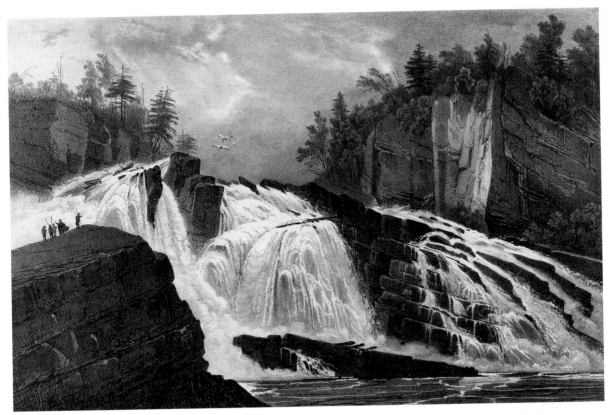

2.6. "Extremity of Adley's Falls [*sic*]." Plate no. 27 in the *Itinéraire pittoresque du fleuve Hudson*. Lithographed by S. Sabatier from a drawing by Jacques Gérard Milbert. The Adirondack Museum 78.49.2.

How many complete sets of the original *Port Folio* were issued is anyone's guess, but it was probably fewer than one hundred. By 1826 only a few sets were left, and they were sold in a lottery. In 1827 Megarey had to place his affairs in the hands of an assignee, and the following year G. & C. & H. Carvill reissued the *Port Folio* with their names added to the plates and with some mistakes in the original numbering corrected. Hill printed many more impressions for them, and in 1829 he repaired the first four copper plates. He billed the Carvills two hundred dollars for this work, so the plates must have been badly worn. Koke says that, in all, thousands of individual *Port Folio* plates were printed and sold.

Philip J. Weimerskirch

The original watercolors for the *Port Folio* were later used to create a moving diorama giving a view of the western side of the Hudson River as seen by a passenger on a steamboat from New York up the Hudson. It was shown during a performance of William Dunlap's play, *A Trip to Niagara,* which opened at the Bowery Theater in New York City on October 28, 1828. A review in *The Critic* for December 13, 1828, said that "The admirable sketches of North river scenery, by Wall, have been for a long time familiar to the lovers of the fine arts, and have excited, from all who have seen them, a tribute of praise, for the freedom, spirit and truth of his pencil."[12]

Collectors of Staffordshire pottery are familiar with *The Hudson River Port Folio,* as the views from it grace many platters and bowls. It is in this form that they probably attained their widest circulation. Andrew Stevenson, a Staffordshire potter, had come to New York in 1823 and established a store there. A few years later Wall's views started to appear on the pottery produced by his firm in Cobridge, Staffordshire. Stevenson later sold his firm to Ralph and James Clews, and they, according to L. Earle Rowe, "evidently well knew the interest and beauty of Wall's work, for they reproduced on their ware almost all of the subjects in the *Hudson River Port Folio,* and flooded the American market with their pottery, sending it over in the shades of blue, black, and brown."[13] Several other Staffordshire firms also made use of the views in the *Port Folio.*

Jacques Gérard Milbert was born in Paris in 1767, studied art with the landscape painter Pierre-Henri Valenciennes, taught drawing at the School of Mines, and in 1800 went on the Baudin expedition to Australia.[14] During the voyage he became ill, as did most of those on board, and ended up spending two years on Mauritius, then called the Île-de-France. On returning to Paris he resumed teaching at the School of Mines, supervised the engraving and printing of the illustrations for the official report of the expedition, and wrote a book about Mauritius, the Cape of Good Hope, and Teneriffe. It was published in 1812 in two octavo volumes and a quarto volume of plates.[15] Most, but not all, of the plates are based on his own sketches.

After coming to America in 1815, Milbert stayed for exactly eight years. He lived in New York City but traveled extensively, especially in upstate New York. At first he supported himself by painting portraits; later he founded a drawing academy with John Vanderlyn and Louis Antoine Collas, a French friend of Vanderlyn's.[16] This partnership was short-lived, however, for Milbert was soon hired to assist in a survey for the construction of the Champlain-Hudson Canal. It was to begin work on this survey that in the summer of 1816 he took his first trip up the Hudson. The survey lasted six months, and when it was finished Milbert was asked to collect natural history specimens for the natural history museum and botanical garden in Paris. This work allowed him to travel. Over the next seven years he sent back fifty-eight shipments totaling 7,868 animals, plants, minerals, and rocks. For

most of this time he is listed in New York City directories as residing and having his own drawing academy there, so he must have taught art during the winter months and traveled when the weather permitted.

On October 20, 1823, Milbert returned to Paris and resumed teaching at the School of Mines. He then published three works resulting from his travels in America, two of which are collections of lithographs with no text. One collection is entitled *A Series of Picturesque Views of North America* and was published in Paris in 1825 in two parts.[17] Each contains seven lithographs of New York City and vicinity. The other collection, *Amérique septentrionale: Vues des chutes du Niagara,* was published in Paris in 1829. It has six lithographed views of Niagara Falls in printed wrappers. It is not listed in Dow's bibliography of Niagara Falls, and the only copy in the United States is in the New York Public Library.[18]

Milbert's major work, the *Itinéraire pittoresque du fleuve Hudson,* differs from Wall's *Port Folio* in many ways. The format is different: the plates are not in color; there are more of them; there is vastly more text which is a valuable and fascinating account of his travels; and it is written in French. Both works are similar in that they sometimes depict the same scenes from nearly the same vantage points during approximately the same period of time. Perhaps most interesting of all is the fact that both William Guy Wall and John Rubens Smith supplied illustrations for the *Itinéraire.* Two paintings by Wall, *Machine for Portage on the Susquehanna* and *Foundery* [sic] *on Jones's Creek Near Baltimore,* were used for plates fifty-one and fifty-two in the *Itinéraire.* Five paintings by Smith were reproduced in the *Itinéraire,* none of which are near the Adirondacks, and Smith also designed the beautiful title page for the *Itinéraire*'s atlas of plates.

The subtitle of the *Itinéraire* is "et parties laterales de l'Amérique du Nord," which can be translated as "and the peripheral parts of North America."[19] Milbert's travels took him to the Great Lakes, through much of New England, and parts of New Jersey, Pennsylvania, Maryland, and Virginia. Forty-one of the lithographs in the *Itinéraire* are views of New York State, and, of these, three are of the New York City area; nine from Tarrytown up the Hudson to just below Albany; two of Albany itself, sixteen north of Albany; four west along the Mohawk River; three of Niagara Falls; one of the Genesee Falls in Rochester; one of Deer Creek Falls; one of Sackets Harbor; one of a sawmill in Brownville, New York, about sixty miles north of Utica; and one of Theresa Falls, on the Indian River.[20] There are also five views of New Jersey; two each of Pennsylvania and Rhode Island; and one each of Maryland, Massachusetts, and Virginia.

The New York State Library in Albany has a fine copy of the *Itinéraire;* two different prospectuses for it; a printed invitation to Milbert's funeral; some miscellaneous related material; and twenty original

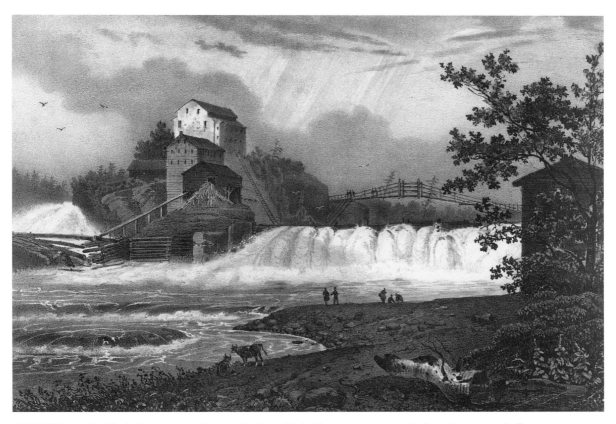

2.7. "Mills on the Black River" near Brownville, New York. Plate no. 40 in the *Itinéraire Pittoresque du fleuve Hudson*. Lithographed by Sabatier after a drawing by Jacques Gérard Milbert; figures added by Victor Adam. The Adirondack Museum 93.12.5.

drawings by Milbert, only one of which, however, relates to the *Itinéraire*. The prospectuses show that the atlas was issued in thirteen numbers; that they were to appear in regular installments on the fifteenth of each month; that each number would cost fifteen francs; and that the text volumes bound in paper wrappers would also cost fifteen francs. Moreover, there were to be twenty-five special sets of the lithographs printed without any lettering and on fine paper at thirty francs a number and twenty-five special copies of the text printed on fine paper at twenty francs a copy.

The original drawing, a sketch of the bridge at Glens Falls, measures about five by seven inches.

2.8. View of the same scene drawn on stone and probably also printed by J. G. Milbert at the Lithographic Press of Barnet and Doolittle in New York, ca. 1821. Note how in fig. 7 the French lithographers made numerous small changes in this view. Courtesy of the New-York Historical Society.

It was used for plate twenty-two in the *Itinéraire,* "Hudson Fall [*sic*] at the village of Gleens [*sic*]." At the lower edge of the sketch Milbert wrote, "I believe that the effect is preferable to the finished drawing." Milbert's sketches were drawn on stone in Paris by several different lithographers, and in the process the sketches were considerably enlarged and sometimes embellished. Indeed, one of the lithographers, Victor Adam, is credited on some of the lithographs with adding the figures. That is, he drew in the people and probably also the animals. Another of the lithographers, Bichebois, exhibited some of the lithographs at the Paris Salon of 1827.

Philip J. Weimerskirch

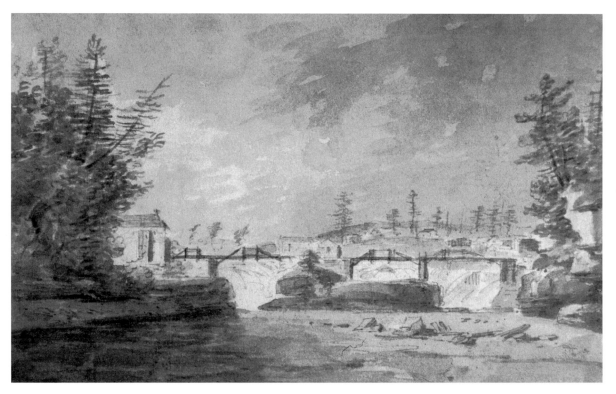

2.9. Wash drawing of the bridge at Glens Falls, New York, by J. G. Milbert in the New York State Library, Albany. Milbert added a few notes in the margin indicating that he thought the effect of the drawing was preferable to that of the finished lithograph. Courtesy of the New-York Historical Society.

Milbert must have been captivated by waterfalls because twenty-three falls are depicted in the *Itinéraire*. Nineteen are shown horizontally and thus are sideways on the page. Only four are shown vertically. Wall's *Port Folio,* oblong in shape, lends itself to the panoramic view. Milbert's *Itinéraire* has quite a few panoramic views also, but one must keep turning the atlas ninety degrees in order to see them properly.

A review of the *Itinéraire* in the *Moniteur Universel,* September 14, 1828, stated that twelve of the thirteen numbers of the atlas had already been published as had one volume of text. It added that all art lovers knew of the magnificent series of lithographic drawings by which Milbert illustrated the

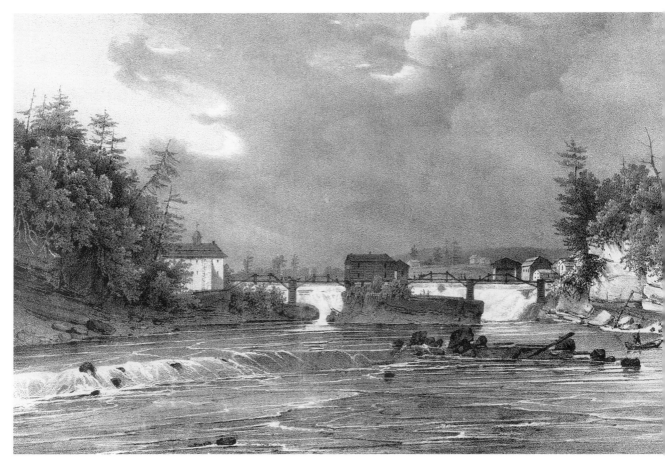

2.10. View of "Hudson Fall[s] at the village of Gleens [*sic*]." Plate no. 22 in the *Itinéraire pittoresque du fleuve Hudson*. Lithographed by Tirpenne from an original drawing (Fig. 9) by Jacques Gérard Milbert. The Adirondack Museum 93.12.1.

most beautiful sites in North America and that this important work was a monument to the progress of lithography in France.[21]

Gordon Ray chose the *Itinéraire* as one of five lithographed topographical works to be included in an exhibition entitled "The Art of the French Illustrated Book, 1700 to 1914" held at the Pierpont

Morgan Library in New York City in 1982. The catalogue notes that Baron Taylor's *Voyages pittoresques et romantiques dans l'Ancienne France* was a powerful influence on lithographed French topographical works, that this influence is everywhere evident in the plates of the *Itinéraire,* and that:

> Indeed, their scenic panoramas, falls, rapids, and striking rock formations are so relentlessly picturesque that the eye welcomes occasional city views like that of Church Street in New York City (plate 3) or the house of the first Dutch governor in Albany (plate 14). It is clear, however, that the three views of Niagara Falls (plates 34 to 36) were the successes of the series. Milbert's second American publication in 1829, *Amérique septentrionale: Vues des chutes du Niagara,* extended his coverage of this marvel of nature in a spectacular way.[22]

Milbert's view of West Point showing soldiers parading was probably used by the Zuber wallpaper firm in southern France for some wallpaper featuring American scenery. First produced in the 1830s, it is still being printed from the original woodblocks. The view of West Point in the wallpaper is not quite the same as the view in the *Itinéraire,* but there are many similarities.

The illustrations in the *Itinéraire* were reproduced in much smaller size, and somewhat altered, as engravings in Jean Baptiste Gaspard Roux de Rochelle's *États-Unis d'Amérique,* Paris, 1853, which also contains engravings after the work of several other artists. Roux de Rochelle was a former French envoy to the United States.

Milbert died on June 5, 1840, leaving a widow and two sons. For his contributions to the advancement of natural history in France he was made a Chevalier of the Legion of Honor, but he was never adequately compensated for his expenses in shipping natural history specimens to France. The scientists who had benefited from these shipments appealed to the government on behalf of his widow, and she was granted a pension.

In commenting on the rise of the marketing and collecting of prints in America in the early nineteenth century, Gloria Gilda Deak wrote, "Printmaking projects that were conceived to celebrate the distinctive charms of the New World's natural surroundings culminated in *Itinéraire pittoresque du fleuve Hudson . . . , Picturesque Views of American Scenery . . . ,* and *The Hudson River Port Folio.*"[23] In her opinion, two of the three most beautiful and ambitious books of American scenery published at this time were the books about the Hudson River by Milbert and Wall. The splendid plates from these books certainly incline one to agree.

The First Eight Plates in the *Hudson River Port Folio*

1. Little Falls at Luzerne.
2. Junction of the Hudson and Sacandaga Rivers. In the Prints and Photographs Division of the Library of Congress are an original pencil sketch for this print and a proof before letters with manuscript notes.
3. Near Jessup's Landing (similar to Milbert plate 26).
4. Rapids near Hadley's Falls (similar to Milbert plate 28).
5. Hadley's Falls (similar to Milbert plate 27).
6. Glenn's [*sic*] Falls (similar to Milbert plate 22; the original drawing for this plate is in the New-York Historical Society).
7. Near Sandy Hill (the original drawing is in the New-York Historical Society).
8. Baker's Falls (the original drawing is in the New-York Historical Society).

Plates of the Same General Area in Milbert's *Itinéraire*

(Note: These plates have been listed in reverse order so that they are arranged from north to south, thus facilitating comparison with those in Wall's *Hudson River Port Folio,* which are arranged in the same direction.):

29. General view of the Hudson at Adley's [*sic*].
28. Rapids on the Hudson at Adley's (similar to *Port Folio* plate 4).
27. Extremity of Adley's Falls (similar to *Port Folio* plate 5).
26. Jessups Landing (similar to *Port Folio* plate 3).
25. Saw-mill near Luzerne source of the Hudson (In some copies this plate is bound at the front of the atlas of plates with the number removed).
25. Bridge on the Hudson River near Luzerne. (In some copies this plate is numbered 25 *bis.* See the previous entry).
24. Lake George and the village of Caldwell.
23. Saw-mill at the village of Glenns [*sic*].
22. Hudson Fall [*sic*] at the village of Gleens [*sic*]. (Similar to *Port Folio* plate 6; Milbert's original wash drawing of this scene is in the New York State Library, Albany, where it is labeled, "Bridge at Glen's [*sic*] Falls").
21. White-Hall, Lake Champlain.
20. Course of the Hudson and the mills, near Sandy Hill. (Similar to *Port Folio* plate 7; the original drawing is in the New-York Historical Society).
19. Falls of the Hudson at Sandy Hill.

3

Illustrations of the Adirondacks in the Popular Press

GEORGIA B. BARNHILL

PRINTS DEFINED and described the Adirondacks for a variety of audiences during the late eighteenth and nineteenth centuries. With the exception of the lithographs published as separate prints and artists' etchings issued in limited editions, publishers commissioned and issued these prints as illustrations for books and periodicals. Consequently, such prints carry two sets of meanings. One is self-contained and is revealed by their visual effect. The second is cumulative and derives from their being part of a text.[1]

Considering illustrations in their original context is crucial to understanding them. On one level, knowing the publication context for illustrations facilitates dating prints and assigning them to publishers. The latter aspect is important because the role of the publisher is an active one. In other words, neither the artist of the original design nor the printmaker is necessarily the active party. The publisher commissions the illustrations for each publication, sometimes in consultation with the author, sometimes independently.

A primary function of illustrations is to provide information that supplements the text or even restates the text in pictorial terms. In *Pastoral Inventions,* Sarah Burns suggests why these prints, considered as minor by some, are important visual documents to collect and study. She notes that the popular arts, particularly periodical illustrations and lithographs, "were and are agents for the broadest diffusion of ideas and images." She also observes that "In nineteenth-century America the line between 'popular' and 'academic' was fluid and undefined. The same subjects appear in paintings, popular prints, and magazine illustrations."[2] The audience reached by prints issued in books and periodicals was enormous, particularly in the latter half of the nineteenth century. Often images in the popular press defined places for the public, not necessarily reality. The power of images justifies

the formation of print collections such as the one at the Adirondack Museum that documents and describes the region so well.

In the late 1700s and early 1800s, American publishers used prints to disseminate information about the physical appearance of the newly discovered and settled regions on the North American continent, including the Adirondack region. During later decades, prints presented other information about the region and even served to further public debate when disputes about the region and its uses surfaced.

Publishers of the leading periodicals published in the two decades after the American Revolution included many views of the new nation, both urban and rural. In her study of these images, Karol Lawson concluded that the "magazines' regular publication of original landscape plates led citizens of the United States to a self-conscious examination of the face of American nature as they sought therein a defining image of themselves."[3] Publishers regularly solicited sketches and written descriptions from amateur artists.

Saratoga, because of its medicinal springs, held a special fascination for readers interested in the new nation. Just fifteen years after the settlement of Saratoga, an engraving of the central spring appeared in the March 1787 issue of the *Columbian Magazine*. George Turner, later a member of the American Philosophical Society and a judge and land speculator in Marietta, Ohio, described the spring as "a well of clear water, contained in a strong crust, or rock, of a conic figure, being at the base twenty-six feet six inches in circumference, in height on the west side, thirty-seven inches, perpendicular, and on the east side fifty-eight."[4] This spring became the basis of a tourist industry and remained an object of fascination for other investigators. Without the descriptive text, the image is almost meaningless.

In the *New York Magazine* for December 1794, appeared "An East View of M'Neal's Ferry at Saratoga," engraved by John Scoles. The text accompanying this view describes the strategic importance of this crossing of the Hudson River during the American Revolution. The view "affords a beautiful prospect of a large bason [*sic*], with two strong eddies on each side and the rapid above noted below. No visitor leaves this place without carrying with him those delightful sensations which its beauties are so well-calculated to excite."[5] Coupling the historical significance of a particular spot with its scenic qualities was a typical part of the commentary on American landscape of that time. The editors of the *New York Magazine* expressed their gratitude to contributors of the views and linked their efforts in providing knowledge about the nation to patriotism.[6]

Lake Champlain appeared in an engraving, "Near Skeensborough on Lake Champlain," published in *The Port Folio* in 1813. The author of the accompanying description noted that "At this

end of the lake it becomes very narrow and reduced nearly to the size of a creek. The scenery on either side is rocky, and in many places rises almost perpendicular, which, with the abrupt turning of this narrow termination of the lake, often presents beautiful subjects for the pencil."[7] Many artists heeded this invitation in the following decades. Other illustrations of Lake Champlain were issued because of the military actions on the lake during the War of 1812.

By the time Horatio Gates Spafford's *Gazetteer of the State of New York* was published in Albany in 1813, Lake George, largely because of its proximity to Saratoga, was already well known. Spafford described it as "surrounded by high mountains, and is excelled in romantic beauties by no similar waters in the world."[8] Peter Maverick engraved a view from an unknown source. The limited scale of this engraving and others published at this time really precluded Maverick and his contemporaries from achieving the superlatives of Spafford's text. The engraving only suggests the actual landscape. Later engravings and lithographs, much larger in size, would remedy this problem.

One of the foremost artist-naturalists to record his impressions of the region was Charles Alexander Lesueur, who traveled through the northeastern United States in 1816. Two aquatints after his drawings were published a year later in William Meade's *An Experimental Enquiry into the Chemical Properties and Medicinal Qualities of the Principal Mineral Waters of Ballston and Saratoga in the State of New York*. The publisher issued the pamphlet to provide a scientific analysis of the springs of the two burgeoning resort towns. Lesueur made the drawings a part of his exploration of the North American continent and apparently made them available to Harrison Hall, the publisher of Meade's treatise. Meade recorded his indebtedness to Lesueur in his preface and remarked that his "talents as a naturalist and a draftsman are too well known both here and in Europe to require any eulogium of mine."[9] The author included information on the natural history and topography of Saratoga and Ballston. He may have found it easier to incorporate reproductions of Lesueur's drawings in his text than to describe the development of the two villages. The two aquatints were by John Hill, who had arrived from England in 1816. The views of both towns depict rather rudimentary settlements; tree stumps in the view of Saratoga, for example, have not yet been replaced by lawns and paths.

Benjamin Silliman and Timothy Dwight wrote of the region in their books published about 1820.[10] Silliman's text is illustrated in part by Daniel Wadsworth of Hartford whose two drawings of Lake George were reproduced as engravings. Wadsworth accompanied Silliman on his tour and made sketches that he completed on his return to Hartford. Although they were not intended for publication, Silliman persuaded him to allow them to be included in his book.[11] Lake George figures prominently in the visual and written documentation of the region. Dwight's description of the lake holds true today: "The water is probably not surpassed in beauty by any in the world: pure,

sweet, pellucid, of an elegant hue when immediately under the eye, and at very small, as well as at greater distances presenting a gay, luminous azure, and appearing as if a soft luster undulated everywhere on its surface with a continual and brilliant emanation."[12] It is evident that the engravings of Lake George cannot suggest the full range of the landscape.

The illustrations published in the late 1700s and the early 1800s share certain characteristics. Small in scale, they barely suggest the majestic qualities of the landscape. Stylistically, these engravings are linear renditions of sketches by skilled amateurs. Since they are printed with black ink on white paper, they are not capable of rendering the colors of the landscape. In spite of their deficiencies, these illustrations are important in defining some places of the region for a wider audience. Finally, subject matter is limited, because artists had not ventured beyond the well-trod paths of earlier visitors.

In the following decades, artists explored less well-known parts of the Adirondack region. In the 1830s the New York State Legislature commissioned Ebenezer Emmons, a professor at Williams College, to conduct an extensive survey of the natural resources of the state. In his party was Charles Cromwell Ingham and John William Hill who depicted several distinctive landscapes. Ingham painted the Indian Pass, a particularly awesome sight.[13] The published reports incorporated over a dozen views of the region, including views of two Adirondack lakes and one river by John William Hill. The three lithographs share a low vantage point and are placid, devoid of the drama of water portrayed by William Guy Wall and Jacques Gérard Milbert.[14] Emmons noted in his text that "these views were not introduced for the purpose of embellishment, or the exhibition of beautiful landscapes, but solely to convey to the reader what has just been expressed [in the text] a correct view of its surface, or of its general outline."[15] This statement is an unusual one and suggests the ability of images to provide information of a physical nature. The lithographs are also noteworthy because they are among the earliest views of interior parts of the Adirondacks. Their aesthetic—the placid tranquility—was continued by Currier and Ives and other publishers whose lithographs were designed to be framed and placed in the office, lounge, or parlor. The finest expression of this search for tranquility and exact transcription is the view of Lake George by Richard William Hubbard, printed by Thomas Sinclair for William Sintzenich of New York in 1865.

The publication of exploratory views of the Adirondacks continued to 1900 with the significant work of Verplanck Colvin.[16] As early as 1868, he advocated the "creation of an Adirondack Park or timber preserve, under charge of a forest warden and deputies."[17] He had created a map of the region for his own use by 1865. In 1872 he was named to the State Park Commission that was appointed to investigate the feasibility of creating an Adirondack Preserve. One by-product of the first report was the authorization by the New York State Legislature of a topographical survey of the

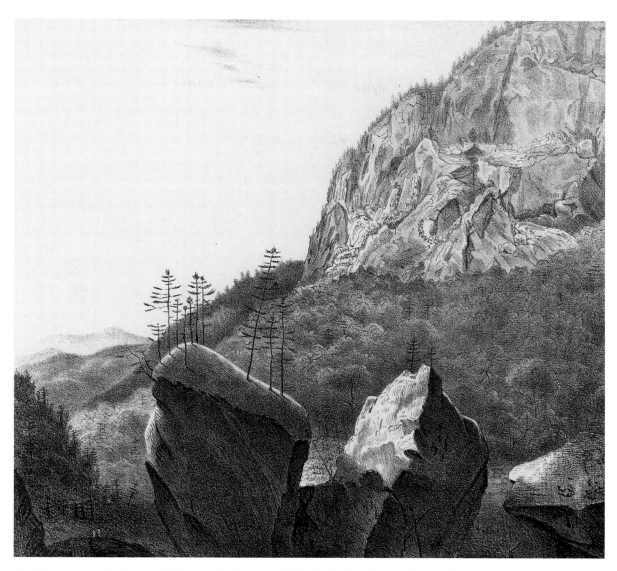

3.1. "View of the Indian Pass." Lithographed by John H. Bufford after Charles Cromwell Ingham (1796–1863); published in Ebenezer Emmons, *New York State Geological Report for 1837* (Albany, 1838). 6³⁄₁₆ x 8⁵⁄₁₆".
The Adirondack Museum 65.35.1.

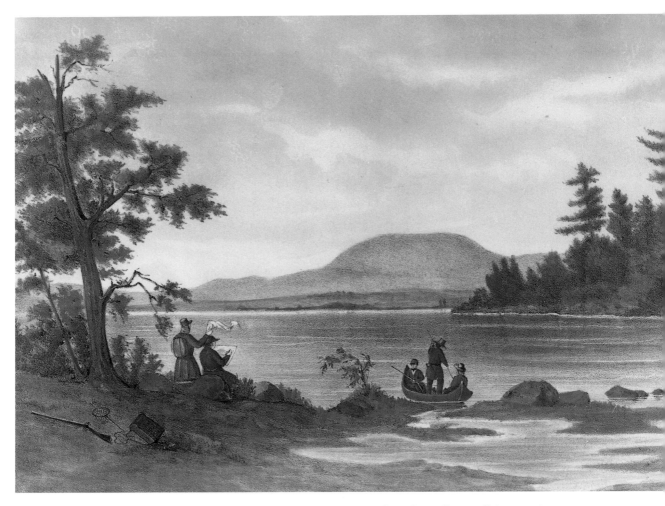

3.2. "Lake Catharine, Hamilton Co." Lithographed by George Endicott after John William Hill (1812–79); published in Ebenezer Emmons, *Geology of New-York, Part IV, No.* 2 (Albany, 1842). 6 ¾ x 9½". The Adirondack Museum 66.95.2.

region and the appointment of Colvin as superintendent. His reports have been characterized as having "the narrative interest and charm of a journal of exploration in some distant land."[18]

Some of the illustrations in his reports merely depict scientific instruments; others provide views of remote areas not depicted by earlier artists and draftsmen. "On Blue Mountain," for example, shows a work crew felling trees to enable the surveyors to do their work. "High Falls of the Saranac River" is subtitled, "Showing Difficulties Encountered in Chain Measurement." It is a dramatic view compared to some. "Primary Triangulation" compares favorably in terms of composition to the work of Harry Fenn, "The Indian Pass," drawn for *Picturesque America*, and even Currier and Ives's *A Mountain Ramble*. In spite of Colvin's competence as a topographical draftsman, though, it is doubtful that his drawings would have been reproduced in any other context except that of a publicly funded series of reports.

Artists, authors, and publishers joined forces to celebrate the American landscape. The author Nathaniel P. Willis, artist William Henry Bartlett, and publisher George Virtue issued *American Scenery* in parts from 1837 to 1839. Since Lake George was already part of the American grand

3.3. "The Indian Pass." Engraved by W. J. Palmer after Harry Fenn (1845–1911); published in William Cullen Bryant, ed., *Picturesque America,* part 41 (New York: D. Appleton and Company, 1874). 9 x 3⅞". The Adirondack Museum 74.306.1.

Adirondacks in the Popular Press

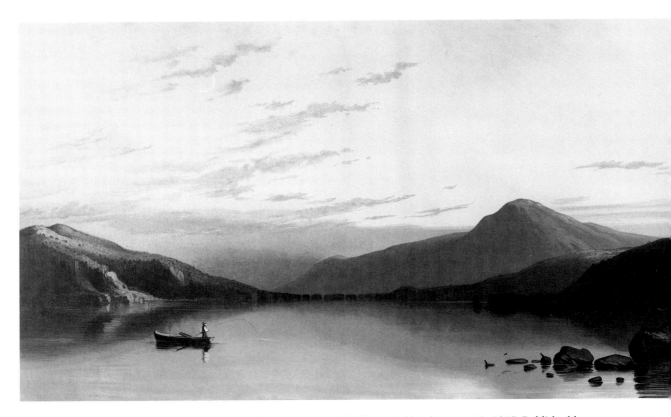

3.4. *Lake George.* Lithographed by Thomas Sinclair after Richard William Hubbard (1816–88), 1865. Published by Edward Sintzenich of New York. 15 x 26". The Adirondack Museum 66.184.1.

tour, Bartlett visited there incorporating six views in the volume. Those views were copied and imitated by other artists, engravers, and publishers during the following decades, often without credit. By the time Bartlett reached Lake George, there was not much sense of wildness left. His views are well populated with the forerunners of today's pleasure craft on the lake. His views, taken from a low vantage point, accentuate the steep mountain slopes that end at the lake's shoreline. The goal of the publisher was to bring the American landscape to the "fire-side of the home-keeping and secluded."[19] He succeeded admirably.

Georgia B. Barnhill

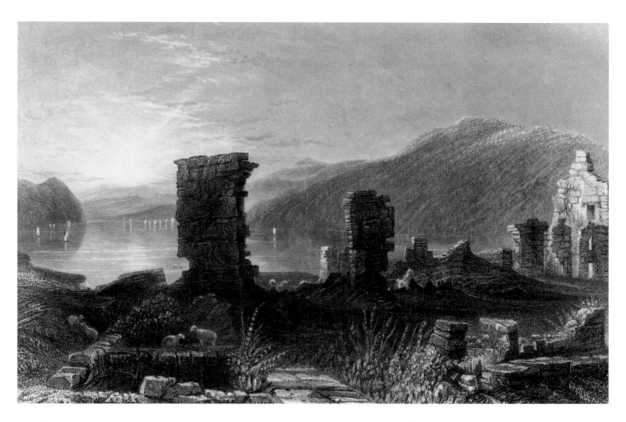

3.5. "View of the Ruins of Fort Ticonderoga." Engraved by T. A. Prior after William Henry Bartlett (1809–54); published in Nathaniel P. Willis, *American Scenery* (London: George Virtue, 1840–42). 4¹¹⁄₁₆ x 7⅜". The Adirondack Museum 66.54.1.

Joel T. Headley sought the Adirondacks on the advice of his physician, who commanded him to "go where a printed page could not meet my eye, and I should be forced to take constant exercise in the open air." He published his reports on that trip and a subsequent one because he wished "to make that portion of our State better known."[20] His book contains eight engravings after works supplied by Ingham, Asher B. Durand, Regis François Gignoux, and John William Hill. He acknowledges his indebtedness to them, so he apparently asked them for their sketches that were subsequently engraved by Charles Burt. The subjects are Lake Colden, Lake Sanford, the Adirondack Pass, Lake

Adirondacks in the Popular Press

Henderson, Forked Lake, Raquette Lake, and Lake Schroon. "The Adirondack," a panoramic view of the highest peaks, is the frontispiece. Headley's prose describes the awesome wilderness that he found. Open to any page and his words capture his experience.

> All day long, and not the sound of a single wheel, but in the place of it the cawing of crows, the scream of the woodpecker, and the roar of a torrent dashing over the rocks in the sullen forest below. The very stumps have a forlorn look, and it seems a complete waste of time and music for the birds to sing, having no one to listen to them. . . . But if one is not entirely spoiled, he soon attunes himself to the harmony of nature, and a new life is born within him.[21]

The combination of admiration for the landscape and its religious significance to the writers constituted a common response to the Adirondacks in the middle decades of the nineteenth century. In the final decades of the century, artists, including John Henry Hill and Arthur Fitzwilliam Tait, became year-round residents for at least several years at a time. Engravings after works by their predecessors, including Thomas Cole, Asher B. Durand, Richard William Hubbard, William Rickarby Miller, and James David Smillie, illustrated poems and rhapsodic descriptions of the region in topographical histories, gift books, and other elegant publications.

The distribution of images published in the popular press after 1850 was enormous compared to the distribution of earlier prints. In 1860, for example, there were some 100,000 subscribers to *Harper's Weekly,* generally members of the professional and business classes, concentrated in eastern cities and their suburbs.[22] By 1880 there were approximately 100,000 subscribers to William Cullen Bryant's *Picturesque America,* and possibly as many as one million copies were in print by 1900.[23] Images published in this context not only had the power to describe and define the region but could also shape public opinion. The illustrations in *Harper's* and other popular magazines presented a different image of the Adirondacks than earlier engravings and lithographs. In general, the earlier prints emphasized the sublime qualities of the Adirondack wilderness. The aim of topographical artists was to present as accurate a rendering of the landscape as possible. In contrast, particularly in the latter part of the nineteenth century, publishers commissioned artists to provide drawings that played one of two functions: to chronicle activities or events and to supplement the editorial position of the publisher on social or political issues. Although the role of the Harper firm in the destruction of New York's Tammany Hall and Boss Tweed, largely through the pictorial satire of Thomas Nast, is acknowledged, its activity in other reform movements is less well recognized. An

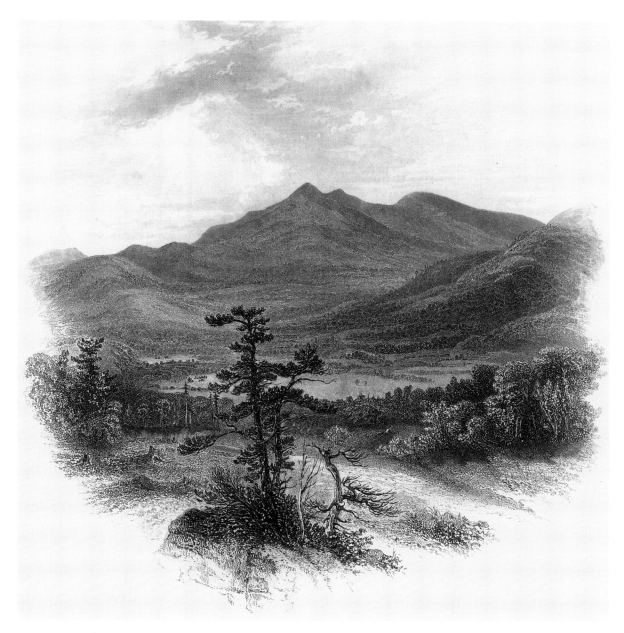

3.6. "A Scene in the Adirondack Mountains." Engraved by John Kirk after Asher B. Durand (1796–1886); published in *The Poet and the Painter* (New York: D. Appleton and Company, 1869). 6 x 5¼". The Adirondack Museum 80.24.2.

analysis of the prints depicting the Adirondacks reveals that the firm advocated legislation to protect forests and game in the Adirondacks.

In the collection of the Adirondack Museum, there are forty illustrations published in *Harper's Weekly* from 1858 through 1891. The primary function of those illustrations issued during the first decade of the magazine's history was to introduce readers to the region and its inhabitants. The illustrations document the change in the region from a place for hunting, fishing, and camping to a haven for city dwellers seeking less strenuous vacations. For example, "The Adirondack Mountains," was published in the August 31, 1867, issue of *Harper's Weekly* to inform the readers about the natural and historical attractions of the region. Of particular note are the vignettes of John Brown's grave and his house. Brown, the leader of the attack at Harper's Ferry in 1859, moved from Springfield, Massachusetts, to North Elba in 1849. Each vignette is based on a photograph by the company of Fay and Farmer located in Malone, New York.[24]

The next year, Theodore Russell Davis provided three illustrations for *Harper's Weekly*. "Bee Hunting in the Adirondacks" illustrated an article titled "Bee Hunting," presumably also written by Davis. In one vignette the guide Max Tredo set fire to a small piece of a honey comb to attract bees. After being attracted to the honey comb and feeding on it, the bees made a beeline to their own hive, leading Max and his helpers to it. The second illustration shows the guide felling the tree to get at the hive that contained close to one hundred pounds of honey. This anecdote of life in the Adirondacks was described by Davis as "illustrative of scenes that one may witness, if so disposed, while camping out in the 'Wilderness.'"[25] Linking an agricultural activity to the north woods makes the wilderness more familiar, and perhaps less threatening, to potential visitors. In a similar vein is *American Forest Scene. Maple Sugaring* lithographed by Nathaniel Currier in 1856 after a painting by Arthur Fitzwilliam Tait.

A second anecdote by Davis describes hunting deer at night. Although it is considered to be unsportsmanlike, not to mention illegal today, this was an accepted practice by some hunters in the nineteenth century. Davis's illustration is true to his words—present are the lily pads, the guide in the stern of the boat with his paddle working soundlessly in the water, the clumsy reflective jack lighting the deer on the lake's edge in the bow. Davis's aim is accurate and he fells the buck with one shot.[26] There is no condemnation in the accompanying text; rather, the pursuit proceeds very easily and quickly. The story reinforces the notion of the Adirondacks as a hunter's paradise, even before the publication of William H. H. Murray's *Adventures in the Wilderness* the following year. That book also contains a description of pursuing deer at night with an illustration. Later, *Harper's Weekly* would condemn such practices.

Georgia B. Barnhill

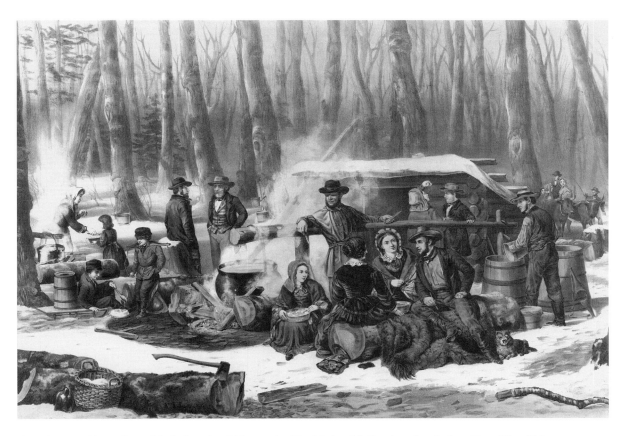

3.7. *American Forest Scene, Maple Sugaring.* Lithographed by Nathaniel Currier after Arthur Fitzwilliam Tait (1819–1905). 18⅜ x 26⅝". The Adirondack Museum 72.137.1.

Davis's final illustrative report of his Adirondack trip looks and reads like an advertisement for the region and his guides.

> If you choose to "rough it," there is no section of this country more favorable for
> your purpose than that in the immediate vicinity of the Indian Pass through the
> Adirondack range of mountains. Via the wagon road from Crown Point on Lake
> Champlain the distance is just fifty miles to Adirondack Village. Thirty miles of this

road is corduroy, which is so rough that the buckboard wagon is or ought to be the only vehicle used to convey the tourist into the wilderness.

Davis goes on to describe the other vignettes and concludes with compliments for his guides. "With them you may tramp through the forest, camp out, hunt and fish, until, satiated with sport, you are weary of the woods and long for civilization."[27] The illustrations include views of a corduroy road, a balanced rock, the Indian Pass, the village of Adirondac, fly fishing, and a rustic cabin. This illustration both informs readers and promotes the region.

Images of camping and sporting life abounded in the pages of *Harper's Weekly* and *Frank Leslie's Illustrated Newspaper*. Edwin Forbes, another Civil War artist who worked for Harper and Brothers, depicted two men trout fishing in 1869.[28] J. S. Jameson's illustrations of winter camping were published in the pages of *Frank Leslie's Illustrated Newspaper* in 1872. William de la Montagne Cary depicted two people resting during a stroll along a stream for *Harper's Weekly* in the issue of September 28, 1878. William Allen Rogers's "Canoeing in the North Woods—A 'Carry,'" also in *Harper's Weekly*, showed a canoeist making a portage with the considerable assistance of a vehicle to carry the heavy sail canoe across land between two lakes. Rufus Fairchild Zogbaum portrayed a man and his guide fishing for black bass for the August 30, 1884, issue of *Harper's Weekly*.

Theodore Davis, along with other artists who had reported on the Civil War for Harper and Brothers, sent illustrations from other distant places. Did Davis and the others go to the Adirondacks on their own or were they sent by the magazine's art editor? The evidence does not exist to be sure in every case, but the magazine did commission artists to travel and report on their experiences. However, since the Adirondacks were comparatively accessible from New York, it is possible that many artists went on their own, sending illustrations back to New York when the subject matter seemed appropriate.[29]

Illustrations of other resorts appeared in the pages of *Harper's Weekly*. Illustrators sent back drawings from fashionable places along the east coast such as Mount Desert Island, Newport, the Catskills, and Cape May. "Lake George, Looking Southwest from Black Mountain," drawn by James David Smillie and published in 1879, is typical of its type, showing tourists involved in admiring the view and participating in an activity, in this case climbing Black Mountain, which is above Hulett's Landing on the east side of Lake George. Such a print is analogous to Currier and Ives's

3.8. *(Opposite)* "Black-Bass Fishing in the Adirondacks." Engraved after Rufus F. Zogbaum (1849–1925); published in *Harper's Weekly*, 1884. 11¹⁵⁄₁₆ x 8¹¹⁄₁₆". The Adirondack Museum 77.196.6.

lithograph *The Source of the Hudson, in the Indian Pass.* In *Frank Leslie's Illustrated Newspaper* in 1886 was published the cheerful scene of "A Dance to the Strolling Players," another illustration featuring typical resort activities. Henry Alexander Ogden's "A Summer Pastime. New York. Drill of the 'Sunflower Brigade,' at Hulett's Landing, on Lake George," also published in *Frank Leslie's Illustrated Newspaper,* shows some of the people who made resort life so comfortable.

A private camp was depicted by William Allen Rogers for *Harper's Weekly* in 1883. The anecdote accompanying the illustration "Camping out as a Fine Art" suggests that he was new to the region in 1882. Invited to visit a "camp" situated on Raquette Lake, he packed

> up his blankets, a small "A" tent that had seen service in the Rocky Mountains, an alcohol stove, and a camp kettle. . . . Imagine his surprise when he found himself before the beautiful camp shown in the upper right-hand sketch, and was invited to an elegant repast in the rustic dining-room depicted in the lower corner! After spending a few days in the beautiful villa, where camping out was combined with the comforts and luxuries of city life, our artist proceeded to Little Forked Lake, where he was treated to a fresh surprise in the form of another villa camp. . . . In these instances camping out has certainly been reduced to a fine art; but has it not been robbed of some of those features which have always been supposed to lend a charm to a life in the wilderness?[30]

The civility of these camps probably astounded readers of *Harper's Weekly.* The pages of the magazine bear witness to the transformation that occurred over a twenty-five year period.

Several illustrators reported on events in the region for *Harper's Weekly.* Frederick Schiller Cozzens provided a series of vignettes of the 1887 meeting of the American Canoe Association. Rogers depicted the organization's 1891 annual meeting at Lake Champlain. These events lasted two to three weeks, featuring a week of races that drew many visitors. Two to three hundred men attended some portion of the meets.

While the Adirondacks were being promoted in the pages of magazines, Currier and Ives and several other print publishers issued lithographs on many of the same themes, particularly hunting

3.9. *(Opposite)* "Drill of the 'Sunflower Brigade,' at Hulett's Landing, on Lake George." Engraved after Henry Alexander Ogden (1856–1936); published in *Frank Leslie's Illustrated Newspaper.* 1883, 10⅝ x 9³⁄₁₆". The Adirondack Museum 85.8.1.

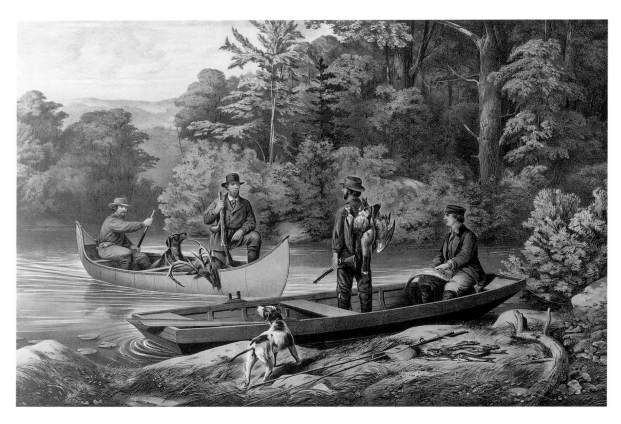

3.10. *Life in the Woods. "Returning to Camp."* Lithographed by Currier and Ives, 1860. 18¾ x 27½". The Adirondack Museum 64.152.10.

and fishing. Many of the finest lithographs were created after the paintings of Arthur Fitzwilliam Tait. In the 1870s Currier and Ives published prints roughly derived from the earlier Tait lithographs. *The Life of a Sportsman, Among the Pines, Deer Shooting, The Hunter's Shanty,* and *An Anxious Moment* were published in the 1870s.

Ironically, as these lithographs and the illustrations from *Harper's Weekly* and other similar magazines promoted the Adirondacks as a place to fish and hunt, the ability of the region to support game was being compromised by extensive lumbering activities and a total disregard for limits on hunting. Four illustrators in particular, William Allen Rogers, Arthur B. Frost, Daniel Carter Beard,

"LAWING" IN THE NORTH WOODS.

SUMMER tourists through the Adirondacks have but little opportunity of studying the real life and character of those to whom this wild region of mountain, forest, and lake is home. They study their guides, and generally find them good-natured, independent, and hard-working fellows, whose conversation is replete with anecdotes adapted to the credulity of their listeners, and monotonous to a degree in that they are all but variations of the one universal theme, deer-slaying, and all contain exactly the same amount of brag.

It was, however, the good fortune of one party who traversed

The Judge on his way to Court

"lawing" forms one of the prominent pastimes of the natives during the long winter months, when they are almost isolated from the rest of the world; while in summer they are too busy to indulge in it to any great extent.

In the alcove behind the judge sat the jury, and at a table in front of him appeared the lawyers and the clerk of the court. Back of them, and making themselves as thoroughly comfortable as circumstances would allow on boxes, barrels, and on the counter, were the witnesses and spectators. The counsel for the defense was a wiry little man, well known as a guide and as a leader in local politics, whose legal knowledge had been, as he expressed it, "mainly picked up here

The Trial.

an' there." The prosecuting attorney was nervous, and intensely interested in the success of this case, as upon it rested his fond hopes for many similar trials, and on it he had based some severe remarks as to how he intended to have law enforced in those parts.

During the examination of witnesses the spectators smoked, chewed, and at times took part in the proceedings by challenging the right of the lawyers to propound certain questions. At such moments all present, including judge and jury, joined in the discussion, the judge leaning far forward over his desk, at the imminent risk of overbalancing himself and it. Suddenly realizing his position, he would sternly command the constable to enforce order and maintain the dignity of the court, when comparative quiet would reign for a few minutes, or until the feelings of the spectators were again exasperated.

The several witnesses, who were evidently prejudiced in favor of the prisoner, skillfully parried the severe cross-examination of the prosecution by well-feigned ignorance or stupidity. They could not swear to dates, as in the woods they had no means of knowing Sundays from other days, and so lost reckoning. "Pa'tridges was sich cur'ous birds they wasn't rightly sar-

the woods late in September, after most of the summer business was over, to light upon a native community in one of its seasons of relaxation and social enjoyment, and this they afterward appreciated as one of the most interesting episodes of their sojourn in the Adirondacks.

The event which was for the moment the one topic of conversation and interest in the little village of L——, and which drew guides from all parts of the woods, was nothing more nor less than the trial, before a justice of the peace, of one of their number, the oldest of the fraternity, charged with violating the game-laws by shooting partridges out of season. If the prosecution was successful, similar charges would be brought against almost every guide in the woods; but if the defendant gained the day, it would be conclusive proof that all the alleged offenders were equally innocent, and all further complaints would be dropped. Thus the reputation of the community was at stake, and the interest in this test case was wide-spread and all-absorbing.

Court was held in the principal store of the village, as no other building afforded space for the several court officials, the jury, witnesses, and the crowd of interested spectators. At one end of the store, in a sort of raised alcove behind the desk of the proprietor, sat the judge, an old man in his shirt sleeves, who, outside of his official capacity, is by turns guide, surveyor, hunter, and farmer. He is the "squire" of the village, and much respected for his legal knowledge. His *code novum* was an immense calf-bound volume of Revised Statutes, for his constant reference to which he apologized, on the ground that "he was generally out of practice in summer, and had not yet read up for the winter's work."

This was understood when it was explained that

Closing Argument of the Defence (After the Jury had retired)

W. A. Rogers

3.11. "Lawing in the North Woods." Engraved after William Allen Rogers (1854–1931); published in *Harper's Weekly*, 1882. 14 x 9¼". The Adirondack Museum 74.156.1.

and Julian Walbridge Rix, provided illustrations for *Harper's Weekly* that were dramatic adjuncts to editorials that appeared in the magazine.

"Lawing in the North Woods," published in 1882, opens with the observation that

> summer tourists through the Adirondacks have but little opportunity of studying the real life and character of those to whom this wild region of mountain, forest, and lake is home. They study their guides, and generally find them good-natured, independent, and hard-working fellows, whose conversation is replete with anecdotes adapted to the credulity of their listeners, and monotonous to a degree in that they are all but variations of the one universal theme, deer-slaying, and all contain the same amount of brag.

To contrast that view is the "courtroom" scene observed by Rogers in late September, "after most of the summer business was over." The trial was held to determine the guilt or innocence of a guide who had shot partridges out of season. At issue was respect for game laws, and the result of the trial would determine whether or not the game laws would be observed by the guides. In the end, the defendant was acquitted, perhaps because counsel for the defense had sent a two-quart bottle of whiskey up to the jury. The judge, depicted in the upper right, was described as "an old man in his shirt sleeves, who, outside of his official capacity, is by turns guide, surveyor, hunter, and farmer. He is the 'squire' of the village, and much respected for his legal knowledge."[31] Two years later Gaston Fay suggested that the game laws were impossible to enforce because of the system of justice in which the jury of peers included many who violated the game laws with impunity.[32] Harper and Brothers favored a uniform and enforceable system of justice as well as the preservation of species that were becoming rare.

The state did mandate the use of game wardens. However, their numbers were insufficient, as Gaston Fay noted in an essay, "The Disappearance of Game." "In the Adirondacks, for instance, to properly protect the vast tract comprised under that name would require the services of a small army; as a matter of fact, three or four game-protectors are assigned to that locality. These are so entirely powerless to guard the territory under their care that their efforts for good are of comparatively no value whatever."[33] Accompanying this essay is an illustration by Arthur B. Frost, "Unsportsmanlike slaughter—no chance for life," showing the hounding of deer by hunters and their dogs. In the issue of November 22, 1884, appeared another illustration by Frost, "Watering Deer—Watching the Lake," equally critical of deer hunters.

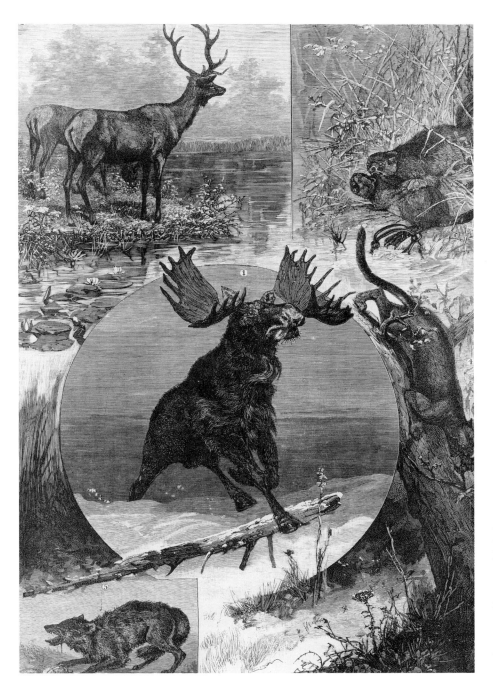

3.12. "'Evicted Tenants' of The Adirondacks." Engraved after Daniel Carter Beard (1850–1941); published in *Frank Leslie's Illustrated Newspaper*, 1891. 13½ x 9". The Adirondack Museum 78.8.4.

"'Evicted Tenants' of the Adirondacks," drawn by Daniel Carter Beard and published in 1885, was a poignant reminder to its viewers of the rich variety of animals that once roamed the forests. The accompanying text did not mince words.

> Greed is a good thing to restrain. It is a good thing to restrain when it sets about to sell the whole Adirondack forests at the current price of lumber, or when it hunts amid those forests a fine race of animals to the point of extermination. The law of the State says now that the deer and the partridge and the trout shall have a chance, and that the sportsman shall be stopped at times in order that these shall not be forever stopped.

The editor continues to document the last of the great game animals, including a moose shot, but not killed, by artist Arthur F. Tait in 1861. Another hunter ended the life of the wounded animal.[34]

Additional commentary on hunting accompanied Rogers's "Miss Diana in the Adirondacks— A Shot Across the Lake."

> The killing of this particular deer was not the result of an accident, nor was the shot made at such short range as to render a miss impossible. Assiduous practice had trained both eye and hand. . . . Queer stories are told in the woods of the Northern wilderness of the devices employed by certain city visitors to obtain a shot at a deer, and thus furnish a sort of foundation for a series of boastful lies that shall last them a lifetime.[35]

The text went far beyond the simple retelling of "Miss Diana's" fine shot the previous September. Her ability as a marksman is contrasted to many visitors who had to rely on jacking or hounding to get their game. Adequate game laws were finally secured and some of the animals depicted in "'Evicted Tenants'" returned to the region.[36]

Julian Rix provided an eloquent series of illustrations on the forests to *Harper's Weekly* in 1884 and 1885. Although these pictures speak for themselves, the editorial that appeared on December 6, 1884, made readers acutely aware of the problems facing New York State residents. The article discusses the silting up of the Hudson and its tributaries and the eastern end of the Erie Canal.

> There is one point of view in which the destruction of the Adirondacks seems much more wanton than the ordinary waste of forests. Ordinarily the land is cleared that it

3.13. "Destruction of Forests in the Adirondacks." Engraved after Julian Walbridge Rix (1850–1903); published in *Harper's Weekly,* 1884. 13¼ x 20". The Adirondack Museum 77.196.9.

may grow a crop more profitable or more immediately necessary than timber. But there is no pretense of this kind in New York. The land is cleared simply and solely for the value of the timber which stands upon it. The work is done, not by settlers, but by speculators, and when it is completed, its scene will be a rocky desert. . . . Our sketches from the devastated regions give almost ghastly evidence of the need that some effective steps should be taken to arrest the conversion of a wilderness into a desert. It is not only, and perhaps not mainly, the loss of the timber actually cut down that makes the destruction a public calamity. It is possible that under an intelligent supervision nearly as much timber might be actually marketed from the

Adirondacks in the Popular Press

Adirondacks as is now done, without destroying their value as a "storage reservoir" of the rain-fall, or their attractiveness to sportsmen and holiday makers. It is the incidental destruction by fires and by the backwater of dams built to facilitate logging operations that most strongly proves the wantonness with which the work has been done, and the need of a rigid supervision on behalf of the people of the State.[37]

In the issue of January 24, 1885, appeared an additional essay by Professor C. S. Sargent reiterating many of the same ideas. Reference was made in this article to the effects of fire on the landscape characterized by poor soil and steep slopes.[38] Julian Rix's "Forest Destruction in the Adirondacks. The Effects of Logging and Burning Timber. A Feeder of the Hudson—As It Was. A Feeder of the Hudson—As It Is" bore eloquent testimony to the devastating effects of fire in the Hudson River watershed.

Eventually an amendment to the New York State Constitution was passed to protect the forests belonging to the state. As residents of the Adirondack Park well know, the controversy is never subdued. Historians realize that nothing ever changes, and discussions about the values of wilderness and open space are still with us. Prints published in the nineteenth century both defined the Adirondacks for the public and eventually protected the region, not so much from summer visitors as from large scale exploitation of its natural resources. Many of these discussions occurred also in the pages of magazines such as *Forest and Stream*. Their presence in *Harper's Weekly* suggests that they were of wide interest. The images and articles were sufficiently powerful to arouse public sentiment and action.

4

The Adirondack Chromolithographs of Robert D. Wilkie

WARDER H. CADBURY

THE ADIRONDACK REGION of forests, lakes, and mountains has been for more than a century an experimental laboratory for discovering and testing the economic, political, social, and aesthetic rationale of wilderness preservation. If we do not press the analogy too hard, the Adirondacks have also been a proving ground for chromolithography as a vehicle for fine art.

In 1848 a restless journalist, Charles Wilkins Webber, traveled northward well beyond fashionable Saratoga and scenic Lake George to Lake Pleasant and Lewey Lake near the center of this wild domain. In a series of letters to a Manhattan newspaper, he described the glorious hunting and fishing, together with picturesque vignettes of his guides and their rustic habitat.[1] Not long after returning home to Philadelphia, he decided to gather his wide-ranging travel narratives into a thick book and to illustrate them with chromolithographs produced by the local firm of Rosenthal. Perhaps his wife, who was a painter of flowers and birds, first suggested it.

Webber clearly thought his illustrated tome had historical significance, describing it in his preface proudly, if not quite accurately, as "this first experiment in a novel field."[2] The craft of printing in colors, he continued, "which is yet in embryo in Europe, has been left for us to develop in this country." We must bring to bear, he continued, "the latest discoveries in Science, in the application of mechanical forces to pictorial illustration, so as to cheapen their cost without any deterioration of artistic value" and thus put quality pictures for the first time "within reach of the people."

It was this early visitor to the Adirondack region who at the beginning articulated the idea that, as Peter Marzio put it, the perfecting of the democratic art was a peculiarly American mission.[3] But the Adirondack region was not quite ready for chromolithography, since no painters had yet penetrated its wild interior of forests and lakes. And chromolithography was not quite ready for the Adirondacks,

since the illustrations in Webber's book (which were prairie scenes from the portfolio of Alfred Jacob Miller) from a technological perspective left—as Webber phrased it—"much to anticipate."

As we now know, "it was left to Louis Prang to experiment and, step by step, finally to perfect the process" of chromolithography.[4] Having made "the reproduction of color his life-long study," Prang was possessed by a ruling passion: to manufacture attractively priced fine art reproductions as a means both of providing a livelihood for American painters and of educating and stimulating the aesthetic tastes of the American public. Thanks to a happy coincidence, it was the well-known Adirondack artist Arthur Fitzwilliam Tait who first helped him to test his dream.

With the end of the Civil War, Prang introduced his first fine art chromos, which were copied from a pair of canvases of New England landscapes by Alfred Thompson Bricher. While quite satisfactory from a technical point of view, they failed to attract retail customers at six dollars each. "The picture dealers," Prang wrote later in his unpublished autobiography, "pronounced them too costly for the American picture buyer. . . . I was importuned by my salesmen to stop this experiment of producing high cost prints . . . nothing over $.50 would sell."[5]

But Prang was unwilling to give up so quickly. "I was determined to test the question thoroughly," he continued:

> An oil painting by A. F. Tait arrested my attention, five downy chicks cunningly grouped on a green plot of grass, so exquisitely painted as I had never seen them painted before. This picture seemed to me to be peculiarly fitted to test the popular appreciation. It was reproduced [by my chief lithographer], printed under my direction, and offered again to the trade. . . . Success followed immediately, the people felt interested in the subject and in a print which resembled closely an oil painting. Five dollars was not thought too high to gratify a desire for a good picture to decorate a bare wall and to make a living room more cozy. [Futhermore, the earlier Bricher landscapes] which had previously fallen flat on the public were sought for,
> it was revelation to the trade . . . everything sold.

Over the next two years thirty thousand copies of Tait's chromo were sold and attracted some rave reviews in the newspapers. "The little chicks," said one, "are as like nature as they could be without the intervention of a hen." When Prang sold the original painting at auction some years later, he said: "The introduction of chromolithography into America must date from its publication" in 1866.[6]

It was good timing all around, for Tait had recently terminated his relationship with Currier and

Ives after more than a decade of selling forty-two of his canvases (some for two hundred dollars each) to be published as lithographs. The last of these pictures, *American Speckled Brook Trout,* appeared in 1863 as perhaps that firm's first half-hearted and occasional venture into chromolithography. So Tait was glad to make a contract with Prang for more pictures for a 10 percent royalty of sales and to serve as friend and consultant. "You ought to push chromos as hard as you can *now,*" he advised, "as I am afraid they will be very common in another year or two, and that will react to the disadvantage of even good chromos. So push them whilst you have the market in your own hands."

Tait also stood with Prang to confront the occasional criticisms the new printing technology provoked. The most colorful carping came from Clarence Cook in the *New-York Daily Tribune,* whose initial response was benign: "Mr. Prang tries with all his might to make his imitations absolutely deceptive, not for the purpose of deceiving, but in order to bring faithful copies . . . within the reach of small purses. We shall not quarrel with him as to his methods of interesting people in art. He has our cordial thanks."

But Cook changed his tune while reviewing Tait's next chromolithograph of ducklings six months later in the fall of 1866: "A clever imitation is nothing but an imitation after all. It can teach nothing, nor benefit anybody." These remarks provoked a running battle with Prang and Tait in the newspaper. Prang replied that if one good canvas can advance the cause of art, how can thousands of skillful facsimile copies hinder it? As he escalated the level of rhetoric, Cook took issue with Prang's claim that "a millenial day for Art is to be ushered in through this invention" of chromolithography. The brightly colored prints, he declared, "are of a piece with false diamonds, false hair, false teeth and with innumerable false appliances by which homely people try to make themselves look pretty, and succeed in making themselves hideous."

After Tait had a personal visit from Cook, he wrote to Prang that while his newspaper articles were "temperate, gentlemanly and to the point," Cook's writings were "very poor trash and no answer to your arguments . . . real Billingsgate. . . . I should have thought better of him from his appearance." As a postscript Tait added: "Let these folks rail and scold—it is all good for publicity and a good advertisement—'Vive La Bagatelle.'"

Prang's American Chromos, as he called them, were his top of the line reproductions of original works of art, intended for framing. By the end of 1868 there were forty-six of these full chromos and more than a hundred by the Centennial Exposition of 1876. They included landscapes, animals, flowers, genre scenes, and portraits. Tait provided ten canvases in all, but only one, *Maternal Love,* depicting a doe and fawn, reflected his experience in the wilderness. His friend James M. Hart was the painter of *Scene Near New Russia, Essex Co., N.Y.—Winter,* a hamlet just south of Elizabethtown.

It was nine-by-sixteen inches and priced at five dollars. A third Adirondack American chromo was a generous fifteen-by-twenty-six inches, *Lake George* after Hermann Fuechsel, which sold for twelve dollars.

A roster of only three fine art chromolithographs would be a meager tally for the Adirondacks if Prang's business had not flourished with an extensive repertoire that included small, less pretentious reproductions, "beautiful art bits" as he called them. His great success during the Civil War with small souvenir portraits of popular generals probably suggested to him that there was a promising market for little two-and-one-half by four-and-one-half inch pictures, sold in sets of six or twelve inside an envelope marked "Album Cards," for as little as fifty cents.[7] The subjects included flowers, birds, leaves, butterflies, as well as marine and landscape views, which all appealed to the color-hungry Victorians. To encourage collectors, Prang also produced his patented albums with hard covers, ranging from three dollars for a hundred cards to eighteen dollars for a thousand.[8] Soon no American parlor was complete without such an album of Prang cards prominently displayed on a side table.

These album cards of landscape views were called Gems of American Scenery or, sometimes, American Gems. They were half-chromos, meaning that only a few stones were used to print the colors, and so they lack the density and texture of oil paint so characteristic of the full chromos. From California to the coast of Maine, the scenes were mostly from the original sketches made on the spot by artists sent there by Prang for that purpose.

Of special note for the visual documentation of the Adirondacks is the two dozen and more small prints of the region that were all the handiwork of one painter, Robert D. Wilkie. We are indebted to his granddaughter, the late Ruth K. Wilkie, who lovingly documented his life and works. Thanks to the kindness of her family, a copy of her typescript is at the Adirondack Museum.

Wilkie's career is the story of the labors of a dedicated man to stitch together a sufficient livelihood to support his wife and child and his artistic aspirations. In Halifax, Nova Scotia, where he was born in 1828, there were limited opportunities to advance his natural inclinations towards drawing and painting. It did not help that his father died when he was four, leaving a widow and four children under twelve. But Wilkie acquired an early a taste for sketching the landscape in good weather and for creating genre pictures to illustrate the works of literature he enjoyed when the weather kept him indoors. The local stationery store exhibited a few of his canvases in its window, as was noted briefly in the newspaper.

In the early 1850s he came to Boston and began to sell an occasional drawing to Frederick Gleason's *Pictorial Drawing-Room Companion,* of which Maturin M. Ballou was editor. The supervisor

of the engraving department was the young Frank Leslie, formerly with *The London Illustrated News,* who employed Louis Prang for a while. In 1853 Gleason published a view of the Hudson River from Hoboken with Wilkie's name as the artist, followed by views of Halifax and several Massachusetts towns. In late 1854 Gleason sold out to his editor, and the magazine became *Ballou's Pictorial.* Wilkie no longer appeared as an illustrator, though Gleason had other periodicals, and Frank Leslie went on to start his own illustrated news in New York City. A decade later, as the Civil War ended, Wilkie reappeared with a few pictures for Leslie's *Illustrated Weekly.* In the meantime Wilkie made his first appearance in a Boston directory as "artist," showed two landscapes at the Boston Athenaeum, designed a few tombstones for friends in the Mount Auburn Cemetery, and began to take in pupils.

In the spring of 1883 Robert Wilkie married Annie Webster, who was from a large and comfortable family, and the couple worked out a life style that suited their special needs. Every summer they moved out of the city by conveniently storing some things with Annie's relatives in town. Ever in search of the picturesque, Robert pursued his painting and sketching, sometimes at the sea shore, but more often in the White Mountains, where there were other cousins to stay with. He occasionally sold a painting to tourists at the small hotels at Plymouth and Conway. With no permanent domicile, the Wilkies moved often, returning to Boston each fall to board at different rental quarters. This may have eased Annie's housekeeping duties, but there were times when there was no adequate studio space for Robert and his pupils.

A decade before his death at seventy-five in 1903 Wilkie enjoyed an exhibition of his *magnum opus,* the work of half a lifetime, as he called it. Over the years he had labored to produce more than a hundred illustrations based on the many works of Charles Dickens, and these were shown to the public at the Pierce Building in Copley Square. A review in the press included these comments:

> The Boston artist is one of the most sensitive and retiring of men we have ever
> known, and indeed this is the only reason he does not today enjoy a national reputa-
> tion. He has chosen to seclude himself, already finding a ready market for his work.
> He has also instructed many of the most promising artists in Boston today.[9]

In the large collection of Prang materials in the Print Department of the Boston Public Library are copies of Wilkie's little scenic album cards, including sets of views of the White and Green Mountains and the Atlantic coast near Boston. The titles of the several Adirondack series follow; unless otherwise noted, each is about two-and-one-half by four-and-one-half inches.

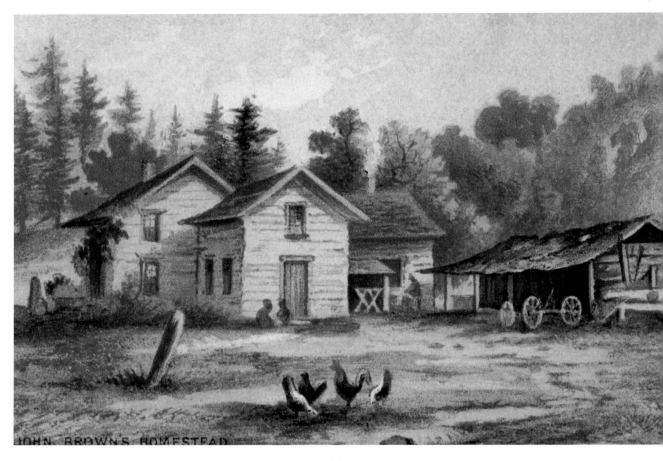

JOHN BROWN'S HOMESTEAD

4.1. John Brown's Homestead, 1875. Courtesy of the Boston Public Library, Print Department.

1. Twelve Adirondack Sketches, (copyright 1875): Birmingham Falls, Ausable Chasm; Lower Lake, Saranac; Camp Edgar, Lake Saranac; Lower Au Sable Lake; John Brown's Homestead; Entrance to Round Lake; Paul Smith's Hotel; Lake Champlain; Lake Placid; Pulpit Rock, Ausable Chasm; Schroon Lake; Fort Ticonderoga.
2. Ausable Chasm, Adirondacks (copyright 1875): Entrance to the Flume; Cathedral Rocks; Jacobs Ladder; Birmingham Falls; On the Rapids; Leaning Rock, Ausable Chasm.

Warder H. Cadbury

4.2. Pulpit Rock, Ausable
Chasm, 1875. Courtesy of
the Boston Public Library,
Print Department.

4.3. Schroon Lake, 1875. Courtesy of the Boston Public Library, Print Department.

3. Twelve Lake George and Saratoga Views (copyright 1875): Caldwell, Lake George; Lake George; Recluse Island, Lake George; Bolton Church, Lake George; Lake George from Bolton; Lake George Narrows; High Rock Spring, Saratoga; Pavilion Spring; White Sulphur Springs, Saratoga; Vichy Spring, Saratoga; Empire Spring, Saratoga; Old Red Spring, Saratoga.

4. Six Views of the Adirondacks (copyright 1876) (five by seven inches): John Brown's Home; Still Waters, Ausable Lake; Saranac House, on the Lake; Paul Smith's, St. Regis Lake; View from Eagle Island (Saranac); Lake Placid & Hotel.

Warder H. Cadbury

76

4.4. Birmingham Falls, 1875. Courtesy of the Boston Public Library, Print Department.

4.5. Caldwell, Lake George, 1875. Courtesy of the Boston Public Library, Print Department.

Except for their titles, these little cards are not easy to identify; many, but not all, have the publisher and date. But Wilkie is credited as the artist only by an occasional and tiny monogram W in a lower corner. However popular these album cards may have once been, these charming vignettes by Wilkie are very scarce today. In forty years of looking for just this sort of Adirondack ephemera, I only recently acquired a dozen that had been added as extra illustrations to an 1875 travel guide published in Boston. Wilkie's views do not seem to have been overprinted as attractive trade cards to advertise, for example, the upscale hotels of Saratoga or Lake George or Paul Smiths. Today they remind us of picture postcards, but these collectible souvenirs were inaugurated twenty years later.

Warder H. Cadbury

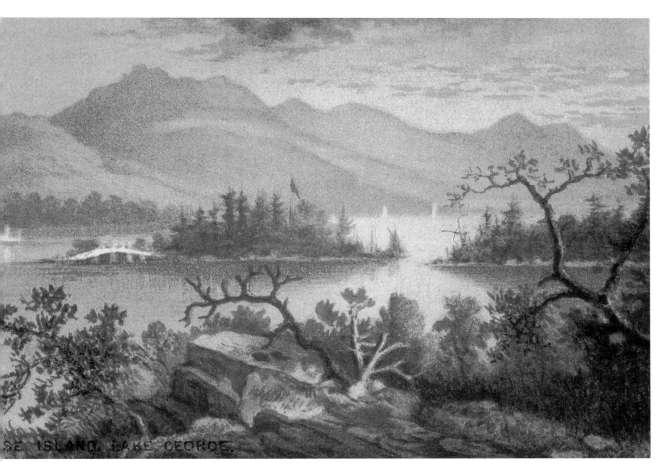

4.6. Recluse Island, Lake George, 1875. Courtesy of the Boston Public Library, Print Department.

The result is that Tait's early prediction to Prang that the market for fine art chromos would not last long proved to be right on the mark. There were many causes of the demise of chromolithography, not the least of which was its initial popularity with the American public. So great was the demand and so intense the competition between publishers that a kind of Gresham's law took over,

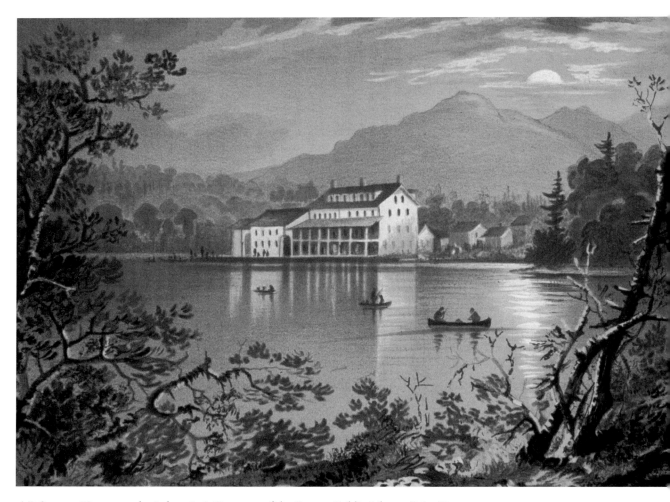

4.7. Saranac House, on the Lake, 1876. Courtesy of the Boston Public Library, Print Department.

in which lower prices depressed both the aesthetic and technical quality of the prints, so that bad art drove out the good. As cheap pictures were offered as premiums to sell everything from magazine subscriptions to soap, fine art was eclipsed by commercial art. The notion of the chromo as a masquerade for the original simply lost its mission. Furthermore, the American public ceased to be

Warder H. Cadbury

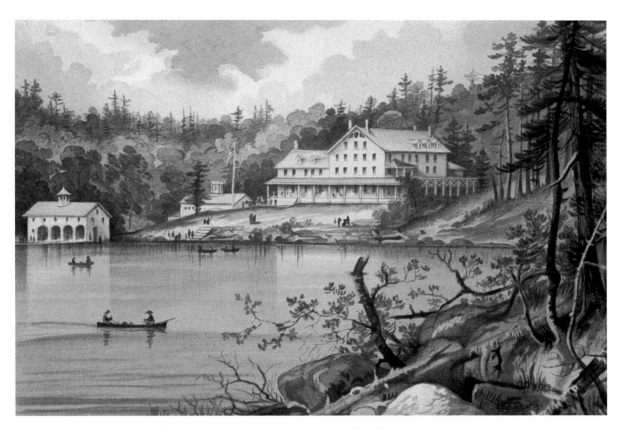

4.8. Paul Smith's, St. Regis Lake, 1876. Courtesy of the Boston Public Library, Print Department.

charmed by the style of Dusseldorf and the dense hues and varnished surfaces of the 1870s. The fresh and airy palette of French art and the light, delicate washes of watercolors carried the day. With sweeping changes in American taste and technological innovations in printing colors, the chromolithograph gradually faded from the scene.

In November, 1889, as Prang retired from much of his business, he sold at auction, over seven days, his vast collection of original art works. Virtually the last lots on the final day were groups of

Wilkie's landscapes, more than fifty of his New England and Adirondack views. Since Wilkie rarely signed his canvases, it would be difficult to rediscover and recognize these gems today.

In the same auction was Winslow Homer's Adirondack watercolor, *The North Woods,* which sold for two hundred fifty dollars and which, together with his *Eastern Shore,* were Prang's last attempts to print faithful copies of such delicate pastel washes. It did not work, and after a few images the stones were destroyed, essentially marking the end of chromolithography as a handmaiden to the fine arts.

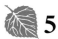

5

"Nature's Forest Volume"
The Aldine, the Adirondacks, and the Sylvan Landscape

JANICE SIMON

WHEN NOVELIST Elizabeth Barstow Stoddard penned an essay for *The Aldine* in 1873 entitled "Nature's Forest Volume," she unwittingly provided the New York publication with a truly felicitous heading for its pages. Under the editorship of her husband, Richard Henry Stoddard, which began in 1872 and continued through 1876, *The Aldine* (1868–79) was transformed from an in house production of the printing firm Sutton, Browne & Company into a subscription magazine featuring original wood engravings, scenic descriptions, poetry and prose offerings, and critical reviews of American and European literature and art.[1] Stoddard ably remade *The Aldine, A Typographic Art Journal* into *The Aldine, The Art Journal of America,* its official title as of 1874. In effect, he unconsciously created as well the nation's foremost "Woodlands Illustrated Magazine." Under Stoddard's direction, *The Aldine* presented not only original engravings of superior quality and quantity, but also an extraordinary number featuring American scenery, particularly of the wooded kind. If a browse through *The Aldine*'s pages reveals an attentiveness to nature in all its variety, a study of its images, poems, and articles discloses an enchantment with the forest as a national asset. Indeed, more than most popular nineteenth-century magazines or any other art periodical, *The Aldine* offers today's reader a virtual compendium of American perceptions of the sylvan landscape during the post–Civil War period. It elucidates, in turn, the importance of periodical imagery in the nineteenth-century

This essay has its genesis in research on the American image of the forest interior conducted while holding fellowships at the Huntington Library in the summer of 1991, the Winterthur Library in the summer of 1992, and more recently at the American Antiquarian Society in the fall of 1993 and 1995. I am greatly indebted to the many dedicated staff members of these research libraries. Amy Meyers of the Huntington and Georgia Barnhill of AAS deserve special mention, for they first suggested that I immerse myself in *The Aldine*. This essay is dedicated to my colleague and friend, Andrew Ladis, for without his encouragement my little thoughts would have never led to big ideas.

definition of the American forest and its relationship to the understanding of wilderness areas like the Adirondacks.

Beginning just before the Civil War and intensifying each decade afterwards, American weeklies and monthlies participated in an expansion of illustrated texts feeding a seemingly insatiable middle-class public. The quality and quantity of images differed for each magazine, but fascination with the natural environment, including the distinctive space of the forest interior, was a constant from the 1850s through the turn of the century. Periodicals offered their readers an opportunity to experience through a dialogue of visual and textual representation unusual as well as familiar forest situations and sites. One could view pictures of the fearsome jungles of Africa as in *Harper's* "Adventures in Gorilla Land," or of the enterprising operations of the lumberer as in *Scribner's* "The Wooded Age," or of distant Adirondack vistas from the sylvan interior as featured on the September 1870 cover of *Appleton's Journal*. In the seventies, competition became fierce as journals sought to provide fresh images of American scenery, especially the newly explored West and ever-exotic South, to a frequently urbanized, nature-hungry public.

Appleton's Journal presented a keen challenge to its competitors by introducing an illustrated serial, "Picturesque America," in November 1870. Two years later, D. Appleton & Co. issued an expanded book version, *Picturesque America; or the Land We Live In,* featuring "the great mountain-ranges, the superb lakes, the beautiful valleys, the grand primitive forests, the cascades, the magnificent rivers, the towns and cities, in brief, all the picturesque aspects of our land, from Canada to the Gulf, from the Atlantic to the Pacific." Undoubtedly, the book's ambitious national agenda and generous inclusion of steel as well as wood engravings contributed to its great commercial success.[2]

Although the forest figured in this encyclopedia of American scenery, and in fact, a forest cascade composes the title page of the first volume, *Picturesque America* did not present an overview of the forest interior as a pictorial type. *The Aldine,* however, its formidable competitor in engraved landscape illustration, devoted large, superior wood engravings to the diverse subject of the sylvan landscape with an incomparable enthusiasm. Whether as protagonist or backdrop, commonplace or exotic, reposeful or threatening, domestic or sacred, American or European, the forest repeatedly appeared in *The Aldine*. Other nineteenth-century journals sporadically matched *The Aldine's* dedication to the forest landscape type; sometimes literally doing so, as with *Illustrated Christian Weekly's* 1879 pirating of *The Aldine's* 1872 engraving of "Adirondack Scenery" by George H. Smillie.[3] *The Aldine's* recurrent presentation of sylvan landscapes, however, communicated post–Civil War concerns regarding the determination of national and regional character, and conceptions of masculinity, femininity, and Darwinism.

From the beginning of Richard Henry Stoddard's induction as editor, *The Aldine* assuredly promoted its presumed status as "a representative and champion of American art" and as the "handsomest paper in the world."[4] Confident of *The Aldine*'s future artistic and financial success, publishers James Sutton and L. M. Franklin held a dinner banquet celebrating the journal's new editor and its expanded national and international circulation of 40,000. The banquet's ambitious, congratulatory rhetoric reappeared in the journal's prospectuses and introduction, including the declaration that "the whole boundless continent is ours."[5] Competitors could not match *The Aldine* in either content or patronage:

> In the rapid progress of the last few years, our country has reached that point of popular aesthetic cultivation which calls for original creations, based on and ministering to the necessities and habits of American thought. . . . It is the recognition of the fact THE ALDINE is in every sense of origin and conception an American idea, a representative and champion of American taste, bearing to the whole world the evidence of progress and achievement in the highest and noblest arts of civilization, that has brought to it a support from the American people, far more earnest and cordial than its beauty alone could attract.[6]

The Aldine's presentation of original works of American art earmarked it as "one of the mightiest agencies in this century in the warfare against polluted pictorial literature."[7] It was an art journal not for just professional artists, but "for the people—the people of America—conceived, gauged, and created in their interest."[8] But those expecting a pandering to a popular predilection for the "weakly [*sic*] wicked sheets" would be disappointed: "With a population so vast, and of such varied taste, a publisher can choose his patrons, and his paper is rather indicative of his own than the taste of the country."[9] *The Aldine* presented itself as a reformer of American taste, thereby appealing to the nation's cultural pride.

Distinguished engravers like W. J. and Henry Linton, J. P. Davis, F. W. Quarterly, Timothy Cole, and Frederick Juengling, among others, filled *The Aldine*'s portfolio-size pages (eleven by sixteen inches) with images specifically created for the journal by such prominent American artists as Thomas Moran, John Davis, Jervis McEntee, and Homer Martin. Each volume included four tinted pictures on plate paper inserted as frontispieces; every yearly subscriber received a free chromolithograph. Although marketed as "a champion of American art," *The Aldine* featured numerous English, French, and German artists as well. Such cosmopolitan inclusions seemed to guarantee that *The Aldine* would "be a successful vindication of American taste in competition with any existing publi-

cation in the world."[10] Indeed, it was a most handsome journal, though conservative in its preference for artists of a Ruskinian or academic bent.

As editor, Richard Henry Stoddard undoubtedly participated in the selection and arrangement of literary and artistic offerings. He was no stranger to the art world, counting landscape painter Jervis McEntee among his friends.[11] Stoddard, a Massachussets native who spent much of his adult life in New York City, has been called "the Nestor of American literature," for he assembled a cultural salon in his home. Friend of such prominent cultural figures as William Cullen Bryant, Bayard Taylor, and Nathaniel Hawthorne, and the fireside poets James Russell Lowell, Nathaniel Parker Willis, and Edmund Clarence Stedman, Stoddard linked together writers and artists who shared his essentially New England sensibilities.[12] For these writers, artists like McEntee and Martin, and the public who avidly responded to their work, the forest afforded an examination of nature and its "shadows."

Amid pictures of winsome and fierce animals, historic and domestic narratives, European maidens and panoramic scenery, the abundance of sylvan imagery in *The Aldine* confirmed that an art journal could respond to "the necessities and habits of American thought."[13] Indeed, the forest was on many an American's mind. A robust tourist industry enchanted Americans and Europeans alike to venture into the nation's forests. As a burgeoning urbanization increased the demands for timber, concern arose about preservation and conservation of America's natural resources. Cultural critics promoted the reformative effects of natural scenery and aesthetic systems founded on harmonic variety. For many, landscapes like the forest interior honed the eye and the mind, elevated the heart, and inspired a contemplation of nature's lessons.[14] *The Aldine* intertwined the tourist's eye, the nation's pride, and the Victorian's morality in its visual and textual re-creations of forest scenery. The journal's expanded landscape offerings under Stoddard's editorship concurred with its messianic rhetoric regarding America's cultural development:

> The ambition and energy which form the leading national characteristic, were sure to push realization and possession far in advance of preparation, when new and unprecedentedly prosperous America appeared as a patron of the fine arts. Probably there was ample cause for the sneers of older civilizations at these first attempts of the young giant, who was beginning to feel that man's superiority should rest on something higher than the thews and sinews of an animal. But now it is America's opportunity to prove to the world that the ideas of her masses partake of the natural breadth, freedom and health of the country.[15]

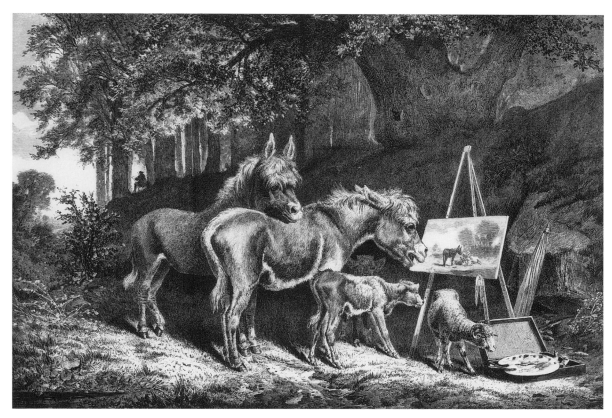

5.1. Peter Moran, "The Critics," *The Aldine* 6 (Jan. 1873): 19.

Therefore, *The Aldine* connected American energies, including her artistic impulses, to the expansiveness of her landscape almost two decades before Frederick Jackson Turner conceived his Frontier Thesis.[16] The journal's illustrated pages proved that the nation was progressing from a cultural primitivism to a civilized aesthetic. The forest, *the* natural resource identified with American vastness and singularity, repeatedly appeared as an example of *The Aldine*'s appropriation of the "whole boundless continent."

A comical example of 1873, however, used the woods to satirize America's cultural aspirations. Peter Moran's dumbfounded donkeys, ram, and calf examine their "portrait" and the artist's palette. Supposedly familiar with what they view, they are, in fact, like most self-proclaimed "critics," culturally

ignorant; their "backwoods blindness" is suggested by the bank of dark, mysterious woods beyond them. The artist, however, sits comfortably under the trees. As he sketches his new environment, his knowledge supposedly expands beyond the mundane, emulating the grandeur of the landscape. According to *The Aldine*, a democratic America, exposed to the journal's illustrated pages, could, like the artist, transcend its provincialism, perceiving the natural environment and itself in a new light.[17]

Several months later, Elizabeth Stoddard's long article, "Nature's Forest Volume," offered readers multiple examples of such a creative identification with nature. She outlined the possibilities of a true knowledge of nature, of how the "masses" could partake of the continent's "breadth, freedom and health" if they would only see, feel, and preserve their native woodlands. Indeed, Stoddard's introductory musings reveal an empathetic projection, a mirroring of subject and object, of viewer and viewed, that Moran's asses lack. Her long meditation on the anthropomorphic nature of the forest is worth quoting in full:

> To begin with a tree. Let us consider it. I have felt a tree to be sentient when I have observed it under the influence of rain and wind—its resistance at the root against the violence of the blast, its boughs so gracefully and pleadingly bending beneath it, and its leaves so hopelessly wet that one thinks them so with their own tears. Look at it revived in the sunshine; how modest and how gay it is, tossing its plumes in the breeze, and composing songs with the airs! Because trees do not eat, drink, and be merry, like human creatures, have we a right to deny them sensation of either pain or pleasure? For all we know, a mighty forest may feel among its members a daily succession of pleasant or unpleasant sensations, similar in kind to those which pervade the population of a mighty city. A tree has life; if you cut it, it will bleed; deprive it of nourishment, it will die. It has a perfect organization—a perfect circulating system; it reproduces itself, and, in favorable circumstances, it will sometimes live for centuries.[18]

Stoddard implies that attentive sight produces honest feeling and moral action. *The Aldine*'s landscape artists, loyal to "the truth to nature" tenets of English critic John Ruskin, therefore, rightly attended to naturalistic detail rather than overt expression.

John A. Hows's *Pines of the Racquette* [*sic*] (1872) and *White Birches of the Saranac* (1873), although both of the Adirondack region, re-create for the viewer the distinguishing characteristics of each species of tree and its particular environment: the birch's ever-shedding "skin" amongst dense over-

5.2. John A. Hows, "Pines of the Racquette [*sic*]," *The Aldine* 5 (1872): 121. The Adirondack Museum 66.63.2.

5.3. John A. Hows, "White
Birches of the Saranac,"
The Aldine 6 (Mar. 1873):
59. The Adirondack
Museum 66.45.11.

growth; the pine's lofty rise over a cascade-punctuated river. The textures of peeling bark, fern leaves, pine needles, and lichen-covered rocks were considered intrinsically expressive, capable of summoning in the viewer familiar sentiments or remembered associations.[19] Moreover, in the highly competitive market of illustrated magazines, the Ruskinian naturalism of such woodland scenes advertised the superior quality of *The Aldine*'s wood engravings.

Precision in the rendering of each tree's bark, leaves, height, and configuration demonstrated as well the importance of the type to *The Aldine*'s contributors and readers alike. Nineteenth-century middle-class Americans regularly tutored their children on the various moral, regional, national, or poetic associations of tree species. Adults themselves consulted floral and tree dictionaries for use in sentimental messages. *The Aldine*'s illustrations and texts participated in this attribution of value to specific trees. Beginning in 1872, *The Aldine* denoted differences between the northern birch and the Adirondack pine, the western juniper and the southern laurel. Elizabeth Stoddard praised the English oak and the Brazilian mimosa; she quoted Coleridge on "the birch, the lady of the woods."[20] Editor Richard Stoddard seemed particularly entranced by the birch; he included in the volume of 1873 no less than five references—a poem, two pictures, two short articles, and Elizabeth Stoddard's "forest volume."[21] Indeed, that year *The Aldine* boldly declared that "the forests of the world contain no tree that is more beautiful than the Birch." Although "the most graceful of all," "the White Birch" is "a hardy tree," inhabiting "the highest latitudes in which any tree can live."[22]

Inspired by John Hows's *White Birches of the Saranac,* editor Stoddard extolled as well the recreational and practical applications of the large canoe birch typical to the northern wilderness. Believing it equal or superior to fir, maples, and beeches, Stoddard rhapsodized about the beauty of the birch's "dainty force" and its "silvery columns, peeling off with amber and deep russet lights," as the bark's inner surface "catches an occasional sunbeam . . . in the sombre stillness of the inner woods."[23] The birch, though rugged enough to survive the hardships of a northern climate, embodied feminine beauty. Seemingly in a state of undress, the birch delightfully exposed itself to the gaze of camper, lumberman, and artist alike. For Stoddard, the birch sustained the trope of a gendered, virgin wilderness awaiting its male suitor.[24]

If the singular tree intrigued the Stoddards and their fellow contributors, the character of distinct forested environments absolutely enthralled. Of primary interest was the interrelationship of the individual, the type, and the whole. Apparently, the writers sympathized with Frenchman Hippolyte Taine's deterministic theories regarding the intersection of human achievement and the environmental, social, and intellectual conditions of a particular time and place.[25] The emotional state of the inhabitant(s) and the physical character of natural spaces converged as well. In "Nature's

Forest Volume," Elizabeth Stoddard extended her dedication to the attributes of specific literary, historical, and regional forests to their salubrious preservation through human effort.[26] In general, *The Aldine* focused much of its visual and written representations on natural milieus, though more in a poetic than scientific manner. Some of this may have been a marketing response to *Appleton's* "Picturesque America." But Richard Stoddard's New England heritage most likely reinforced an identification with the natural landscape that was fast becoming an entrenched component of American consciousness.

Elizabeth Stoddard constructed an opposition between northern and southern environments that echoed throughout *The Aldine's* pages. If the "delicate and pensive beauty" of the English forest fostered centuries of literary and historical associations for her, the "immense tropical forests of the Old and New worlds" "almost as terrible in their beauty as in their desolation," seemed too over-whelming for the power of language. A catalog of exotic flora and fauna, and dangerous diseases and auspicious antidotes, replaced the histories of Robin Hood and Lord Byron.[27] *The Aldine's* first full-page visual representation of the tropics similarly inundated the nineteenth-century eye with a "prodigious force of production" and labyrinthian space. In "A Tropic Forest" of January 1872, Granville Perkins violated pictorial landscape conventions. A bewildering variety of vegetation, re-flective of what Stoddard dubbed "the monstrous and the gigantic," block penetration into the syl-van environment. Neither tree tops nor sky are visible; no river cuts through the mysterious forest deep. Three lily pads diagonally aligned on a patch of water create a smidgen of shallow space, barely alleviating the oppressive foliage. There is little sense that the accompanying poem's "wilding daugh-ters of the wood, / That stretched unwieldly their enormous arms" will ever end.[28] Unlike Martin Johnson Heade (*Brazilian Forest,* 1864) or Harry Fenn (*A Florida Swamp, Appleton's,* 1870), Perkins removed any remnant of compositional focus, whether a waterfall, single tree, or opening of sky. Vegetation leads the eye only into blackness.

Two and one-half years later, *The Aldine* featured three large engravings on the tropical land-scapes of Florida. J. D. Woodward, fresh from providing illustrations of New England for *Appleton's* "Picturesque America" series, supplied *The Aldine* with images that competed directly with those by Harry Fenn for "Picturesque America." Unlike that series, *The Aldine* featured an image and discus-sion of the hummock, a fertile and timbered oasis amidst arid lands. Woodward placed the hum-mock into a spilling, picturesque-porthole composition that invites a voyeuristic gaze deep into the forest's recesses; the startled deer peering out underlines the intrusiveness of the scope-like experi-ence. With depth restored, the tropics, though still foreign and wild in their growth, no longer threaten the viewer. Indeed, the text emphasizes the "luxuriant soil" that feeds oaks, laurels, orange and fig trees,

5.4. Granville Perkins, "A Tropic Forest," *The Aldine* 5 (Jan. 1872): 21.

A HUMMOCK, FLORIDA. — J. D. WOODWARD.

hanging foliage sweep the upper deck so continually no one can remain there with safety. Strange sights constantly meet the eye, and strange sounds fall upon the ear. The tree-tops and tangled vines interlace, innumerable birds swarm in the air, huge and numberless reptiles crawl in the waters, and solid patches of flowers in bloom, half a mile in length, stretch through the swamp. Turkey-buzzards, snake-birds, white cranes, wild ducks, herons, loons, and hundreds of smaller birds infest the woods, filling the air with grand oratorios, or inexplicable chatter.

Some distance up this strange river is the famed Silver Spring, a great, deep, surprisingly clear basin of water, which boils up from the bowels of the earth with much force, forming a river one hundred feet in width, which in the course of seven miles forms a junction with the Ocklawaha. This spring is seventy

feet deep, as clear as crystal, fresh and cool. At one time, it is supposed, an Indian village of six thousand inhabitants clustered around it. The old boat shown by the artist was the very primitive craft in which he made his tour, at the rate of five miles an hour. Originally a steam saw-mill, which failed to do a paying business, its owner placed the boiler upon a flat boat, fitted up a paddle-wheel, and threw together the craft which now runs as a trading-vessel, and for the accommodation of those who dwell in the swamp.

The last illustration of this series is a beautiful one of what is known as a hummock, a term applied to fertile and timbered lands in Florida. Oaks, magnolias, laurels, wild fig-trees, and others, usually grow in these lands, which are of the best description for general purposes. General Winfield Scott, when in Florida, wrote of the hummock as an "emerald

island," in the midst of a desert of sands and fir-trees. The orange, the lemon, hundreds of varieties of flowers and fruit-trees, grow on the hummock, while pure springs of water babble up from the ground. "As you approach the land of promise," continues the General, "you see spread before you one of the most imposing, and at the same time beautiful scenes in nature. A luxuriant soil, extending perhaps for many miles, is covered with every variety of the laurel and other evergreen trees and shrubs, while in the midst, towering above them all, grows the stately magnolia, the surrounding atmosphere redolent with its delicious flowers. Who can describe the many beautiful rills, flowing over white sand, which spring from the feet of these giants of the forest, to traverse the hummocks, and lose themselves in the pine woods?"

5.5. J. D. Woodward, "A Hummock, Florida," *The Aldine* 7 (May 1874): 95.

"THE BROKEN LYRE."

Ring down the curtain! The act is finished — why prolong the tableau and the agony of the actors? The drama of the maiden's life has been played through; the world has nothing more to offer her, nor she it — why, then, should it gaze upon her, as she does not care to gaze upon it?

Time was, and but yesterday, when all was different — oh, so different — from the present gloom. Then the sun shone, the skies were bright, the birds sang in the leafy coverts, the butterfly — most mortal emblem of immortality — fluttered joyously in the sunshine; Cupid hovered in mid-air, exulting over a successful shot; two figures walked together; and the maiden swept its strings only pæans for victorious love. For the maiden loved. Her first — nay, her only love, for is not love immortal? Beside her walked him whom she loved, to whom was offered the sweet incense of the drop of maiden blood Love's first arrow had drawn from her breast.

How swift, alas! the change. Thick clouds came up the sky; the birds sought their shelter; the storm broke, even as broke, with one loud wail of agony, the strings of the lyre, when he who should have been the maiden's refuge turned from her side — the arrow which had pierced her tender heart having but glanced from his breast; and so she sank down despairing, the useless lyre falling by her side, while Love, weeping at his failure, hides his tearful face with his garments.

This is the picture M. Chaplin — always represented at the Paris Salon, and known for the grace and spirit of his female figures — has given us. In it the whole story is told and with powerful touches. Nothing could be more admirably conceived than the dejected attitude of the principal figure; the relaxed muscles; the fingers idly interlocked, as if they could never again be moved to action; the garments, neglected, slipping from the shrinking form; and, crowning all, the head, with disheveled tresses, and the face, from which the last ray of hope has departed.

But there is yet a future. The lyre may be restrung; Love will dry his tears and smile again; even the butterfly is not yet wholly beaten down and hopes the storm may pass, as it will, and the maiden will not die — for Love's wounds are not so surely mortal — but will live more strong for pain, more wary from experience, and nobler through suffering.

ISLES OF THE AMAZONS.

We have here all that is richest, most luxuriant and most enticing in tropical scenery, whose great attraction is its prolific life, both animal and vegetable. Nature seems to have tried to show there what wonders her forces can accomplish if allowed to work untrammeled. Life forms which we scarcely know at the north, or know only as pigmies, there develop into hugest giants. The sober hues and quiet tints which animals and vegetables wear in our colder climes, are there replaced by the most gorgeous tints, the most dazzling hues. All space is made available, too, and in the depths of tropical forests can scarcely be found room for the entrance of man.

All this is beautiful; but it is with a sensuous beauty, moving one with a sense of wanton luxuriousness, aided, perhaps, by the fierce heat which has begotten all this display. Deep draughts, however, of this too luxuriant beauty, produce an intoxication not good

ISLES OF THE AMAZONS. — Mary Nemo.

" Droops the heavy-blossomed bower, hangs the heavy-fruited tree —
Summer isles of Eden lying in dark-purple spheres of sea."

for the human mind, which needs the healthy tonic of difficulties to be overcome, in order to thrive. If man is obliged to strive in order to live, he will do other things in living; but here life comes so easy to him, he becomes supinely content with existence. Thus Enoch Arden and his companions found :

" No want was there of human sustenance,
Soft fruitage, mighty nuts, and nourishing roots ;
Nor save for pity was it hard to take
The helpless life so wild that it was tame.
There in a seaward-gazing mountain gorge
They built, and thatched, with leaves of palm, a hut,
Half hut, half native cavern. So the three,
Set in this Eden of all plenteousness,
Dwelt with eternal summer."

One might, with no very violent stretch of the imagination, conceive this to be the very island, so well does the subsequent description seem to fit it :

" The mountain wooded to the peak, the lawns
And winding glades high up like ways to heaven,
The slender coco's drooping crown of plumes,
The lightning flash of insect and of bird,
The lustre of the long convolvuluses
That coiled around the stately stems and ran
Even to the limit of the land, the glows
And glories of the broad belt of the world,
All these he saw."

The painter of this charming tropical scene — which, though not a landscape portrait, is not a fanciful sketch, but a composition from careful studies — hides her identity under the pseudonym of "Mary Nemo." She is known, however, to an increasing circle of admirers of her work, as the wife of an artist of growing reputation, and to whose brush the readers of THE ALDINE have been often indebted for beautiful delineations of American scenery.

The harmony of tone and color, characteristic of "Mary Nemo's" pictures, can not be reproduced in an engraving; but the firm handling, the excellent management of light and shade, and the careful integrity with which the work in them is done, can be shown and admired — as they will be in this example.

OUR WORLD'S-FAIR.

If, as Macaulay tells us, an epitome is never interesting, how shall an epitome of an epitome be invested with interest? How shall I make an acceptable summary of the artistic features of this New-World's-Fair, when a mere catalogue of the ten times ten thousand different objects would occupy many a sturdy volume? How convey any adequate idea of the vast aggregation of works of art, strictly so called, gathered from every part of the earth, and displayed, not only in the art galleries, but in nearly every one of the two hundred buildings on the Centennial grounds?

The polite reader, on encountering a new book, looks for an introduction giving, in a word, some intimations of character and purposes — a slight ceremony by which we expect any new acquaintance to be presented. But this civility requires the good offices of a friend already intimate with the person or subject approached. The preface of a book, though the first pages to be read, are the last to be written, being properly a digest of the author's conclusions after close study and careful deliberation. An introduction by a stranger is an impertinence; by an intimate it may be pleasant and serviceable.

I regret that I am not able to extend this courtesy to the readers of THE ALDINE — that I am not yet on such terms with the Exhibition as will permit my taking that liberty. Indeed, I do not know where any wellbred person could be found who would, at this time, undertake to say : "Allow me to make you acquainted with the United States Centennial Exposition."

For my own part, though I saw the first sod turned

and "the stately magnolia, the surrounding atmosphere redolent with its delicious flowers." Woodward, however, retained the tangled interlaces of vines, trunks, and ferns synonymous with the eerie confusion of tropical woods.[29]

Mary Nimmo Moran departed even further from Perkins's inviolable tropical wall in her *Isles of the Amazons,* published in *The Aldine,* July 1876, under the pseudonym of Mary Nemo. A tunnel of water cuts through foliage and rock to create a natural bridge, enabling the viewer to see into the distance where a large ship ranges. Yet *The Aldine* reaffirmed in its text those alien qualities deemed by New Yorkers and New Englanders alike as forever separating the New World tropics from the New World North: plants and creatures were brighter in color, bigger in size, and bolder in their use of space. Bluntly stated, "in the depths of tropical forests can scarcely be found room for the entrance of man." Even worse, the tropics possessed a "sensuous beauty" that instilled a "wanton luxuriousness" dangerous to the moral character and the economic health of society:

> Deep draughts, however, of this too luxuriant beauty, produce an intoxication not good for the human mind, which needs the healthy tonic of difficulties to be overcome, in order to thrive. If man is obliged to strive in order to live, he will do other things in living; but here life comes so easy to him, he becomes supinely content with existence.[30]

Later in the same volume, a full-page engraving of A. Goering's *Scene in Venezuela* and accompanying commentary, reiterated such a world of utter luxury and repose. Goering opened up Perkins's impenetrable wall of palms with sky patches and a flowing waterfall, creating a "bosky dell." However, "the heavy palms, the clinging vines, all help to increase the feeling, born first of the climate, that one has nothing better to do than to indulge in the *dolce far niente.*"[31] *The Aldine* echoed fears voiced elsewhere in American culture about the assumed negative influences of tropical climates on commerce and culture.[32] One might interpret this as an implicit northern critique of the Reconstructed South. But unlike other periodicals, *The Aldine* essentially omitted southern topography beyond the North Carolina mountains, except for Woodward's Florida spread. According to *The Aldine,* African-American experience was virtually nonexistent. In short, the American South took a back seat to Alexander von Humboldt's more exotic South America. As we have seen, the journal acknowledged the extraordinary beauty of that paradisal environment, but judged it completely unconducive to the progress of civilization. It was virtually flaccid in contrast to the more virile, wooded North.

Janice Simon

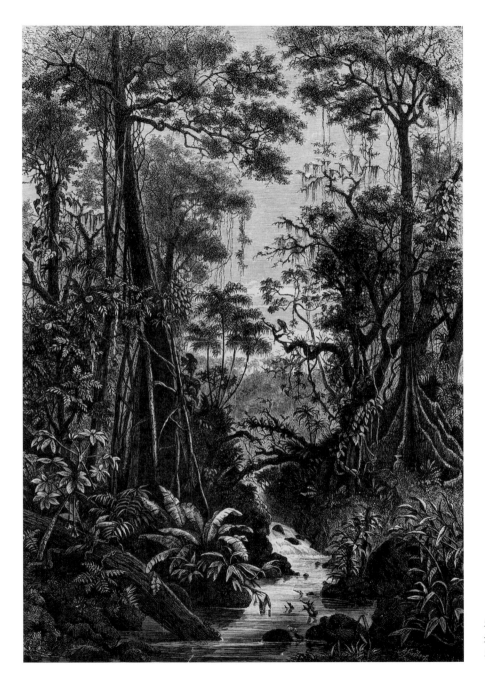

5.7. A. Goering, "Scene in Venezuela," *The Aldine* 8, no. 11 (1876–77): 348.

Northeastern forests, the landscape most frequently illustrated in *The Aldine,* alternately instilled fear and repose, for inspiration, not lethargy, were their anticipated effect. Like the birch, they conveyed the masculine rigor of the Sublime in tandem with the feminine tranquility of the Beautiful. John Hows's *Pines of the Racquette* (1872) (p. 89) or his *Kettle Run, Altoona* (1874–75), or Worthington Whittredge's *A Catskill Brook* (1873), present forests at once peaceful and energetic in their harmonic disposition of rugged boulders, rushing waters, soaring trees, fallen logs, gnarled roots, and active wildlife.[33] Perkins's and Goering's tropics, however, invite complete relaxation with their shallow depth, limp moss, droopy vines, still pools of water, and sleepy birds. The northern woods challenged without terrifying the viewer; the tropical forest enervated with its intemperate loveliness.

The Far West, though possessing areas rich in timber, appeared in *The Aldine* as "a world as wild as the one we see in dreams." Thomas Moran, who depicted the Adirondacks and Alleghenies as well, pictured Yellowstone and Utah as filled with difficult, precipitous mountain ranges; pines barely hung onto odd-shaped rocks. At times, as with the tropics, language and art were "baffled by the stupendous wildness" of western geology. But unlike the South or the forested North, the West's effect on moral character was never mentioned. Its extraordinarily colored topography "just" astonished.[34]

Instead of the Rockies or the tropics, the quintessential northeastern forest interior illustrated "Midsummer Art," an article celebrating American superiority in landscape painting featured in *The Aldine*'s last volume. For the editors, a muscular oak tree amidst various forest growth epitomized the virtues of American nature gleaned by artists in close "communion with the true and beautiful." Indeed, the wild grandeur of American scenery, replete with "emblems of infinity," "compelled" American artists "to paint broadly, to be animated with profound, serious and exalted thoughts, these in turn producing strong, masculine pictures free from mean details."[35] American nature was the elixir of American art. From it, American painters gained their courage, strength, and genius. Years of illustrated sylvan landscapes demonstrated that the American forest had a restorative effect on American art equivalent to that of the Adirondack woods on William H. H. Murray's emaciated businessman wearied by city life.

The Aldine incorporated more references to the Adirondacks than any other mountainous range, suggesting that they epitomized the value of the northeastern woods for America. In an article featured in the same issue of 1873 as "Nature's Forest Volume," and accompanied by four large engravings, the Adirondacks are pictured as the ultimate respite from commercialism, "the wrenching, harrowing world," and "that great bore, Civilization." F. T. Vance's images *Flume Falls of the Opalescence, Calamity Pond,* and *Avalanche Lake,* along with descriptions of precipitous recesses and "primeval forests," stress the fierce sublimity of the Adirondacks: "It has much of the Alps and Pyrenees about it, but

THE HEART OF THE ADIRONDACKS.

It is now the time when summer tourists, surfeited at last with out-door life, are setting foot again upon the city pavements, and finding new pleasure in the life and labor of the town. The men are laying down the rod and rifle, and taking up the ruler and the pen; it will require a season's bleaching within their confines to remove the tan from their faces, or bring their brawny hands to the size of the gloves they wore last spring. The women are rejoicing in the kaleidoscopic glory of autumnal fashions. The boys are singing, "O, ain't I glad to get out of the wilderness!" and the girls are longing — but who may interpret the mingled, delightful anticipations of a young girl's fancy — maidenfree? Although the reign of Nature is thus, for many of us, at an end until another year, such pictures as Mr. Vance's sketches of Adirondack scenery are none the less enjoyable even now. We look at them with the pleasure which travelers, bringing home photographic views of famous places they have visited, have stored up for their future idle hours. They keep fresh the memory of the beauty we have seen, and assure us, again and again, that our summer pilgrimages were not enchanted dreams.

Even the malign effect of Mr. Murray's Adirondack romance has not disturbed the sensible popular conviction that, after all, the region where its scene is laid, is the noblest of the forest parks whose waters find an outlet to the Atlantic. The mountains which form a lofty western wall to Lake Champlain, and the great northern wilderness, extending from their skirts to the blue waters of Ontario, and to the Mohawk Valley on the south, are still an almost exhaustless reservoir of health, of backwoods' sport, and (what more concerns the readers of THE ALDINE), of primeval beauty, for the landscape-artist to study and reproduce with pencil or brush. A cat may look at a king, and even in the Old World there is little restriction upon the sketcher's wanderings and works. But, speaking of game, we, who are born to the freedom of the woods, and inherit a hunting-ground so large that poaching is a crime unknown to our calendar, scarcely can appreciate the delight of a middle-class European, who discovers that, among the Adirondacks, he has the right of venery over millions of acres, and may kill deer and trout in their season, with no gamekeeper to say him nay. We have a friend who occasionally laments that his lease of life was not dated from the middle of the next century, when men will navigate the air, and our present refinement will seem a kind of barbarism; yet he consoles himself with the reflection that, to our successors of the fifth generation, the delightful zest of hunting natural game, in aboriginal forests, will be quite unknown. This joyous liberty then will have gone forever; the land will be so thickly settled that the chase of fin, foot and feather, can only be followed in preserved waters and artificial parks. Fishing in

true, can not be destroyed, nor the abrupt sheer of the broken cliffs which guard their approaches. But to reach what admirers of the northern wilderness have taught people to look for, one must penetrate quite within the *terra disputata* along its borders. Then, if he goes far enough and wisely, even if the trout do not fasten themselves upon his hook, and the deer curiously refrain from crowding about his shanty, awaiting their turns to be shot, he will at least behold the immemorial forest: the fir-tree uplands, where the dark-green conical balsam branches dip in the edges of a thousand ponds; where the ground is covered with a yielding depth of moss, and everywhere spotlessly clean and pure; where the waters are blue as steel; where spring-fed lakelets are hoarded among woody heights that utterly surround them, and repose each like water in the bottom of a malachite bowl, or are open mirrors, engarlanded in framework of white and golden lilies, among which the royal antlered race wade and splash and nibble, at twilight of every sultry eve and morn.

In qualities of this kind, and in dryness and healthfulness of air, the Adirondack wildwood cannot be surpassed. Perhaps no other region displays so broad a combination of the various features we seek for in an upland sojourn, although more than one of its rivals comes out very strong, as Mark Tapley would say, in attractiveness of a special kind. Its peaks are not so lofty as those of the White Mountains, and there is nothing among them to equal, for example, the abrupt grandeur of the scenery around the Franconia and Crawford Notches. The nearest approach to this is in the neighbor-

THE GLEN. — F. T. VANCE.

the former is but a mockery of Cleopatra, whose carp were fastened by divers to her silver hook; and hunting in a *parc aux cerfs*, over the velvet lawn, may do for pampered, encostumed courtiers, but not for a keen-scented, sharp-eyed inheritor of the Indian's torrents and unshorn forest-glades.

Large portions of the Adirondack tract, however, are in that disagreeable transition state, between their normal wilderness and the finish of a settled region, which makes them less attractive than they would be in either condition. The edges disappoint the average fair-weather tourist, having been lumbered over and burnt over until they put on the barren, scrawny aspect, which is so repulsive a phase of border scenery. The clearness and sparkle of their waters, it is

hood of the difficult "Indian Pass." On the other hand, "Echo" and "Profile" lakes, at Franconia, are but types of hundreds of equally picturesque sheets of water, scattered throughout the whole distance from the Black River to the Saranac. Plymouth County, Massachusetts, described at some length by the writer of the "Old Colony Letters," in last summer's *Tribune*, is thickly spangled with lakelets, and its woods are almost uninhabited. But the Massachusetts' wilderness is within the low, monotonous, sandy reaches of the sea-coast; the borders of its ponds are not so elevated and picturesque as those of the Adirondack waters; nor do they bloom beneath that marvelous northern atmosphere, now transcendent as the ether, and anon magical with haze and the mirage of the

stress the fierce sublimity of the Adirondacks: "It has much of the Alps and Pyrenees about it, but with a savage, primitive nature that is peculiar to the American wilderness." Its "mysterious depths" and "inaccessible rocks" proved a true challenge to the committed sportsman. Rewards abounded, especially from the resinous hemlocks and spruce: "Breathing in woods of this kind, feels absolutely like a new sense. The tonic properties of the air increase the appetite, and brace the muscles to a wonderful extent."[36] A year earlier, with F. T. Vance's *The Glen* as illustration, Stoddard bluntly declared the Adirondack region "the noblest of the forest parks whose waters find an outlet to the Atlantic." There "the immemorial forest" "where spring-fed lakelets are hoarded among woody heights that utterly surround them, and repose each like water in the bottom of a malachite bowl" provided health, sport, and beauty in spite of intruding settlements. Vance's arched forest cascade evoked the rugged yet sacred space that the Great North Woods interior typified.[37]

Such admiration for the Adirondacks continued through the last volume of *The Aldine*. Sidney Grey's long, impassioned plea for protecting the Great North Woods extolled the Adirondacks as a site of savage energies and spiritual epiphanies. A vast forest with a thousand lakes "many yet unvisited," the Adirondacks protected the watershed feeding the Hudson. They nurtured as well the American artist. John Davis's full-page image, *Morning in the Adirondacks,* represented for Grey all the virtues of the North Woods and their importance for the health of the nation. Thick, diagonally thrusting birches act as a natural entranceway into "one of the last strongholds of primitive nature left near us." Indeed, the old crisscrossing trunks, half-submerged moss-covered log, and "the tangled forest" blocking any distant view reaffirmed to Grey "that no mortal hand has ever interfered with their natural growth." The "smooth water" and "profound silence" seem about to break, however, as ascending waterfowl announce "the cautious hunter" about to "wake the echoes with the shot" that kills. Significantly, Grey prefaced his discussion of Davis's hunter penetrating "the heart of the wilderness" with an assertion linking American greatness in landscape art directly to preservation of "Nature in her most primitive dress." The Adirondacks must be preserved not only for their health-restoring powers, but also "for the sake of all that is aesthetic among us." And as if to bless America's superior wildness that pumps up her art into virile expressions of national destiny, Grey transformed Davis's hunting scene into a spiritual rhapsody: "One is transported, as it were, in looking upon it, to the solemn aisles of the wilderness—Nature's great temple—and is irresistibly forced to think of the glories of the opening day and of the rising of that luminary which has been revered since time began."[38]

The Adirondacks furnished that "immemorial forest" of solitude so appealing to an increasingly

5.9. *(Opposite)* John S. Davis, "Morning in the Adirondacks," *The Aldine* 9 (1878–79): frontispiece for article, 18–19. The Adirondack Museum 77.196.3.

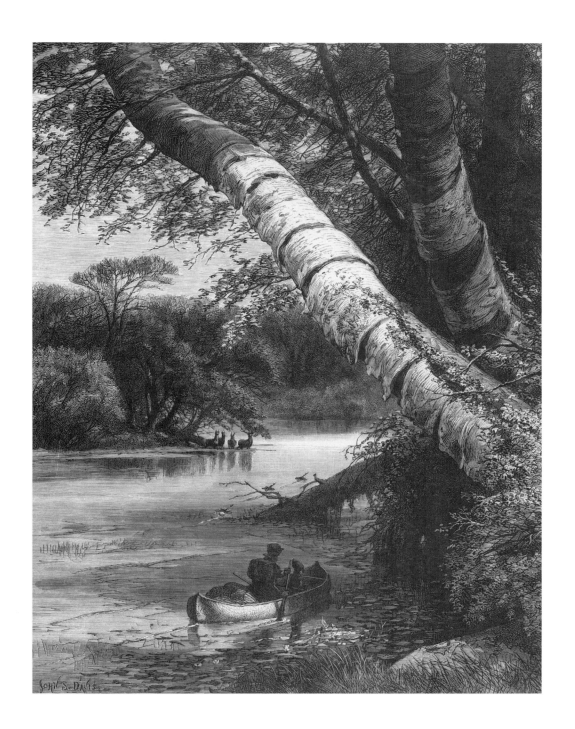

5.10. G. Deiker, "The Pine Marten," *The Aldine* 6 (May 1873): 102. Courtesy of the American Antiquarian Society.

urbanized Northeast. They supplied as well that "healthy tonic of difficulties" deemed necessary for survival in the post–Civil War age of Darwin and primitive masculinity.[39] The impending violence of Davis's quiet scene upheld *The Aldine's* decade-long recognition of nature as "red in tooth and claw." John Davis applied a typically American restraint to his many illustrations of hunters who, often with dogs, engage in savage acts as proof of their masculine dominion over the forest primeval.[40] Explicit images of preying animals and the cruel death they exact, however, permeate the journal's pages. *The Pine Marten*, by the German artist G. Delker, characteristically depicts a carnivorous animal typical to northern forests, including the Adirondacks where it abundantly ranged. In his commentary, Stoddard reiterated the violence conveyed in the composition's tangled branches, sharp needles, rough bark, and bared teeth. Taking Mary Howitt to task for her "entirely false," pre-lapsarian poems of the wilderness, he affirmed nature's deadly reality: "The peace and tranquility which she so beautifully describes, exists only in her imagination. Sylvan life is an interminable war of species. . . . The pine marten . . . rapacious, blood-thirsty, implacable . . . is especially the terror of the places which it haunts. Agile, quick-sighted, untiring, it always hunts its victim to the death."[41]

How appropriate that in 1873, the same year *The Aldine* featured "Nature's Forest Volume" and "The Adirondacks," Stoddard paid tribute to the white birch, the "dainty force" of the North Woods, and to the pine marten, its "indefatigable sportsman." With such images of the sylvan interior, *The Aldine*, *The Art Journal of America* reminded Americans that, indeed, trees do feel, and that the mighty forest is the site of pain as well as pleasure.

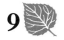

9

The Hermit of Phantom Island
John Henry Hill's Etchings of Lake George

NANCY FINLAY

I N THE WINTER of 1873, the photographer Seneca Ray Stoddard visited Lake George collecting materials for a guidebook of the region. One of the inhabitants whom he interviewed was the artist John Henry Hill, whom he found living by himself on an island in the Narrows. Stoddard's guidebook, *Lake George: A Book of Today,* depicts Hill as an eccentric character:

PHANTOM ISLAND . . . is the home of the "Hermit of Lake George," of whom rumor hath many tales, dark and mysterious, to tell, although, in fact, the subject is an inoffensive, modest, and gentlemanly appearing individual, who writes his name J. Henry Hill. He came here in 1870, erected his house, which may be seen through the trees, substantially finished and furnished it, and has lived there summer and winter ever since alone, for even his dog seemed to pine for company and left his master. He is ostensibly engaged in making studies of Lake George scenery and foliage, to be reproduced in etchings by himself and published at some future time; some already completed are wonderful bits of combined strength and delicacy. Mr. Hill is one of a third generation of artists, which, judging from present indications, will never blossom into a fourth, for he is wedded to his art, and if reports be true, is not overfond of the gender sex.[1]

While Stoddard's description of Hill is on the whole accurate, the "modest and gentlemanly" artist cannot have appreciated the way Stoddard exploited him as a tourist attraction, even suggesting that he was the subject of "many dark and mysterious" tales and clearly indicating the home of "the Hermit."

on a map that he included in his book. Hill's own account of his life on Phantom Island in the Lake George Narrows, as it emerges in the diary preserved in the Adirondack Museum, is less sensational, but in popular tradition, he remains a colorful figure, the crotchety "Hermit of Phantom Island."

Lake George enjoyed a long and fairly continuous artistic tradition, beginning in the mid–eighteenth century. While writers lamented the fact that most American landscapes were lacking in historic and literary associations, Lake George was celebrated both in history and in literature.

6.1. Seneca Ray Stoddard, *Map of Lake George*, detail, from *Lake George: A Book of Today* (1875). The New York Public Library, Astor, Lenox and Tilden Foundation.

The earliest view of Lake George commemorates the battle that was fought there on September 8, 1755. Previously known as Lac du Saint Sacrement, the lake was renamed by General William Johnson after his force of 2,000 Englishmen and 250 Mohawk warriors defeated the French under General Dieskau. Samuel Blodgett's *Perspective Plan of the Battle Fought near Lake George* was published on December 22, 1755, a mere three months later. Blodgett himself was present at the battle, and his schematic rendering of the action, as engraved by Thomas Johnston, has all the immediacy of a first-hand account. The site of the battle had become a popular tourist attraction by the turn of the eighteenth century. Jacques Gérard Milbert included a view of Lake George from the village of Caldwell (later Lake George Village), drawn in 1815, in his *Itinéraire pittoresque du fleuve Hudson et des parties latérales,*[2] and Countess Charlotte Julie de Survilliers, the daughter of Joseph Bonaparte, sketched the lake in 1822 and included a lithograph of it in her *Vues pittoresque de l'Amérique,* published in 1824.[3] An engraving by Peter Maverick is dated 1825.[4] All these early views are taken from the southern shore of the lake, near the ruins of Fort William Henry. The popularity of Lake George as a tourist destination continued to increase, and views of Lake George proliferated following the publication of James Fenimore Cooper's novel *The Last of the Mohicans* in 1826. Much of the action of that novel takes place at Fort William Henry, and the beauty of the surrounding landscape is described in glowing terms. Although Cooper judged Lake George to be inferior to the finest Swiss and Italian lakes in "the height of the mountains which surround it, and in artificial accessories," he considered it equal or superior "in outline and purity of water" and "in number and disposition of its isles and islets." He called particular attention to the Narrows, which he described as "crowded with islands to such a degree as to leave passages between them frequently of only a few feet in width."[5]

Such a notable romantic subject was not neglected by the artists of the Hudson River School, the native American school of romantic landscape artists. Thomas Cole portrayed Lake George as early as 1830; Sanford R. Gifford painted Lake George scenes in the 1840s; and John W. Casilear and John F. Kensett both made the lake a speciality in the 1850s. In the 1860s, it was painted by Alfred Bricher, Jasper Cropsey, and Martin Johnson Heade.[6] While some of these artists continued to favor the traditional view up the lake from the site of Fort William Henry, by this time occupied by the comfortable Fort William Henry Hotel, others ventured farther afield in search of picturesque motifs. William Henry Bartlett, that indefatigable chronicler of the American landscape, made drawings of Caldwell, Sabbath Day Point, Rogers' Slide, The Narrows, and a "Scene among the Highlands" when he visited the lake in 1838, all of which were reproduced in Nathaniel Parker Willis's *American Scenery* in 1840. Nor did Currier and Ives neglect a subject with such obvious popular appeal. Their *Lake George: Black Mountain* of ca. 1860 was closely based on Bartlett's view of the same subject.[7] Both

hunting parties and pleasure boats were appearing in Lake George views with considerable regularity by this time; Lake George enjoyed a far less rugged image than most of the region, and ladies with parasols were at least as common as hunters with dogs and guns in these mid-century views.

Hill took little account of this artistic tradition, though no doubt he was aware of it. As the son and grandson of important topographical artists, he was thoroughly familiar with both the American and the British landscape traditions. His grandfather, John Hill (1770–1850), was trained as an aquatint engraver in England and was active in London where he engraved works after Joseph Mallord William Turner and other romantic painters before emigrating to the United States in 1816.[8] There he quickly became one of the most important engravers of topographical views. His *Picturesque Views of American Scenery,* after paintings by Joshua Shaw, was published in Philadelphia in 1820. His most famous work, *The Hudson River Port Folio,* engraved after paintings by William Guy Wall, appeared in 1820–25. This suite of twenty prints traces the Hudson River from Little Falls at Lucerne to New York Harbor and includes several scenes in the Adirondacks: the print of Little Falls, a view of the junction of the Sacandaga and Hudson Rivers, a view near Jessup's Landing, and two views of Hadley's Falls.

Although there is no evidence that John Hill himself ever visited the Adirondacks, his son, John William Hill (1812–79), was one of the first artists to explore the northern wilderness. Unlike his father, who is chiefly known as an engraver of other men's works, John William Hill was a skilled draughtsman and extremely precocious.[9] Like his father, he at first specialized in topographical views. An early series of watercolors of the Erie Canal were drawn when Hill was not yet twenty years old. Originally these were to be engraved by John Hill and published, but the project was never completed. Several of the drawings are in the New York Public Library and the New-York Historical Society. Several of the locations depicted are near the southern foothills of the Adirondacks, but it was apparently not until 1840 that Hill ventured into the mountains themselves. He then accompanied Dr. Ebenezer Emmons on a geological expedition for the New York State Natural History Survey. Three small lithographs by Endicott and Co. after drawings by Hill appeared in Emmons's published report in 1842. These depict the Cedar River, "Lake Janet," and "Lake Catharine." "Lake Janet" would later be known as Blue Mountain Lake.[10] An engraving after another of Hill's drawings, this one of Raquette Lake, appeared in 1849 in J. T. Headley's *The Adirondack; or, Life in the Woods.*[11] Hill evidently retained a favorable impression of the area, for almost thirty years later, he recommended the Adirondacks as a destination to his sons.

The influence of John William Hill on his son John Henry Hill (the "Hermit of Phantom Island") was lasting and profound. Not only did John Henry Hill become a landscape artist under

his father's influence, his artistic style was also strongly affected. About 1855, John William Hill discovered the writings of the British art critic and theorist John Ruskin and became one of the leading figures in the American pre-Raphaelite movement. The youngest Hill also embraced pre-Raphaelite principles of truth to nature and attention to precise detail.[12] In 1864–65 he spent a period of about eight months in England, studying the paintings of Turner. Turner's landscapes were recommended as models by Ruskin; the knowledge that a number of them had been engraved by Hill's grandfather before he emigrated to America must have increased his interest in them. In fact, the influence of Turner was not immediately apparent in the works that John Henry Hill executed upon his return from England. The etchings in his little book, *Sketches from Nature,* published in 1867, reflect the deliberate realism of minor British pre-Raphaelites such as William Henry Hunt, John Brett, and William Dyce, whose painstaking renderings of natural forms were also praised by Ruskin.[13] Ruskin's own detailed watercolors of geological features must also have had great appeal for an artist whose father had taken part in a geological surveying expedition and who was soon to join such an expedition himself. Hill would later say that the works of his grandfather and the early works of his father, done before he "woke up to the importance of Ruskin's system of accurate drawing," were of little artistic value.[14]

Hill paid what was apparently his first visit to the Adirondacks in 1867. His brother Charles was in poor health, and their father, John William Hill, remembering his own experiences with Professor Emmons, suggested a camping trip. Interestingly, this was two years *before* the publication of William H. H. Murray's famous book, *Adventures in the Wilderness,* sent droves of invalids rushing to the North Woods in search of miraculous cures.[15] John Henry and Charles were joined by a third brother, George, a mathematician. George would later assist John Henry with his survey of the Narrows of Lake George.

The following summer, and again in 1870, John Henry Hill accompanied the geologist Clarence King on the United States Geological Expedition to survey the fortieth parallel. King, like Hill, was a member of the Association for the Advancement of Truth in Art, the American pre-Raphaelite organization. The expedition explored the Sierra Nevada and Rocky Mountains, visiting the future sites of Yosemite and Yellowstone Parks. One of Hill's sketchbooks from the 1870 expedition, containing views of the Pacific Northwest, is in the New-York Historical Society. Between expeditions, the artist again went camping in the Adirondacks.[16] This time, on his way home, he spent some time on an island in Lake George,[17] and in the fall of 1870 he returned to occupy the cabin known as "Artist's Retreat" on Phantom Island, which would be his principal home for the next few years.[18] The first entry in Hill's diary is dated December 25, 1870; by this time, he had already been living in the cabin for several months.

6.2. John Henry Hill, "Artist's Retreat." Pencil drawing in diary. The Adirondack Museum.

Hill's diary is an extraordinary document that reveals an incredible amount, not only about his daily life on Phantom Island, but also about his working methods, the specific sites that he depicted, and how he marketed his paintings and etchings. Few artists' diaries contain so much pertinent information. There is even a detailed account of his meeting with Seneca Ray Stoddard on February 20, 1873:

> Stoddard from Glens Falls called in the afternoon, came up to get some photographs
> of winter scenery on the lake and is going to have published a small guide book of

the lake and wanted to know what he was to say about this establishment. Said there was a great deal of curiosity . . . and many enquiries made about it. Yes, thinks I, I have had a studio in Broadway and have exhibited pictures on the academy walls for a number of years and have received high commendation from most of the New York artists and from Rossiter and Ruskin and thousands of people have seen my work and precious few enquiries have been made about it, and now when I choose to take them at their word and cut clear . . . and tend to my own business, the numbsculls are wide awake with astonishment: Why I don't see how he lives, I should think he would be awful lonesome.[19]

At least during the first year, a good part of Hill's time on Phantom Island was spent on oil paintings and watercolors based on sketches that he had brought back from Clarence King's surveying expeditions. These include views of Yosemite Valley, Shoshone Falls, Mount Shasta, and a "sunset over the desert." Most, if not all, of these were done on commission, several of them for King himself. As time went by, however, Hill devoted more and more time to the depiction of local subjects. Surrounded as he was by natural beauty, he seems to have done very little random sketching but instead to have deliberately selected certain views that he considered particularly typical of Lake George. He then reworked these landscapes in different media, reproducing the same view in watercolors, oils, and etchings.

The etchings were printed on Phantom Island itself, on a press that Hill had hauled over the ice from Bolton Landing, early in January 1871.[20] One of the vignettes surrounding Hill's etched map of the Narrows may depict this operation. It shows Hill approaching his cabin hauling his hand sleigh. The press was probably a small proof press similar to the one described in Philip Gilbert Hamerton's *Etching and Etchers,* published in London in 1868.[21] Presses of this type were used by other American artists at the beginning of the etching revival.[22] Americans were just beginning to rediscover the artistic potential of etching in the 1870s, and Hill was one of the earliest to experiment with the medium.[23] His first etchings, *Sketches from Nature,* were published in 1867. Hill must have been inspired by prints that he saw in England and by the fact that both his father and grandfather were skilled in the use of the technique as a reproductive medium. This is confirmed by Hill's occasional use of aquatint in his prints, a technique rarely, if ever, employed by British and American painter-etchers but used by both of the older Hills in their reproductive work.

At the back of Hill's diary is a list of the etchings made at Lake George: (1) Cascade, (2) Farmington, (3) Map, (4) Island Pines, (5) Island Rocks, (6) Caldwell Island, (7) White Mountains, (8) Rocks

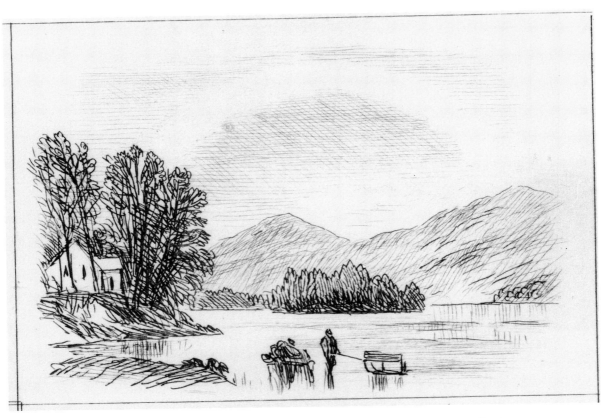

6.3. John Henry Hill, [Lake George in winter], detail of *Map of the Narrows*. Etching. Print Collection, New York Public Library, Astor, Lenox and Tilden Foundation.

on Big Island, (9) Ticonderoga, and (10) View from Bolton. "Farmington" may be identified as "Crossing the Stream, Farmington, Connecticut," an etching that Hill made after a drawing by his father, John William Hill. This etching was apparently the first one that Hill printed on his press.[24] Since neither *Farmington* nor *The White Mountains* can by any stretch of the imagination be considered Lake George views, this leaves a modest group of eight etchings to document Hill's years on Phantom Island. Hill's diary also records a few additional watercolors and oil paintings of Lake George and Adirondack views. These include a watercolor of Little Falls,[25] an oil painting of the

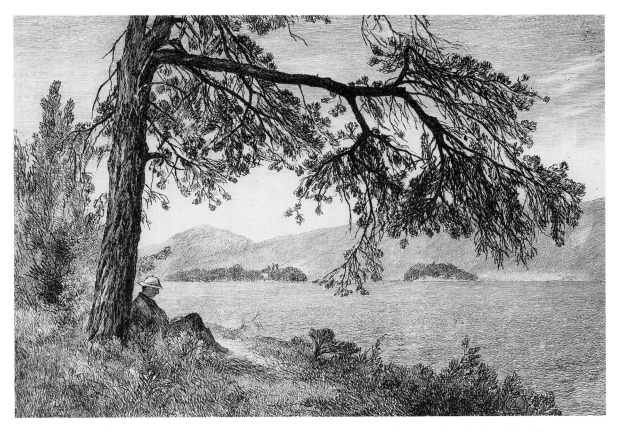

6.4. John Henry Hill, *Black Mountain from Caldwell Island*. Etching. Print Collection, New York Public Library, Astor, Lenox and Tilden Foundation.

Raquette River near the outlet of Long Lake,[26] and a number of drawings and watercolors of camp-sites and summer houses that Hill made for sale to visitors. For example, a diary entry of September 18, 1871, records that Hill made a sketch of the house on Recluse Island for the man who built it.

The first of Hill's Lake George etchings to be completed was *Black Mountain from Caldwell Island*. This is signed and dated July 1871. A large pine tree with an overhanging branch takes up much of the foreground. A contemplative figure seated at its foot may be a self-portrait. Hill was never especially good at drawing the human figure and this one is no exception. The composition

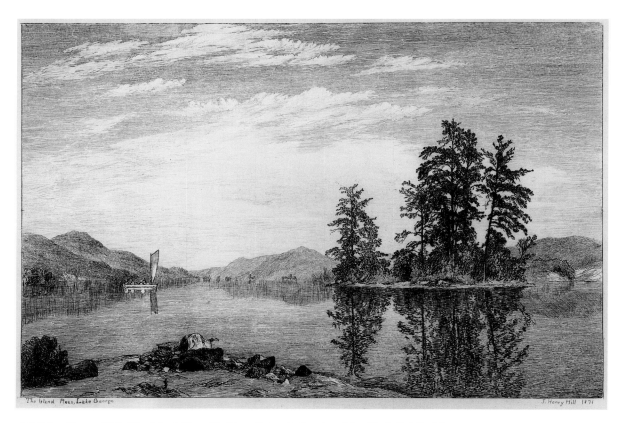

6.5. John Henry Hill, *The Island Pines.* Etching. Print Collection, New York Public Library, Astor, Lenox and Tilden Foundation.

as a whole has a sketchy experimental quality to it that to modern eyes gives a rather Impressionistic effect quite unlike the pre-Raphaelite clarity Hill always claimed to admire. Despite the fact that he did not include this view among the vignettes surrounding his etched map of the Narrows, it was one of Hill's favorites and the only one of his Lake George etchings he included in a list of his "most important works" compiled in 1880.[27]

Perhaps the most thoroughly documented of Hill's Lake George subjects is the view of a group of pine trees on a small rocky island in the Narrows, which Hill called *The Island Pines.* The artist first made a small thumbnail sketch of the subject in his diary on January 14, 1871, commenting

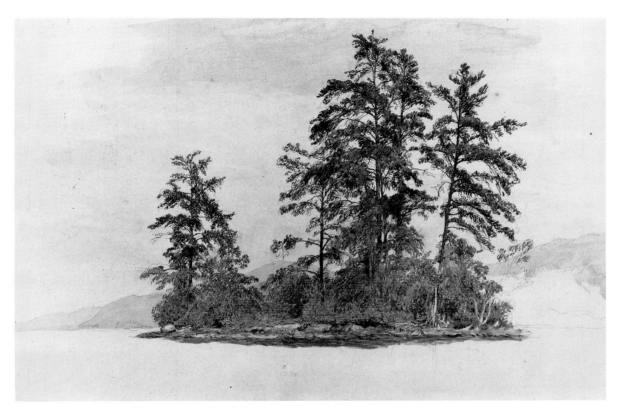

6.6. John Henry Hill, *The Island Pines, Lake George*. Watercolor. The Adirondack Museum 57.132.4.

that it "looked as though one might get some very nice sketches around [here] in summer time." On January 15, he elaborated on his search for the right subject, noting that "a little below Dollar [Island] . . . is a small rocky island with some very nice pine trees on it . . ." and noting that there was another "small island nearer shore [with] a picturesque group of pines upon it but one of them had blown down and spoiled the group."

Small rocky islands crowned with pine trees are typical of Lake George and of Adirondack lakes in general. This generic quality seems to be something that Hill deliberately sought in his Lake George views. Although the next reference to *The Island Pines* in Hill's diary does not occur until October 18, the watercolor of *The Island Pines* in the Adirondack Museum was probably made some-

time in the early spring and is probably a preliminary study for the etching. On October 18, Hill "finished etching [the] subject Island Pines and applied aqua-fortis." It was not until October 27 that he "printed a few impressions of the island pines which came out nicely." Thus, although the composition had been quite fully worked out the preceding January, it was mid-October before Hill finally transferred the design to the copperplate and more than a week later that he finally printed the image. This leisurely pace may be explained in part because Hill was simultaneously working on other projects and also because quite a bit of his time was spent making improvements to his cabin and assuring that his larder was well-stocked for the winter. The pleasure that the artist took in these daily chores is evident in his diary and may reflect his conscious emulation of Thoreau. "What an interesting book Thoreau would have made if he had lived on this Lake," Hill noted in his diary for January 20, 1871. However, "My business is to draw and paint and not to write so I will stop this desultory rambling. . . ."

Hill returned once more to *The Island Pines* in 1873. On January 10 of that year he "sketched out subject 'Island Pines' on canvas 32 x 48 in. to hang on west wall of studio." On the 17th, he recorded that he had "been painting all this week on oil picture of Island Pines, got the sky, Black Mt. which is central feature and the pine trees painted in. Distance to right and left and water and rocks in front remain to be painted."

A similar subject, which Hill referred to as "Rocks on Big Island" or simply *Study on Lake George,* was etched in November 1871. This depicted "a group of trees on a rocky bluff at the end of Big Isl[and]." Hill noted that the "subject [was] within sight of the house [i.e., his cabin, Artist's Retreat] and nearly north of it." Since there seem to be no other references to this composition, the implication is that Hill drew and etched it in November, probably working from the cabin itself.

Hill's view of *Shelving Rock Falls* is almost as fully documented as *The Island Pines* and was almost as long in execution. Hill visited the waterfall on May 6, 1871, and described it in his diary: "The main mass of water ran swiftly, it divided, spreading out like a fan over [a] shelving mass of rock. . . . The view from below was very pretty, but would be still better with about half the quantity of water." Hill's use of the name Shelving Rock Falls seems to suggest the same kind of generic quality as *The Island Pines* or *The Island Stones:* waterfalls flowing over broad shelving masses of rock are as characteristic of the Adirondacks as pine-covered rocky islands. Seneca Ray Stoddard recommended Shelving Rock Falls as one of the chief beauty spots of Lake George in the 1873 edition of his guidebook.[28] It is tempting to imagine that the name was first used by Hill and later popularized by Stoddard in his guidebooks, but the name already was associated with the waterfall, the mountain behind it, and the bay into which the waterfall tumbles in Benjamin Franklin da Costa's 1868 guide-

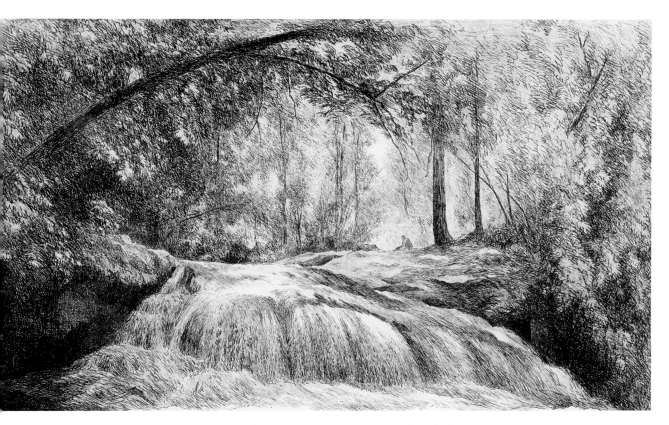

6.7. John Henry Hill, *Upper Cascades of Shelving Rock*. Etching. The Adirondack Museum 57.132.7.

book, where the site is recommended as "one of the most charming spots on the lake for a picnic."[29] In Nelson's *Guide to Lake George and Lake Champlain,* also published in 1868, Shelving Rock was described as "a bold semicircle of pallisades, famed for its dens of rattlesnakes and its good fishing."[30]

It was autumn before Hill began work on the etching of the view that he first admired in the spring. On October 19, he "laid a ground on two plates and partially etched subject upper cascades of shelving rock. Forgot to reverse it, but it is of little consequence as few would notice the difference." The prints pulled from a copperplate are, of course, mirror images of the design as it is etched on the plate, so Hill's error meant that his view of the waterfall would appear backwards. The refer-

ence to two plates is intriguing. Perhaps one was to be of Shelving Rock Falls and the other of a different subject. On October 20, however, Hill stated that he "finished first etching of above subject [Shelving Rock Falls]," suggesting that both plates were of the waterfall. Hill continued with a long discussion of his etching technique:

> I think it is the best plan to etch the darker lines first, then, if the acid on the plate 35 min. will make them strong enough, apply it say 20 min., then etch the lighter lines and apply 10 min. and then the faintest and apply 5 min. This plan has some advantages over the more common one of stopping out, the principal is that you have dark and light lines crossing each other. By combining both methods and applying the acid three times, you could have lines of six different degrees of strength.

Hill was still experimenting in December. On December 5, his diary reads: "Cold again. Worked on Shelving Rock cascade with drypoint and rolett [*sic*] to get more depth of color, took some impressions." It may be that Hill had difficulty with the portrayal of the cascading water and actually experimented on two different plates. The finished version is one of Hill's most complex and successful etchings. One wonders what became of earlier states and the alternate version. Although Hill reworked the plate in December, the impressions of Shelving Rock Falls in the New York Public Library and the Adirondack Museum are both dated October 1871.

The etching *The Island Stones* shows the "view from a small rocky inlet looking South towards Dome Island."[31] Hill first sketched the subject in his diary on April 22. He was apparently on his way back to Phantom Island from Bolton Landing when he made this sketch, and the small rocky inlet is probably on the west shore of the lake, not on one of the islands in the Narrows. Hill further mentions that he sketched the subject "on canvas 30 x 42 in."—and again, on April 27: "A rainy day. Painted on subject Island Stones." In other words, an oil painting of *The Island Stones* preceded the etching of the same subject. Exactly the reverse was true in the case of *The Island Pines*. For other Lake George views, no known paintings or watercolors correspond to the etchings. The last mention of *The Island Stones* occurs on November 21: "Worked on etching of island stones." The date on the etching in the New York Public Library is November 1871.

Hill's final etching of 1871 was a map of the Narrows, based on a survey that he made with the help of his brother George in February.[32] As usual, the etching itself was executed months later, in November.[33] Nearly all of the sites that Hill portrayed in his 1871 etchings fall within the area of the map, and many of them are identified on it: Big Island, Caldwell Island, Gravelly and Watch

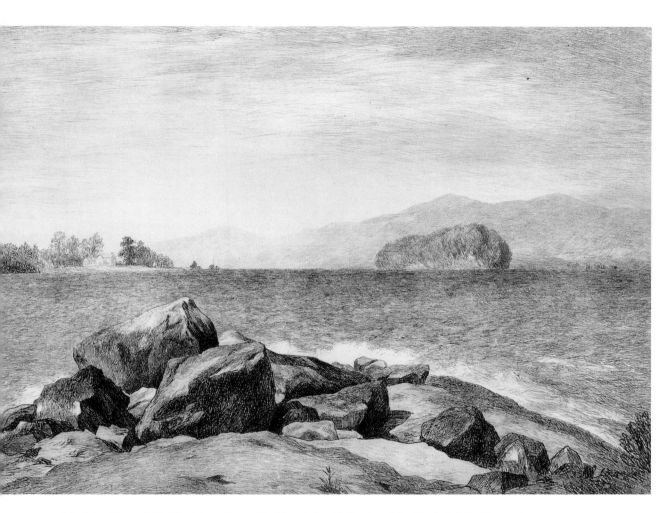

6.8. John Henry Hill, *The Island Stones.* Etching. Print Collection, New York Public Library, Astor, Lenox and Tilden Foundation.

6.9. John Henry Hill, "The Island Stones." Pencil drawing in diary. The Adirondack Museum.

Islands. Only Phantom Island itself is unidentified, perhaps a reflection of Hill's desire for privacy: it is one of the little cluster of small, unmarked islands between Gravelly and Fourteen Mile Islands. Big Island is today known as Big Burnt Island, Caldwell Island as Ranger Island.[34] Among the vignettes surrounding the map it is possible to recognize *The Island Pines, Study on Lake George,* and *The Island Stones.* The middle composition on the left closely resembles the watercolor in the Adirondack Museum that has always been associated with *The Island Pines* (p. 115). The remaining vignettes, the two clusters of pine cones at the lower left and lower right, and the three views across

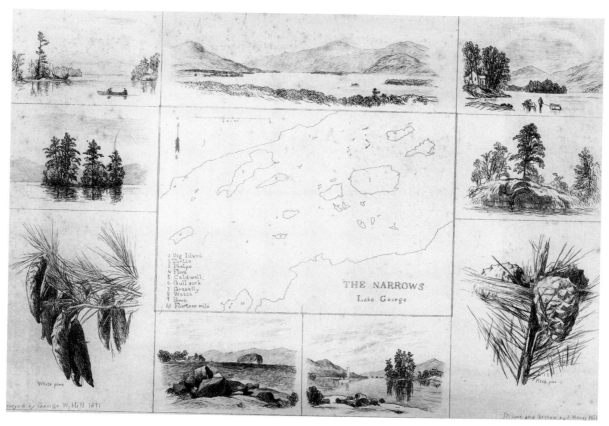

6.10. John Henry Hill, *The Narrows Lake George*. George W. Hill, surveyor. 1871. Etching. The Adirondack Museum 57.132.6.

the top, apparently were never reproduced as separate etchings. The right-hand vignette shows Hill hauling his "hand sleigh" across the ice; the left-hand vignette shows two men in a boat (Hill and his brother George?) among the islands, and the central vignette is a distant view of the Narrows from the south.

As far as it is possible to judge from his diary, 1871 was Hill's most productive year on Phantom Island. In 1872 he produced only one etching, a *View from Bolton, Lake George*. This may reproduce the view that Hill admired on October 22, 1872: "Rowed over to Bolton . . . from the schoolhouse

on the hillside is a fine view over the lake." The figure with a fishing pole may be a self-portrait. The little dog may be the one that Seneca Ray Stoddard described in his guidebook: "even his [Hill's] dog seemed to pine for company and left his master." The dog's true fate may have been grimmer, however; Hill's diary strongly suggests that poor Prince, a "rough shaggy cur" whom Hill acquired on October 30, slipped from an icy slope during a winter walk and was never seen again.[35]

Hill made at least two trips up the lake during 1872, one in June and one in September, stopping and sketching at Sabbath Day Point and Fort Ticonderoga. At Ticonderoga, on September 18, he specifically described beginning a sketch in watercolor twelve by eighteen inches. It is notable that Hill was working out-of-doors in watercolor on such a scale and may reflect the influence of Ruskin and the British pre-Raphaelites. More than a year passed before Hill made etchings based on these drawings. On November 28, 1873, he reported that he "bit in the etchings Sabbath Day Point and Fort Ticonderoga." On December 11, he "took first impressions from etchings of Sabbath Day Point & Fort Ticonderoga, worked on watercolor drawing 12 x 18 in. of the fort," and on December 13, "finished drawing of the fort." If this is the watercolor drawing begun on September 18, 1872, this is a remarkable example of Hill's custom of working on a single subject over a prolonged period of time. On January 3–4, 1874, Hill again "worked on the etching of Fort Ticonderoga, scratching in the delicate tints with dry point, [and] printed a few impressions." Since Hill had already printed a few impressions of *Fort Ticonderoga* on December 11, there must have been at least two separate states of this print, before and after the addition of the lines in drypoint. Unfortunately, I have been unable to locate either state of this print.

Only in these later views of Fort Ticonderoga and Sabbath Day Point did Hill make any concession to popular taste; perhaps he hoped such subjects would find a ready market with the ever-increasing numbers of tourists who were visiting Lake George. If so, he was evidently disappointed, for judging from the notes in the back of his diary neither his early "pre-Raphaelite" etchings nor his later more popular views seem to have sold very well. However, this dearth of sales may have been as much due to Hill's reclusive nature and very unaggressive marketing techniques as to the success or failure of the etchings themselves to satisfy the taste of local visitors. In any case, it is likely that he printed only a few impressions of each print. In his diary, Hill lists a total of six sets of etchings sold. His notes for the individual etchings are more difficult to decipher, but it appears that he sold twenty-four impressions of the Map of the Narrows (p. 121), six impressions of *The Island Pines* (p. 114), three impressions of Shelving Rock Falls (p. 117), three impressions of *The Island Stones* (p. 119), and two each of *Black Mountain from Caldwell Island* (p. 113), *Fort Ticonderoga, Crossing the River at Farmington,* and *The White Mountains from Gorham, N.H.* No individual impressions of *Study on Lake*

George (Rocks on Big Island) or *View from Bolton* were listed as sold, and *Sabbath Day Point* does not even appear on the list, perhaps suggesting that it was never completed to the artist's satisfaction.

Hill's last years on Phantom Island are less fully documented and appear to have been rather sad. His Lake George diary ends on March 25, 1874; later entries are less frequent and less extensive than earlier ones. It appears that his eccentricities and antisocial behavior became more pronounced as time went on. Stoddard's guidebook, with its highly colored description of his meeting with Hill and a map showing the location of "The Hermit" on Phantom Island, was first published in 1875 and may have been a contributing factor. The slight increase in the sale of the etchings in 1875, recorded in Hill's diary, may be due to Stoddard's publicity of the "Hermit" and his activities.

By 1876 or 1877, however, the unwonted attention proved too much for the reclusive artist. He suffered temporary insanity and was removed to an asylum.[36] The most sensational account, which suggests that Hill has become something of a local legend, appeared as recently as 1989:

> In 1870, an eccentric old artist moved onto [Phantom Island] to get away from other people. The vacation trade on the lake, however, was rapidly developing and tourists daily passed the little island. It is said the artist would shout and shake his fist at the visitors and was soon classified as a menace. Constables were sent to the island to pick up the fellow but could not find him. When the constables returned empty-handed, reports of the artist's tirades surfaced again. It was almost as if he possessed phantom powers. The artist was eventually captured when two constables hid on shore while their boat was driven off by a colleague. Hearing the boat leave, the old artist emerged from his hiding place and was taken into custody.[37]

Although part of this story—the artist's mysterious disappearances "as if he possessed phantom powers"—was obviously concocted long after the fact, presumably in explanation of the name of the island, the basic fact that Hill suffered some form of mental breakdown while on the island seems beyond dispute.

Happily, the story does not end here. Following a second trip to Europe in 1878–79, Hill returned to his family home in Nyack, New York. There, in 1880, he was contacted by Sylvester Koehler, who was in the process of founding a new journal, *The American Art Review*. Koehler recognized Hill's importance as a major figure in the American pre-Raphaelite movement and as one of the precursors of the etching revival. An article by Koehler on Hill's work appeared in the first volume of the review and was later reprinted in *American Etchings: A Collection of Twenty Original*

Etchings by Moran, Parrish, Ferris, Smillie and Others (Boston: Estes and Lauriat, 1886). With Koehler's encouragement, Hill resumed making etchings, having abandoned the technique following his departure from Phantom Island. In these later prints, he experimented with different inks and papers and different ways of wiping the plates to produce elaborate tonal effects, in sharp contrast to his early, cleanly printed pre-Raphaelite works. He also reprinted some of his earlier etchings, including *Crossing the River at Farmington,* one of the prints he made while at Lake George, in this elaborate tonal style. He does not appear to have reprinted any of his Lake George views at this time, however, and only one of his Lake George views, *Black Mountain from Caldwell Island,* was included in the list of his "most important etchings" published by Koehler in 1880. His extensive correspondence with Koehler contains no reference to his experiences at Lake George. In the 1880s and 1890s, nearly all of Hill's work appears to have been reproductive. A number of his etchings after the designs of other artists were published by Christian Klackner in signed, limited editions calculated to appeal to collectors.

Hill lived on in Nyack until 1922. His antisocial tendencies came out again in his old age; neighbors remembered him as "a shy and eccentric recluse who chased children out of his apple orchard."[38] He died at the age of eighty-three and is buried beside his father and grandfather in the Old Dutch Cemetery in West Nyack.

Winslow Homer's Adirondack Prints

DAVID TATHAM

WINSLOW HOMER'S association with the Adirondacks spanned four decades. He first traveled to the region in 1870, when he was thirty-four and a leading American painter of the younger generation. He made his last visit in 1910 when he was seventy-four, three months before his death at Prout's Neck in Maine, by which time he had become a revered American master. In all, he journeyed to the Adirondacks on at least twenty-one separate occasions, always to fish, to enjoy good company, to partake of the region's bracing cuisine, and sometimes also to draw and paint. From his visits came a dozen oil paintings, more than a hundred watercolors, a few drawings, and six prints—five wood engravings and a single etching. The prints tell much about both Homer and the Adirondacks, but, as we will see, they tell somewhat different things than do his paintings.[1]

Though normally a peripatetic artist in his travels elsewhere, Homer tended to stay put when he was in the Adirondacks. In the course of forty-one years he is known to have spent time in only two locations, both in Essex County. He stayed in and around the village of Keene Valley, then known by the less alluring name of Keene Flats, in 1870, 1874, and 1877. In 1870 and 1874, and perhaps 1877 as well, he went also to a boarding house in a remote forest clearing in the town of Minerva. Minerva was about thirty-five miles southwest of Keene Valley, but much wilderness separated the two places. By road, they were about one hundred miles apart.[2]

Of the two locales Homer visited in the 1870s, Keene Valley, nestled in the High Peaks, was the livelier place. By 1870 it had already become a summer community with a real sense of village life. In 1874, and probably also in 1877, Homer stayed at Widow Beede's Cottage just south of the village, in St. Hubert's. This modest, purpose-built, summer inn stood on land near to the present-day Ausable Club. Among the several other artists who resided in or passed through Keene Valley in the summer of 1874 were J. Francis Murphy, Roswell Shurtleff, Calvin Rae Smith, and Kruseman van

Elten, all of whom appear with Homer, two women, and a boy in a photograph taken on the bank of the East Branch of the Ausable River.[3] If Homer produced any work in Keene Valley that summer, there is no record of it, but his return to the village and its environs three years later, in 1877, had very different results. It brought forth three important paintings: *The Two Guides, In the Mountains,* and *Campfire.* These oils, which rank among his strongest works of the mid-1870s, depict visitors to the wilderness—women hikers and sportsmen campers—and those who cared for them—guides—but they show little of the routine life of those who resided in the region. No prints or watercolors came from any of Homer's visits to Keene Valley.

His visits to Minerva in the 1870s were more productive. In 1870 his first stay at the clearing resulted in his first Adirondack oil, *The Trapper, Adirondack Lake.* This work, which depicts a solitary woodsman standing on a partly submerged log at the edge of a lake, differed from the three he later painted in Keene Valley by taking as its subject a local activity unrelated to tourist life. From Minerva in the 1870s came further oils, some early watercolors, and five of his Adirondack prints.[4]

These five prints constitute an important contribution to the history of Adirondack graphic art. Prints by others dealt almost exclusively with the landscape and with tourist and sporting life. Homer's depicted a different life, that of people who, like his painted trapper, lived and worked within the great forest. He approached his subjects directly and unsentimentally, and this has made these prints seem transparently truthful as historical documents, though it is clear that he, like all master artists, edited and rearranged nature's details to improve on the truth.

The five prints are wood engravings machine-printed from steel-faced electrotypes and published as pages in large-circulation pictorial magazines. For each print Homer drew the image on the surface of a wood block. A master wood engraver and his team of assistants then cut the block, following Homer's lines faithfully. Once electrotypes had been made from the wood block's engraved surface and fitted to cylinders, high speed presses within a day or two printed between fifty thousand and one hundred and fifty thousand impressions, all in black ink on white paper. These magazine pages are not fine or "original" prints, but the images represent precisely what Homer intended.

In the thirteen years before his first trip to the Adirondacks, Homer had drawn more than two hundred subjects on wood blocks for pictorial magazines.[5] Nearly all of them were subjects of his own devising, and not illustrations for authors' texts. This independence, coupled with his strong sense of design and his powers as a draughtsman, had made him by the end of the Civil War one of his era's most distinctive and original graphic artists. Concurrently, he had begun (in 1862) to establish himself as a painter. He addressed the viewers of his magazine work rather differently, however, than he did the viewers of his paintings. His magazine work includes a greater quotient of anecdote

and story-telling detail than does his work on canvas. He designed his magazine pages to accomplish in black and white much of what he achieved through color in his paintings.

Of all the drawings he made for magazines, his five Adirondack subjects are among the most carefully composed. Four of them are original in concept and have no counterpart in his painted works. All five reflect Homer's intense interest in a new (to him) world of Adirondack wilderness, not as he had come to know it in the more cultivated milieu of Keene Valley but rather as he observed it in the simpler life of the clearing at Minerva.

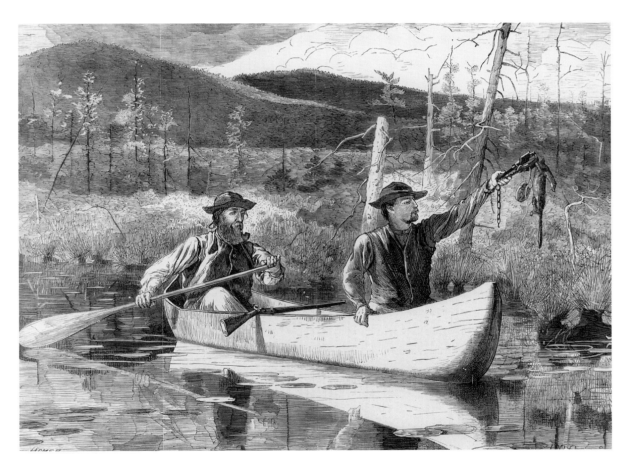

7.1. "Trapping in the Adirondacks," 1870. Wood engraving by J. P. Davis after a wood block drawing by Winslow Homer, 8 ¾x 11½". Published in *Every Saturday* (Dec. 4, 1870). The Adirondack Museum 94.28.9.

That life revolved around the log farm house at which Homer boarded. It was managed by its owner, Eunice Baker, a widow, and her two daughters. They farmed with the help of a few hired hands on land cleared from their forest tract of five thousand acres. Several ponds lay within a mile or two of the house. The Hudson River, which in summer was often little more than a rocky stream, ran just west of the tract. A road connected the clearing to the village of Minerva, nine miles distant. North Creek, nine miles beyond Minerva, offered the closest rail connection.[6]

In the 1870s Eunice Baker's hired hands doubled as guides for those of the Bakers' boarders who ventured out to fish, hunt, or camp. Two of them appear in Homer's first pictorial report from the region, *Trapping in the Adirondacks*. A letter from the painter Eliphalet Terry, who, like Homer, was an avid fisherman, to one of Mrs. Baker's daughters makes it clear that the figure with the paddle is Rufus Wallace and the man in the bow is Charles Lancaster. Lancaster holds on high a trap and its catch, a mink; this is an allusion to the body of water (Mink Pond) on which the boat glides. Wallace carries in his mouth a meerschaum pipe, undoubtedly the very one that a few months earlier he had asked Terry to obtain for him in New York and which Homer may possibly have delivered. Homer took the trouble to include the pipe in other depictions of Wallace, among them the watercolor of 1874, *Trappers Resting*.[7]

Wallace posed for Homer season after season, probably at the usual guiding wage of twenty-five cents an hour. White-bearded by 1889, he appears in several of Homer's later Adirondack watercolors. Homer evidently considered this guide a friend as well as a model. Wallace once owned the 1894 watercolor *Hunting Dog among Dead Trees*, presumably having received it from the artist as a gift.[8] Indeed, it is a measure of Homer's good feeling about life at the clearing that he presented other watercolors to friends there.

None of the sketches that Homer made in the field for this print seem to have survived. Following the standard practice of the time, the team of wood engravers destroyed the drawing he had made on the block as they cut through it. But his elaboration of reflections on the pond's surface and his rendering of closely observed detail in the landscape testify that he invested much time in preparing the drawing.

Trapping reached publication in the Boston pictorial weekly *Every Saturday* in December 1870. His next two prints, both published in the same journal in January 1871, make it clear that Homer had remained at the Baker farm into snow season, probably well into November. In the first of these, *Deer-Stalking in the Adirondacks in Winter*, two hunters on pickerel snowshoes pursue a deer. The crusted snow allows their hound to bound effortlessly over the drifts into which their prey sinks. The men's dress shows them to be local hunters; they are without a doubt guides from the Baker

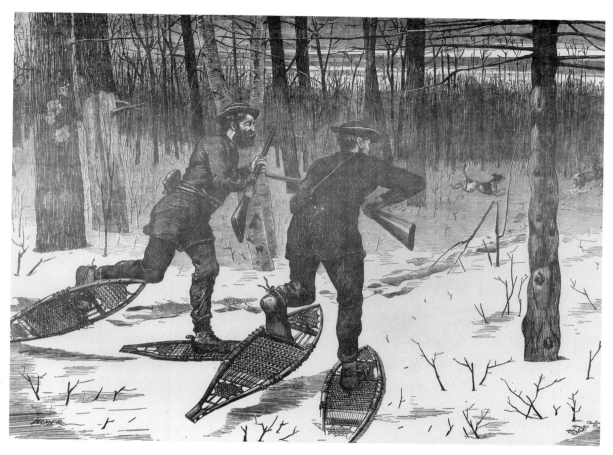

7.2. "Deer-Stalking in the Adirondacks in Winter," 1871. Wood engraving after a wood block drawing by Winslow Homer, 8¾ x 11¾". Published in *Every Saturday* (Jan. 21, 1871). The Adirondack Museum 66.112.3.

farm. Wallace is on the left; Lancaster may be the other figure. Sportsmen hunters of the 1870s would have attired themselves in more finely cut and tailored sporting apparel than we see here. *Deer-Stalking* is an anecdotal subject, showing part of the drama of a hunt in progress. As in his earlier print, *Trapping,* Homer included enough narrative elements to allow viewers to construct a story, or at least an incident, around them.

In *Lumbering in Winter* the last two words of the title are superfluous, for Adirondack logging oc-

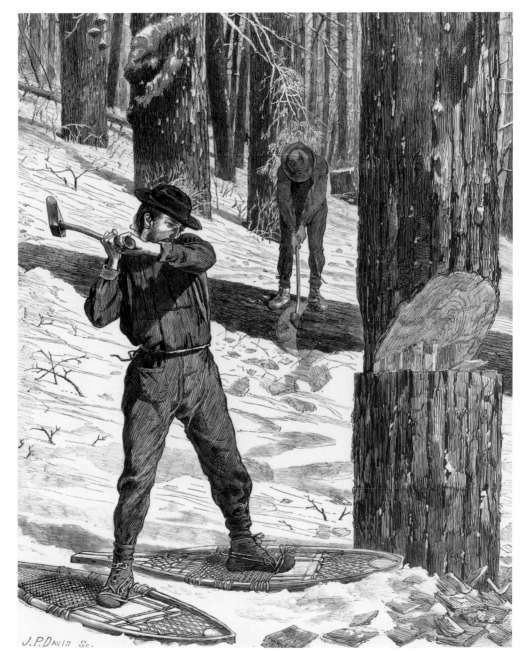

7.3. "Lumbering in Winter," 1871. Wood engraving by J. P. Davis after a wood block drawing by Winslow Homer, 11½ x 8¾". Published in *Every Saturday* (Jan. 28, 1871). The Adirondack Museum 66.112.2.

J.P.DAVIS Sc.

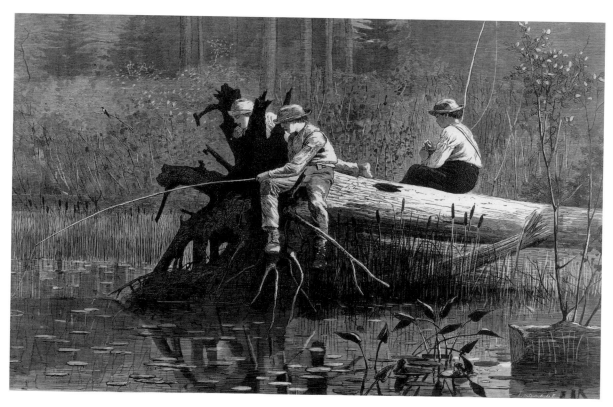

7.4. "Waiting for a Bite," 1874. Wood engraving by Lagarde after a wood block drawing by Winslow Homer, 9¼ x 13¾". Published in *Harper's Weekly* (Aug. 22, 1874). The Adirondack Museum 94.28.11.

curred in no other season. Homer probably records the felling of trees by the Bakers' hired hands for use on their farm. If the more distant of the two axemen seems oddly oblivious to the danger of a tree about to fall, we should perhaps assume that Homer has telescoped time to show two moments in the activity of a single person. The compositional structure of this print gives it a strength that suits its subject. In its design it follows the system of the Golden Proportion, superimposing on it an arc of trunks to lead the eye into the background.

Four years later, in 1874, Homer's visit to the clearing resulted in two wood engravings. The first of these, *Waiting for a Bite,* published in *Harper's Weekly* in August, is one of three variants of a

single composition. The other two, also dated 1874, are an oil of the same title and a watercolor also called *Waiting for a Bite* but originally titled *Why Don't the Suckers Bite?* A tradition holds that Homer found the fallen tree that appears in all three works near the Mink Pond inlet, and that remnants of its roots survived well into the twentieth century. But Homer, like any able artist, never hesitated to rearrange the facts of the natural world to achieve a better composition. He may have taken the tree from that site, but in his three treatments of it he used two quite different backgrounds. The wood-engraved version, like the watercolor, has a background of dense forest. The oil version of the subject has an open landscape of stumps, scrub, and burned trees taken from his watercolor of 1874, *Lake Shore*.[9]

The oil version of *Waiting for a Bite,* begun at the same site but perhaps completed in Homer's studio in New York, includes two figures. The print, like the watercolor version of the subject, contains three. For his popular audience he added to his wood block drawing at lower right a pair of frogs seated on lily pads beneath a bower of pickerel weed. They watch the boys who watch for fish. A red-winged blackbird perches on a bough in the background at left; this is a homey touch unseen in the oil.

The boys' sapling rods and string line are a far cry from the sport fisherman's equipage in Homer's last Adirondack wood engraving, *Camping Out in the Adirondack Mountains,* which was published in *Harper's Weekly* in November 1874. The fisherman is unseen; he seems to have excused himself from the picture-making session, leaving behind two guides. The missing fisherman is, of course, Homer, who was not shy so much as he was following his already established principle of using as figures in his Minerva works persons who seemed naturally at home in the forest—people who had a oneness with the wilderness. Later, in his only Adirondack etching, he made an exception to this rule when he depicted a sportsman in a fishing costume that contrasts sharply with the dress of the guides in *Camping Out.*

In *Camping Out* Wallace sits at the opening of the lean-to. To his right hangs a long-handled landing net. Closer to the other guide rests a wickerwork creel. Upright between the net and the creel in a cylindrical fabric case stands a disassembled, sectioned, split-bamboo fly casting rod, recently used, it is fair to assume, to catch the string of trout arrayed on the ground near the birchbark canoe. Beaver Mountain, rising over Mink Pond, supports the tradition that Homer drew this scene on one of the islands in that lake, less than a mile from the Bakers' house. He used this mountain as part of the background in some two dozen of his oils and watercolors, modifying its shape to suit the needs of his compositions.

Homer's absence from the Adirondacks between 1877 and 1889 was occasioned in part by his

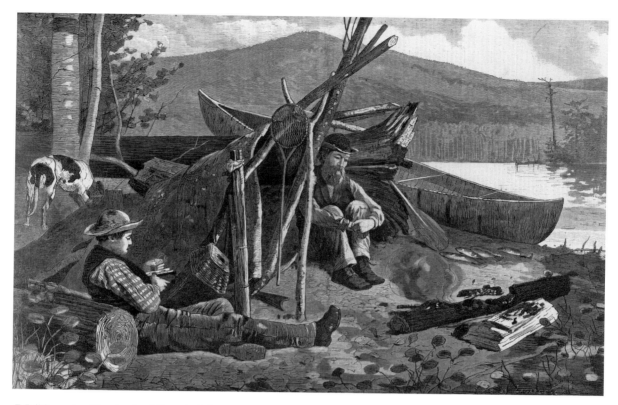

7.5. "Camping Out in the Adirondack Mountains," 1874. Wood engraving by Lagarde after a wood block drawing by Winslow Homer, 9¼ x 13¾". Published in *Harper's Weekly* (Nov. 7, 1874). The Adirondack Museum 83.62.1.

travels to new locations in search of new subjects and different conditions of light. He spent summers in such different places as Gloucester Harbor in Massachusetts, Mountainville near West Point in the lower Hudson Valley, Cullercoats on the northeast coast of England, and Prout's Neck on the coast of Maine, where in 1884 he settled into the Spartan quarters of his new home and studio. Then, in 1888, he joined the two-year-old Adirondack Preserve Association, a sporting club that had purchased the Baker property in Minerva. (The often-repeated claim of his first biographer that he was a charter member of the club is erroneous.) The following year, at age fifty-three, he returned to the clearing for the first time in a dozen or so years. There he met old friends and made new ones.

Eunice Baker, retired from the farm, lived near Minerva. Her daughter and son-in-law, Jennie and Robert Bibby, who would work for the club for many years as superintendent, were nearby. In time Bibby, too, received a watercolor from Homer.[10] In 1895 the Adirondack Preserve Association changed its name to the North Woods Club.

As early as the late 1880s the club's members brought their families to the clearing with them, and it is perhaps useful to note, in view of Homer's not entirely fair reputation as a social recluse and even as a misanthrope, that from the Bakers to the present, women and children have been as much a part of life at the clearing as men.[11] As late as the 1950s older members recalled having carried Homer's paint box for him when they were children. In the club's minute book, soon after his death, he was recalled as having possessed a "singularly simple, kindly, courteous and gentle nature."[12] He seems to have valued the club not only because he found good friends there but also because its members adhered to the Adirondack ideal of a simple life lived close to wild nature. In standing apart from the pace and trappings of resort life, they perpetuated the unpretentious spirit of the Bakers' original boarding house.

During the years immediately preceding his return to the clearing, Homer had worked intensely at Prout's Neck as an etcher. He was to some extent responding to the heightened interest among artists and collectors in etching as a fine art, an interest that had arisen in America in the 1870s and would peak in the 1880s. But Homer was by no means a typical American painter-etcher of his time. The etching movement prized original subjects rendered directly from nature onto a copperplate, small in scale, quiet in mood, delicate and subtle in execution. The great model for American etchers was Whistler's widely admired work in the medium. Whistlerian aestheticism influenced the movement deeply and encouraged etchers to direct their work to a small, sophisticated audience of connoisseurs. Homer subscribed to none of this. Rather than etching original subjects taken from nature, he reproduced his recent oils and watercolors. Instead of choosing the quiet subjects typically favored in the etching movement, most of those he selected were highly dramatic. He executed them powerfully on a large scale, aiming not at connoisseurs alone but also at a more general art-interested audience. His relation to the etching movement of the 1880s was akin to that of a fly fisherman laden with tackle and catch who joins a fancy dress tea party.[13]

The sale of Homer's etchings in the late 1880s had been disappointing, as, indeed, had been the sale of his paintings during the same years. His return to the clearing in 1889 reinvigorated him, however, and between early May and late November, in two separate visits, he spent just short of eleven weeks at the club. He painted at least three dozen watercolors. One of these was a monochromatic wash drawing, *Netting the Fish,* showing a properly dressed young sportsman in a guide-

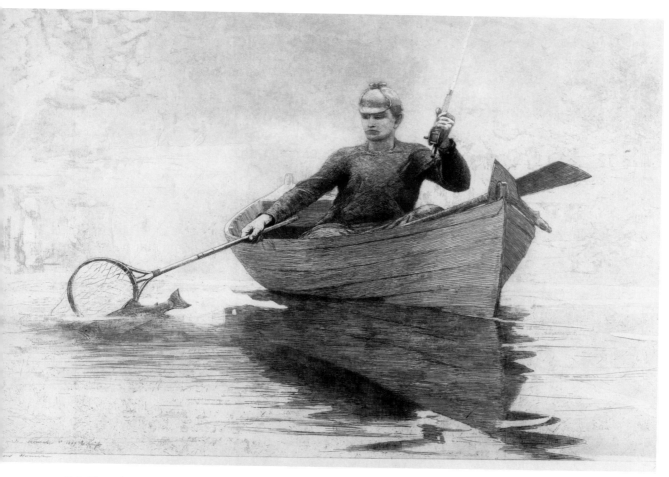

7.6. *Fly Fishing, Saranac Lake, 1889*. Etching by Winslow Homer, 17½ x 22⅝". Photo courtesy Museum of Fine Arts, Boston. The Adirondack Museum 76.217.1.

boat about to use his long-handled net to land the trout he has hooked with a state-of-the-art cast-ing rod and reel.[14] Homer seems to have painted this watercolor as the basis for an etching. He completed the plate at Prout's Neck and shipped it to his printer in New York. He titled it *Fly Fishing, Saranac Lake*. This title is almost certainly a misnomer. There is no reason to suppose that

Homer journeyed away from the club's ponds to paint *Netting the Fish*. He is not known ever to have been to Saranac Lake, a favorite summering spot for many, but its name was much more likely than Mink Pond to register with Adirondack aficionados and print purchasers.

With this print Homer for the first time made important use of aquatint. He achieved through it in the background of the print something of the freedom and texture that distinguish the watercolors he painted at the club in the same year. It is an exceptional print, even though the fisherman seems a little too rigid, too unconforming to our expectations of what a fisherman playing a fish from a boat ought to look like, an expectation formed in no small part from Homer's Adirondack watercolors. Despite his masterful work on the plate, *Fly Fishing,* like his other etchings, did not sell well. Of a presumed one hundred numbered impressions in the edition, fewer than thirty have been located.

A different success ameliorated the failure of *Fly Fishing.* When in February 1890 Homer's dealer in New York exhibited thirty-two of the watercolors he had painted at the club the previous summer, critics acclaimed them. Twenty-seven sold immediately. Probably as a result of this turn in his fortunes, Homer resumed painting in oils and, remaining at Prout's Neck all summer, completed six major marine subjects. When his dealer exhibited four of them in New York early in 1891, they elicited the highest critical praise Homer had yet received. One critic described them as "the four most powerful paintings that any man of our generation and people has painted." They were the work of, he continued, "a great American artist, in the full greatness of an art as truly American as its creator." Two of the paintings sold immediately. This turn of events kept Homer busy as a painter in oils and watercolor, and left him with no reason to persist as a printmaker.[15]

Beyond the six prints already mentioned, each undoubtedly an Adirondack subject, two other wood engravings drawn on the block by Homer have also been claimed as Adirondack works from the region. One, *A Quiet Day in the Woods,* published in *Appleton's Journal* in June 1870, may possibly depict a scene in Keene Valley, though the tourist season would hardly have been underway there by the time this print reached publication.[16] It can scarcely be from Minerva, for Homer did not make his first trip to the Baker farm until late summer. Nothing in the work identifies its locale, but one would like to know more about it, because it is an especially fine specimen of Homer's magazine work.

A year earlier, in 1869, he contributed to *Appleton's Journal* a drawing that the magazine titled *On the Road to Lake George.*[17] Although Homer may have visited Saratoga Springs in the summer of 1869, no evidence places him in Lake George. The print's title offers no help in locating the site or the route of the coach. Further, in the thinking of 1869, Lake George was a geographic entity distinct from the

neighboring Adirondacks. Tourists did not travel to Lake George to find a vast and pristine wilderness; then, as now, it had a different mystique. Wilderness lay beyond it, in the Adirondacks.

For Homer the attraction of wilderness never waned. Though he found another, wilder wilderness in Quebec, and still another one, more open and benign, in the waters of Florida and the Caribbean, it was to the clearing in the Adirondacks that he repeatedly returned. In June 1910, weakened by prolonged illness, he journeyed out of Maine for pleasure for the first time in a year and traveled to Minerva. He stayed at the club for a week. It was his last trip away from Prout's Neck. Within three months he was dead.[18]

Homer's Adirondack paintings are great works of art and have long been recognized as such. His Adirondack prints, masterful as they are within the context of popular graphics of his day, are lesser works by comparison. Still, they accomplish some things that he had no room for in his paintings. Only in the prints do we see trappers and hunters actively at work, loggers felling trees, and Homer telling stories through pictures in his ever-laconic way. Minor works by a great artist, they nonetheless enrich the graphic record of a region that, more than any other in nineteenth-century American art, brought wilderness to art, not only as a subject, but as a way of life.

"A Passion for Fishing and Tramping"
The Adirondacks Etched by Arpad G. Gerster, M.D.

CAROLINE MASTIN WELSH

> Etching is a domestic occupation which can be followed in town during odd hours;
> it can be interrupted at pleasure without inconvenience, and offers most refreshing
> diversion from the exhausting tension of busy professional life. Nothing in the
> world can make a man forget himself and his cares more quickly than the etcher's
> needle.[1]

SO WROTE New York City surgeon Dr. Arpad Geyza Gerster in 1917 of an art that he had learned in the late 1880s. A pioneering surgeon and diagnostician by profession, Dr. Gerster (1848–1923) was also a scholar, linguist, musician, artist, writer, and antiquarian. But above all, he loved the "great outdoors," and his "passion for fishing and tramping" led him to the Adirondacks for twenty-three summers beginning in 1883. An artist by avocation, Dr. Gerster's etchings add a fascinating dimension to the pictorial documentation of Adirondack people and places.

The etching revival of the 1870s was the first of a series of consciously "fine art" movements in American printmaking. Beginning in France in the 1850s, the art of etching was revived as it was practiced by Durer, Rembrandt, and other Great Masters in the sixteenth and seventeenth centuries. James Abbott McNeil Whistler was key to the revival in England, and his extraordinary prints inspired many American painters to create etchings of great subtlety and delicacy. The oeuvre of these painter-etchers, working from the 1870s into the 1890s, established a definite distinction between prints created as fine art and those that were made for the popular press or for commercial purposes.[2] More or less coincident with the availability of European etchings to American artists, a new, more intimate, vision of landscape was taking hold in America. Small, introspective scenes replaced broad,

8.1. Arpad Geyza Charles Gerster (1848–1923), self-portrait. 1894. 4⅞ x 3". The Adirondack Museum 67.67.6.

panoramic vistas. This approach was highly compatible with the size, scope, and versatility of the copperplate.

Arpad Geyza Charles Gerster was born on December 22, 1848, in Kassa, Hungary. Educated in public and private schools in Kassa, he went on to the University of Vienna, where he was awarded a degree in medicine in 1872. After a brief stint as an army surgeon, he decided to emigrate to the United States. He arrived in New York on March 9, 1874, having met his future wife, Anna Barnard Wynne of Cincinnati, on shipboard. He settled in Brooklyn and practiced general medicine for his first years in this country. His practice soon flourished, and he married Miss Wynne at her home in Cincinnati on December 14, 1875. Their only child, John C. A. Gerster, was born November 27, 1881.

Between 1878 and his retirement in 1914, Gerster practiced surgery and taught at Lenox Hill Hospital, Mount Sinai, New York Polyclinic, and the College of Physicians and Surgeons, Columbia University. An early proponent of aseptic surgery introduced by Lord Lister, Gerster was the first in America to publish a textbook, in 1888, on the new surgery. This revolutionary book, entitled *Rules of Aseptic and*

8.2. "The Duo,
Sept. 17, 1897."
Pen and ink. The
Adirondack
Museum.

Antiseptic Surgery, went through three editions in two years. The book was also distinguished by its early use of half-tone pictures, made from the author's own plates, and thus was a contribution to book-making as well as medicine. Among Gerster's many students were prominent physicians such as William J. and Charles H. Mayo. Dr. William Mayo wrote to Gerster on March 4, 1897: "My brother, Dr. C. H. Mayo, and myself have both been instructed by you in the N.Y. Polyclinic courses and the modest work we have done has been largely the result of your teachings and following the principles you have laid out in your book on 'Aseptic and Antiseptic Surgery.'"[3] In addition to his teaching and surgical practice, Dr. Gerster served as president of the American Surgical Association in 1911–12. This was then, as now, one of the highest honors to be bestowed on a physician by his peers.[4]

Successful in his medical practice, surgery, and teaching, Dr. Gerster also excelled at his many avocations. He read the literature of at least six modern languages. He and his family loved music; Gerster was accomplished on the violin, organ, and piano. His wife played the piano and his son, the violin, a fact that he captured in pen and ink in 1897. In addition to his textbook, he wrote clinical and historical papers and also an autobiography, *Recollections of a New York City Surgeon* (1917). And he was an avid outdoorsman. This Renaissance man demonstrated a profound love for the beautiful in nature, literature, music, and art and a keen interest in advances in science and the arts.

In his opinion, Dr. Gerster's preoccupation with literature, art, and music was not widely shared by his medical colleagues. He wrote in 1916:

> While battalions could be raised of physicians who play poker, pinochle, bridge,
> billiards and golf, neither tennis, horseback riding, yachting, fishing nor shooting
> would furnish more than a few companies. Music in its better forms could also sup-
> port a company or two. It is regrettable that literature, in the shape of reading, most
> accessible of all pastimes, does not attract many of us medical men. The fascinations
> of ancient and modern languages, of their literatures, of history and the natural sci-
> ences, have little attraction for the average physician. . . . No! Etching will not be-
> come like golf and cards, the favorite pastime of modern medical men.[5]

While art and art appreciation may have had few followers among Gerster's colleagues, there are known proclivities among medical practitioners for precise renderings of what they see. The physician's heightened powers of observation used for diagnosis are analogous to those of the artist used for visual transcriptions of what is seen and perceived. Dr. Gerster reminisced in 1916 that "the quality of the etched line had always attracted me. Its freedom . . . the peculiar roughish grain of the

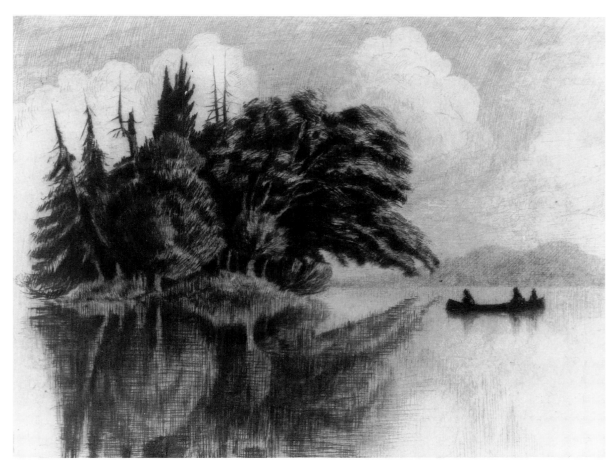

8.3. *A Northwoods Island,* 1894. 4⅜ x 5½". The Adirondack Museum 58.273.5.

edges of the line . . . the wonderful possibilities of the printing process brought out by a skillful com-
position of the shade of ink, a wise selection of color and grain of the paper and the discreet yet bold
use of retroussage."[6] Gerster exemplified his love of the etched line in a dry point etching called *A
Northwoods Island.* He describes it as follows: "The rich, velvety effect of the shadows is due to the
storing of the ink not only in the groove, dug out of the metal by the needle's point, but also in the

'beard.' This 'beard' is a raised 'embankment' of metal, displaced by the point of the needle to one side of the 'ditch' or groove dug by the tool."[7]

The artist-engraver James David Smillie and physician-etcher Dr. Leroy Milton Yale introduced Gerster to etching and taught him the art. On April 30, 1877, Smillie and Yale cofounded the New York Etching Club. Two other artists' clubs were also founded that year in New York City: the Society of American Artists and the Tile Club. They joined many other groups devoted to drawing, landscape, watercolor, and other artistic pursuits and afforded their members opportunities for ideas, information, technical advice, critiques, companionship, and, most important, a place to exhibit their work.[8] Smillie learned the technique of etching from his father, the well-known banknote engraver. He contributed greatly to the etching movement by teaching the art to his fellow artists and club members and by providing technical assistance. He promoted the art form through lectures to artists and the public and organized exhibitions that were often accompanied by catalogues.[9]

Dr. Yale was a friend and medical colleague of Arpad Gerster. He demonstrated the process of etching to Gerster when they met accidentally at an exhibition of the Etching Club in 1889 or 1890. Gerster described their encounter the next day:

> He [Dr. Yale] appeared at my home [56 East 25th Street] armed with a copper plate and the necessary paraphernalia for grounding, smoking, protecting the back of the plate, and for stopping out. When the plate had been properly prepared he bade his pupil draw in some design. It seemed almost a sacrilege to ruin with a bungling line the immaculate, soft velvety blackness of the freshly-smoked plate. Timidly the drawing was done, then followed the biting with nitric acid, and thus the elements of the process were reviewed. Next day young Henry Voigt [Kimmel & Voigt, printers, at 242 Canal Street], one of the best artistic printers who ever lived, drew the first proof. It was a genuine disappointment. Few first proofs can be otherwise.[10]

Dr. Gerster made the acquaintance of James David Smillie through their common interest in art. In addition, the two shared a love of the Adirondacks, where Smillie had been a frequent visitor since the 1860s. He and his brother George painted many scenes in and around Keene Valley, where James "owned the land at the upper end of the Valley, a hilltop under towering pines which [we] always called 'Smillie's hill.'"[11] According to Gerster's autobiography, a warm friendship developed between the two men and Smillie's "thoughtful advice infused [Gerster's] work with new interest." Gerster admired Smillie's "splendid" draughtsmanship, "marvelous" technique, and "exquisite" print-

ing.[12] He revealed Smillie's frustration and preoccupation with what Smillie perceived to be a failure at painting. "Smillie's gentle, melancholic patience in bearing his supposed artistic disappointments was touching. He was a slow, methodical, even pedantic man, with no trace of the Bohemian about him or his belongings. Everything in his studio was spick and span, and tools and materials were always in apple-pie order."[13]

Smillie was also a patient of Dr. Gerster's. In gratitude for surgery, Smillie presented his physician with "an etcher's press, which had been used both by his father and by himself, and a 'jigger'—the printer's work table—with all its subtle appointments."[14] He inscribed the gift: "To my friend Dr. A. G. Gerster 1906 Smillie his mark." The work table was designed to hold the whiting used in cleaning and polishing the copper plates prior to printing, and to hold rags for wiping ink from etched plates. Plates ready for treatment were placed on the top of the jigger.[15]

An avid sketcher, Dr. Gerster captured the scenery and his colleagues and friends with equal deftness in pencil. The drawings he made at the conference table during meetings with colleagues were much coveted. Mrs. Gerster, along with Dr. Yale and artists James David Smillie and the Swedish etcher Andres Zorn, can also be credited with encouraging her husband to take up the etcher's needle. However, Dr. Gerster was unfailingly modest. He wrote: "There is little to be said about my own etchings, for they amount to no more than most amateur's work. Proofs of one plate only were sold."[16]

Gerster's writings do not indicate that he had specific knowledge of contemporary art theory, criticism, or prevailing styles. His own style was realistic and documentary; his compositions simple and straightforward. Clearly, he responded to art and nature with great appreciation and sensitivity. The August 12, 1896, entry in his diary bears out his powers of observation and knowledge of art: "Passing Bluff Point [Raquette Lake] I realized that James D. Smillie's poetic etching of West Mountain must have been conceived from Bluff Point."[17]

In spite of Dr. Gerster's modest assessment of his own efforts, he left a collection of etchings numbering twenty-three, their copperplates, and nearly one hundred drawings in sketchbooks, as well as the etching jigger given to him by James David Smillie. These items, and the silk tent he took on his camping trips, were all donated to the Adirondack Museum in 1958 by his son Dr. John C. A. Gerster. The subjects of his works were the Adirondack lakes of Raquette and Long, and their inhabitants and environs. His etching *Dawn in the Adirondacks* dated September 10, 1892, captures the fleeting moments of the early morning mists rising over an Adirondack lake.

Thoreau and Emerson were Gerster's favorite American writers. It was through Thoreau's writings that Gerster was first introduced to the quiet inspiration of the forests. This love for nature and the outdoors manifested itself in "his passion for fishing and tramping," which Gerster enjoyed in

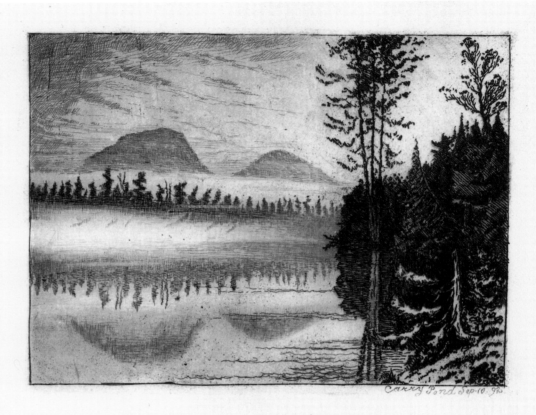

Carry Pond. Sep. 10. '92

Dawn in the Adirondacks.

Etched + printed by
Alpad G. Gerster

For Anna W. Gerster. New Year's 1893.

8.4. *Carry Pond. Sep. 10, '92, Dawn in the Adirondacks*, 1892. 4 x 5¼". The Adirondack Museum 58.273.9

Caroline Mastin Welsh

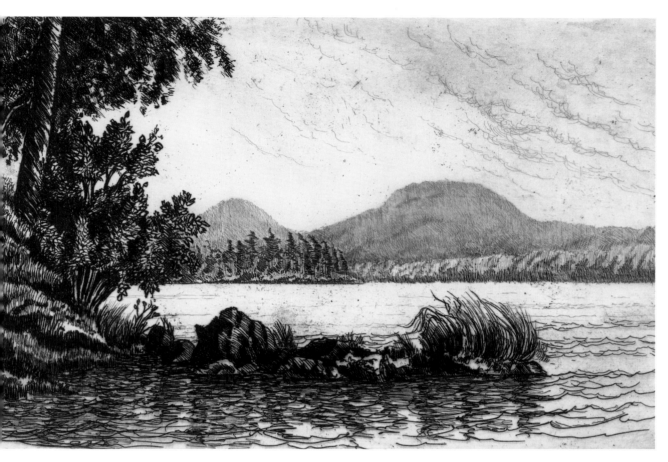

8.5. Lake and Mountains, n.d. 5½ x 8½". The Adirondack Museum 58.273.22.

both the Adirondacks and Canada. His informative diary, kept for the years 1895 to 1898, recorded primarily his life in the Adirondacks. It described and illustrated in pen and ink the people he met and his adventures and those of his family, often laced with philosophical and humorous observations. He also filled sketchbooks with pencil sketches, some of which he later translated into etchings. His love of the Adirondacks was not only documented by his verbal and visual transcriptions, it was also manifested by his membership in the Association for the Protection of the Adirondacks, founded in 1901, and by his service as a trustee for that organization in 1912.

Adirondacks Etched by Arpad Gerster

8.6. *Oteetiwi and Dandy Sept. 19, 1890.* 4⅞ x 5 ⁵⁄₁₆". The Adirondack Museum 58.273.17.

Dr. Gerster first came to Raquette Lake, "a gem of solitude in its unspoiled bloom of freshness,"[18] in 1883, for a brief visit at a hotel known as the Hemlocks. He discovered it through the proprietor, Ed Bennett, who was brought to Gerster's house in New York by a patient. The next year he and his family took a cabin near Bennett's hotel. The Gersters moved that autumn into a two-story camp on Big Island, across from Long Point. For the next twenty-two summers the Gerster family

lived in this camp, which he named Oteetiwi, "ever-ready" in the Iroquois language. Gerster depicted the camp in an etching called *Oteetiwi and Dandy* dated September 19, 1890.

In 1905 Dr. Gerster sold Oteetiwi to the sculptor Karl Bitter. In 1906, he moved to a camp on the west shore of Long Lake, where he had purchased ninety acres in 1904. Dr. Gerster recorded that among the attributes of this camp "was a splendid outlook to the northeastward of the serrated skyline of Mount Seward, twelve miles beyond a lacustrine foreground, diversified by a group of small wooded islands—a noble composition from the hands of the Master Artist himself. To the author this is the finest view in the North Woods."[19]

The central Adirondacks in the first half of the nineteenth century were considered inaccessible to the average person. It was not until the mid-1800s that artists and others arrived in the Adirondacks in any numbers. By 1850 most prominent artists had been to the Catskills and to the White Mountains and had exhibited paintings of these subjects at the National Academy of Design. These two mountain areas were more accessible to the artistic centers of New York, Albany, and Boston, while the more rugged terrain and greater distance of the Adirondacks made them less so. Improved transportation and greater knowledge about the region—partly gained through paintings and prints visualizing it—opened it to artists in greater and greater numbers after 1850. Print publishers recognized that the attraction of the region for artists was shared by the population at large, particularly city dwellers who yearned for simpler ways of life in the face of growing industrialization in urban centers.

Gerster, too, may have seen images of the Adirondacks before he saw the reality. In 1869 William Henry Harrison Murray published his guidebook *Adventures in the Wilderness*. Illustrated by Homer Dodge Martin and Harry Fenn, it was serialized in *Every Saturday* magazine and went through innumerable printings. This book characterized the region as a sportsman's paradise in such alluring terms that thousands began to "rush to the wilderness."

At this same time, Dr. Thomas Clark Durant, vice president and manager of the Union Pacific Railroad and owner of a large tract of land near Raquette Lake, was interested in opening up and developing the Adirondacks as a summer resort. In 1871 he completed a rail line from Saratoga Springs to North Creek. To get further west, visitors took the stage from there to Blue Mountain Lake, a steamboat through the Eckford Chain of Lakes to Durant's Marion River Carry railroad, and a boat to points on Raquette Lake. In later years, visitors could travel by rail from New York City to Utica, north to Thendara near Old Forge, then east on the Raquette Lake Railroad, thanks to Durant's son William West Durant and his associates. In 1890 Gerster recorded North Creek, a frequent stopping place for late nineteenth-century travelers, including Dr. Gerster, as an etching. In

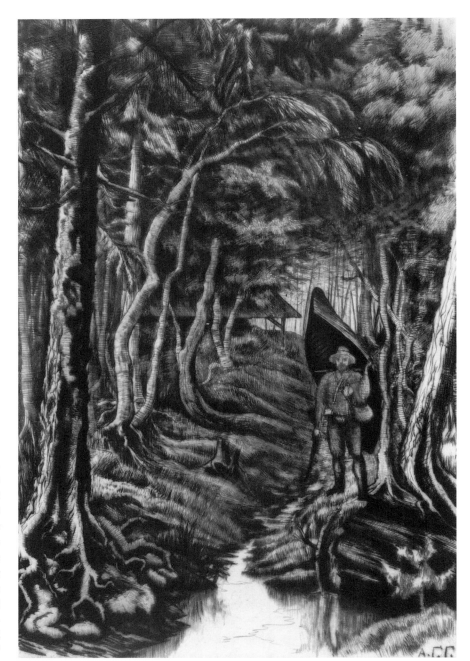

8.7. *The End of the Carry,*
1893. 8 ¹¹⁄₁₆ x 5¾". The
Adirondack Museum
58.273.1. Dr. Gerster's
grandson reported to
Sidney Whelan, who
has transcribed Gerster's
diary, that his grandfather
"wrecked an ankle" on
a carry in 1896 and
"madam" (as Gerster re-
ferred to his wife) forbid
any more "solo carries."

8.8. North Creek, 1890. 3¼ x 5⅞". The Adirondack Museum 58.273.23.

his diary Gerster quoted the guide Alvah Dunning who described the North Creek road as "'no more than a rabbit path,' over which could be drawn not more than 5–600 pounds of freight."[20]

William West Durant came to Raquette Lake as a young man with his family and spent many of his adult years building camps on and around the lake, generally promoting the properties and the region to wealthy friends and associates. In the late 1890s Durant and Dr. Gerster, who had become friends, built a hunting camp on Sumner Lake (now Lake Kora), described by Gerster as "a gem of wild beauty ... [with] a fine view of distant mountains."[21] Located to the south of Raquette and adjacent to lakes Shedd and Mohegan (now lakes Sagamore and Uncas), Gerster found the woods "alive with deer" and "Sumner [Lake] with trout."

Adirondacks Etched by Arpad Gerster

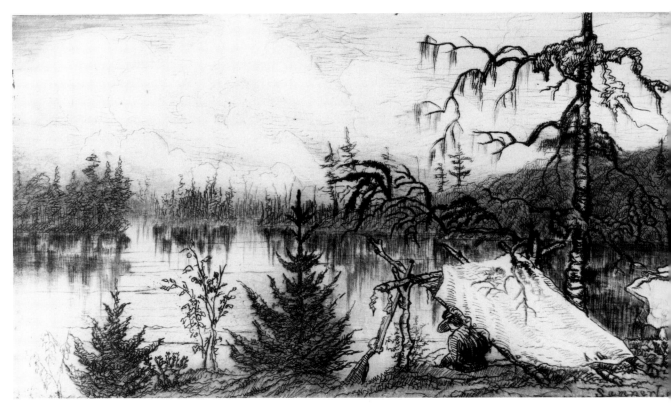

8.9. *Sumner Lake,* 1890. 3⅜ x 5⅞". The Adirondack Museum 58.273.18.

Dr. Gerster stated that he "never went out without paper and a short pencil with a rubber tip" in order to make rapid sketches of "fellow travellers" or favorite scenes. Gerster's talent as a portraitist captured details of physiognomy and personality that raise them above his more prosaic landscapes. Adirondack guides were a favorite subject. A keen observer of the passing scene, Dr. Gerster noted, in hindsight, in his autobiography, that "even in the eighties the Adirondack guide began to change his character. From a woodsman, he was turning into a mere machine for transportation, losing his woodcraft, his leisurely and knowing ways, and his aplomb."[22] This was not the case with the guides at Sumner Lake. Gerster described Wesley Bates as "one of the most pleasant guides I ever camped

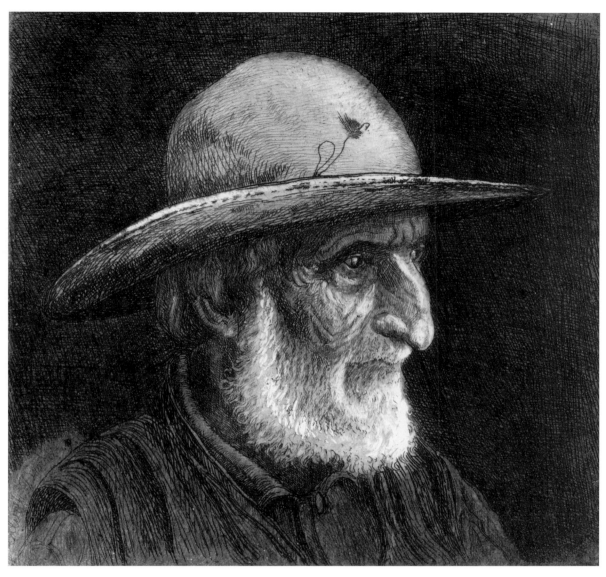

8.10. *Alvah Dunning,* 1892. 5½ x 5¹¹⁄₁₆".The Adirondack Museum 58.273.7.

with in the woods. Quiet, cheerful, of an even temperament, an excellent woodsman on foot and afloat, a good cook, a sound and honest boat builder . . . 'Wes' and Mike McGuire were our favorite guides on many a memorable hunt on Sumner Lake."[23]

Guide Alvah Dunning, according to Gerster, "was an excellent shot, a good fisherman and an all-round backwoodsman, as tough against heat, cold, wet, hunger and thirst, as the wild beasts he trapped and shot . . . a fierce enemy, but a staunch and true friend of those to whom he took a liking."[24] The only etching Dr. Gerster ever sold was made after a Seneca Ray Stoddard photograph of Dunning in order to raise enough money to replace Alvah's silver watch, which he lost on a fishing trip with Dr. Gerster while hauling a large trout into his boat on Eighth Lake. Dr. Gerster recalled:

> Twenty proofs were disposed of, netting the sum of $100. With this, a gold watch was bought at Benedict's, where the proprietor added (as his contribution) a super-gorgeous gold chain. At the Christmas celebration at [Durant's] Camp Pine Knot, Raquette Lake, the gift was placed in Alvah's palm by Mr. Durant. The old man toppled over in a dead faint. He soon revived, however, and lived to enjoy the use of his timepiece for many years.[25]

Alvah was a frequent subject for Gerster. He rendered him in pencil, in pen and ink, and sketched the interior and exterior of his camp on Raquette Lake, not too far from Oteetiwi.

During the 1880s the eyes of the medical community as well as the nation began to turn to the Adirondacks as news spread of Dr. Edward Livingston Trudeau's pioneering efforts in the sanatorium method for the treatment of tuberculosis. Gerster and his colleagues were undoubtedly familiar with his work. Colleagues and friends like Dr. Frederick Kammerer, a fellow practitioner in New York City, often visited the Gersters at Raquette Lake. Gerster made an etching, *Cozy Corner at Camp Oteetiwi,* as a souvenir for Dr. Kammerer, reminding him of happy vacation time in the Adirondacks.

Alfred L. Donaldson, a prominent New York City banker, was another friend who visited. Dr. Kammerer and Donaldson were members of a string quartet that performed once a month in the winter at the Gerster's New York City home.[26] Donaldson, afflicted with tuberculosis, moved to Saranac Lake to cure under the care of Dr. Trudeau in 1895. While there he researched and wrote his two-volume *History of the Adirondacks,* which was published in 1921. John Gerster described Donaldson as "handsome, intelligent, quiet, unassuming, and musical. Kammerer played the cello, Donaldson the violin—both were good amateurs."[27]

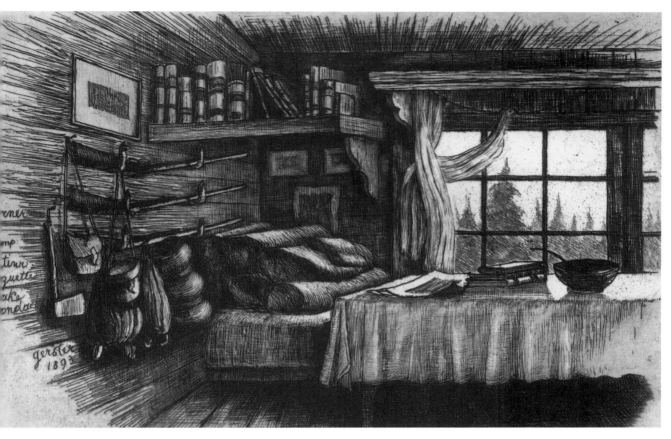

8.11. *Cozy Corner at Camp Oteetiwi Raquette Lake Adirondacks.* 1893. 5⅜ x 8¾". The Adirondack Museum 58.273.14.

Dr. Yale—Gerster's etching mentor—and his son Roy were also frequent visitors and ardent fishermen. In May 1897, Gerster's diary revealed that Yale "adorned the title page of our visitor's book with a fine pen and ink sketch, entertaining Madam and the boys with fish lore from Mepignon and the Grande Decharge of Lake St. John. We all like him very much on account of his kindly disposition and the mellowness, which is the birthright of the honest fisherman."[28] In addition to socializing and fishing, Dr. Gerster and his medical colleagues were frequently called upon to see and treat residents and summer visitors to Raquette Lake and its environs.[29]

Adirondacks Etched by Arpad Gerster

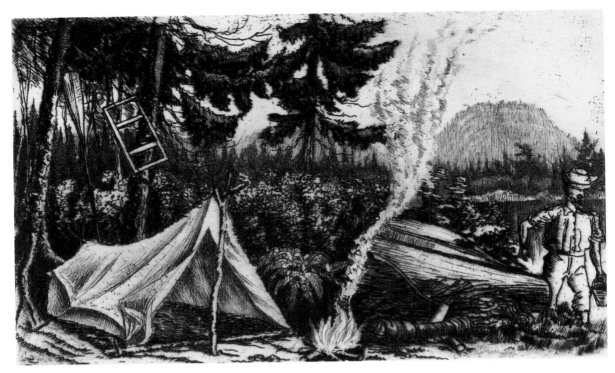

8.12. *My Camp at Carry Point. Sept. 1892. 3⁷⁄₁₆ x 5⅝"*. The Adirondack Museum 58.273.10.

But it was the wilderness that captivated Dr. Gerster: "the balmy fragrance and heavenly repose of the woods which furnish[ed] a precious setting for this haven of serene tranquillity."[30] He sums it all up in his 1916 description of his etching of his Camp at Carry Pond:

> The plate has no merit as an etching. I selected it because of pleasant associations.
> The pond lies to the north of the Niggerheads, a chain of hills visible from
> Raquette Lake, on the trail between Little Forked and Little Tupper Lake. It was
> a charming trip in the old days, starting from Raquette Lake down to Long Lake,
> then on to Big Tupper, Little Tupper, Rock Pond, Bottle Pond, Sutton Pond, Carry
> Pond to Little Forked, Big Forked Lake, and back to Raquette. I used to make this

trip without a guide, camping on the way, doing all the work, to reduce flesh and to strengthen the heart muscle. It was a delightful experience. A 12-foot cedar canoe built ad hoc, weighing 34 lbs., a silk tent, 5 lbs., a light axe, blankets, an aluminum cooking kit, one or two days' provisions, a small rifle with ball and shot cartridges, a map, sketchbook and tobacco, made an outfit I could easily handle. Leisurely and without being nudged by hurrying guides, I travelled along like the philosopher who was never at a loss for a home. "Omnia mea mecum porto" became for once a truth, and I enjoyed the delights of this liberty to full contentment. Sketching here, fishing there, listening to the approaching cry of driving hounds, watching wild life so plentiful, when your approach is stealthy and noiseless; stopping for a chat and useful information when someone was met; cooking meals as and when I pleased, pitching camp where the view was attractive, balsam, water and fuel handy and abundant. Sleeping nightly like a babe in its mother's lap, my only care was of the need of the moment, or of the finding of an unknown trail through hitherto unvisited country. Truly a paradisiacal existence, and the sweetest balm for the jaded nerves of a metropolitan surgeon. I was lucky in never losing my way, never hurting myself or being hurt by falling trees, my worst accident being a broken paddle blade. But the second blade of my double bladed paddle, suitably lengthened by an improvised handle, served excellently to extricate and to bring me home.[31]

Dr. Gerster's last etching was a bookplate made for Dr. Bernard Sachs in 1906 or 1907. Shortly after Gerster's death in 1923, Dr. Bernard Sachs eulogized him in the Proceedings of the Charaka Club. This club was named after the Indian Brahmin physician Charaka and was organized to promote interrelationships between history, letters, the arts, and medicine. Gerster was elected to the club in 1906, and served as its president in 1909. Dr. Sachs described Gerster as a "man of super abundant energy, of deliberate and careful speech, a man of commanding presence, quick in thought and decisive in action . . . a true master and friend of his fellow man, a man of liberal instincts with broad vision and a disdain for intellectual and spiritual narrowness."[32] In sum, Arpad Gerster was an extraordinary man. He excelled at his profession and at his many avocations. In the pantheon of artist etchers he was a journeyman, as he would be the first to say. Unlike Homer and Hill and the artists who graced the pages of *The Aldine,* he was not a great artist by profession or gift but, like them, he heeded the call of that "wild sort of beauty," noted by Thomas Cole in 1836, and produced a valuable pictorial and verbal record of the Adirondacks between 1883 and 1906.

Adirondacks Etched by Arpad Gerster

9

Responding to Nature
David Milne's Adirondack Prints

ROSEMARIE L. TOVELL

"THE THING IS THAT while I write or paint with one hand, I have to have someone, nature mostly, hold the other."[1] David Milne (1882–1953) made this remark in 1927 while living in the Adirondacks. At face value, this unassuming statement would seem to be a surprising observation for an artist schooled in modernist art and aesthetics. But this dichotomy, found in a man philosophically grounded in the nineteenth century and artistically committed to the twentieth century, began to fuse during the twenties, when Milne found himself artistically isolated, yet immersed in the natural world of the Adirondacks. For any other artist, these divergent ideologies would probably produce a form of artistic schizophrenia, but for Milne they led him into a whole new way of making art that evolved spontaneously out of his own art and his response to nature. In the twenties David Milne invented his own print process, the multiple plate color drypoint, whose inspiration was the Adirondack landscape and whose purpose was to convey Milne's excitement with its beauty.

David Brown Milne was born in 1882 on a pioneer farm near Paisley, Ontario. After a brief career teaching at a local country school, in 1903 Milne left for New York to pursue a career as an artist. Following two years of study at the Arts Students League and many visits to the art exhibitions and public collections to be found in the metropolis, Milne chose to align himself with the Modernists. His art developed quickly as he absorbed the influences of French and American Impressionism and Post-Impressionism, Cézanne, the Fauves, and Matisse.[2] Whistler was a particular influence on a set of etchings made between 1909 and 1911.[3] Milne moved into the front rank of American Modernism, exhibiting at the Armory Show and associating with artists such as Maurice Prendergast, John Marin, and Marguerite and William Zorach.

However, his promising career in New York City was cut short by a nervous breakdown, and he

needed to focus his life and his art away from his frenetic life in the city. In 1916 Milne moved to Boston Corners, New York, in the Taconic Mountains near the Massachusetts border.

The outdoor country life had a salubrious effect on Milne's art, and he could begin to digest and synthesize his art influences, developing a style of his own. His painting became more naturalistic and relaxed. The change in Milne's style was also the first clear indication of Milne's continuing responsiveness to the landscape. In the future each move to a new locale would translate into a stylistic shift.

With his health fully recovered, Milne enlisted in the Canadian Army in early 1918. He was still in a British training camp when Armistice was declared. Shortly after, he became a war artist with the Canadian War Memorials.[4] Milne's watercolors of the now uninhabitable and devastated killing grounds, which had seen Canadian action in Northern France and Belgium, underwent a dramatic change of style. Brush work became dry and linear, with a limited palette of densely applied color taken straight from the tube and scrubbed onto the paper. The white blank paper became a critical element in the construction of the composition.

Following his return to Boston Corners, Milne's drastic alteration in style continued. To understand it and bring it under control, he began to read the books of such divergent art critics as John Ruskin, Clive Bell, and Roger Fry. They helped give Milne's art a philosophical base as well as structure and vocabulary. These readings were also lessons on methods to analyze his work. And soon Milne began his own painting journal, augmented by the letters he wrote to his friend and patron James Clarke.[5]

Nevertheless, at this time, Henry David Thoreau's *Walden, or, Life in the Woods* had the most profound effect on him. After reading it, Milne instantly decided to replicate the experiment as the best method of coming to terms with his art. Over the early winter months of 1921, Milne went into solitary retreat in a rough-hewn cabin that he built on Alander Mountain near Boston Corners. Here he re-created the Walden experience and completely immersed himself in the natural world, painting the subjects close at hand. As Thoreau passed through "an invisible boundary" toward an understanding of the laws of Emersonian naturalism, so too did Milne pass through a boundary toward an understanding and solidification of his art. An important aspect of this new awareness was the clear realization that his media (at this time watercolor and oil) had to work in tandem in order to further his art. The Alander retreat also honed his visual acuity and emotional response to nature. These skills came to maturity in the Adirondacks and brought about a personal philosophical truth that underlying all his Modernist aesthetic concerns, nature provided Milne his model and his guide.

The end of Milne's winter at Alander marked the beginning of his Adirondack years, which lasted from 1921 to 1929. The region's tourist industry and a need to earn a living brought Milne to Dart's Lake, Big Moose Lake, and Lake Placid. In the Adirondacks and primed by the Alander winter, Milne was able to find all the subjects he needed for his painting as he responded wholeheartedly to his natural surroundings. Although he found companionship in the society of the year-round, somewhat rustic, inhabitants of the Adirondacks, the audience for his art was almost non-existent.[6] Aside from his friend James Clarke in New York, Milne enjoyed only two brief encounters with anyone interested in art.

In the spring of 1921 David Milne joined his wife at Dart's Lake. Patsy Milne had found employment for both of them at Dart's Camp, where she worked as a clerk and he worked half days as a handyman. With his afternoons free, Milne was able to devote regular time to painting, working entirely in watercolor. Painting in broad daylight with the bright light reflecting off the white paper, color became less important. As a result, his watercolors became almost monochrome—linear and highly textured dry brush drawings. He made no effort to use tints or washes. He began to apply the paint in a new manner in which parallel spidery strokes of black watercolor, made by the splayed bristles of the brush, created the composition, while color was added in small daubs and streaks inserted between the black lines.

This method of painting reminded Milne of drypoints, and the following winter, at Mount Riga, he experimented with a multiple plate color drypoint technique using hardware store zinc, his wife's sewing needles, and a neighbor's laundry wringer. Although Milne saw real possibilities with the color drypoint, he did not pursue it at this time; his paintings and watercolors were going very well, and he did not wish to impede the steady progress he was making by dissipating his energies and attention in developing the new medium.

In the summer of 1922 the Milnes returned to the Adirondacks to run their own tourist enterprise, The Little Tea House on Big Moose Lake. Adjacent to Dart's Lake, Big Moose Lake with its many cottages and the large Glenmore Hotel was a significant tourist center, promising a good potential for the business. (The hotel and lake are best known as the locale for the sensational murder that inspired Theodore Dreiser's *An American Tragedy,* published while the Milnes were at Big Moose Lake.) That first summer the Milnes set themselves up in the basement of the Glenmore Hotel and the following year moved into a rented cottage next to the hotel. The tea house was a serious affair. They had their own postcards made up and sold local crafts. Milne carried the "Blue Dragon" motif of the chinaware into the decoration of the cottage, painting the tabletops and installing paper

lanterns. Ready for business, Milne described themselves as "waiting like spiders in a web" for their customers to arrive.[7] The famous actress Minnie Maddern Fiske, who owned and summered on the islands just off shore from the tea room, was one of their most loyal patrons.

With the hope of establishing himself back home, Milne returned to Canada, living in Ottawa during the winter of 1923–24. But while he enjoyed some success, he was both lonely and economically vulnerable, unable to find employment or buyers for his art. The National Gallery of Canada purchased six watercolors, but a large, one-man exhibition in Montreal and a group exhibition in Toronto had failed to produce a single sale. To solve his problems, Milne decided to return to the Adirondacks. With Clarke's financial backing, he set about building a cottage on Big Moose Lake, the anticipated sale of which would give Milne a guaranteed income and allow him to work solely on his painting.

Located five or six lots to the east of the Glenmore Hotel on the north shore of the lake, the cottage took Milne four years to build and occupied much more of his time and energy than expected. He not only built the entire cottage, he also designed it to suit vernacular architecture of the famous Adirondack camps. Using local materials, Milne designed the cottage to reflect its natural surroundings both in architectural form and decorative detail.[8] At first the construction went quickly. By July 1924 he was able to operate the tea house out of the unfinished cottage. Two years later it was sufficiently advanced for Milne to begin offering it for sale. He entertained hopes for a quick sale, given the increasing desirability of land on Big Moose Lake now that road construction into and around the lake was reaching completion and making it accessible by car.[9] However, more work was needed to attract a buyer, and it was not until 1928 that Milne managed to make his sale.

From April to December during the years 1924 to 1928 while at Big Moose Lake, Milne was only able to take Sundays off. Enjoying these solitary and quiet days in the woods, he devoted this precious time to relaxing, letter writing, and painting. Several favorite spots provided a wealth of material that would develop into print subjects. His favorite locale was Gamble's Cliff, the rise of land behind his house on the north shore of the lake. The cliff and open promontory known as Billy's Bald Spot had a spectacular view over the lake; the view from the cliff became one of Milne's most famous subjects in a series titled "Painting Place."[10] Squash Pond behind Billy's Bald Spot served as the subject for another series, "Outlet of the Pond," in which Milne explored his favorite aesthetic problem—reflections in still water. The abandoned lumber camp between Big Moose Lake and Dart's Lake, whose still-usable iron stove gave Milne warmth on cooler days, offered Milne several subjects of dark forest interiors, minutely observed and inventoried in letters and paint. Milne's solitary Sunday retreats into the forest brought him into close contact with the natural world. Among its manifestations were a number of still-life paintings of wildflowers that Milne created as celebrations

of spring's renewal and summer's bounty. Although he never translated these subjects into prints, from his Adirondack years on, the floral still-life became a principal part of his repertoire.

During the winters of 1925 to 1929, the Milnes made an annual migration to Lake Placid to run Ski-T, a restaurant owned by the Lake Placid Club and located at the bottom of the Intervale Ski Jump.

Milne soon learned the relatively rare sport of cross-country skiing from the legendary Jack Rabbit Johannsen. Enchanted with it, Milne explored the many trails, particularly across the North Elba Plain toward the McIntyre Range, Mount Colden, and Mount Marcy. One year he cross-country skied from Lake Placid to Big Moose—a four-day trek that caught the attention of several Adirondack guides more used to snowshoeing. They apparently timed his progress via the telephone as he passed by them from one locale to the next.[11]

Life at Lake Placid offered Milne more leisure time to devote to his painting. Despite his ability to range all over the Lake Placid area, he found his subjects relatively close at hand. A favorite subject was the valley of the West Branch of the Ausable River, either looking from the top of the ski jump or from the forested hill across the way. On his regular run to the Lake Placid Club for supplies, Milne took in the view toward Lake Placid and the Sentinel Range. John Brown's farm, tucked in behind the ski jump hill, became the subject for a painting and a print. And the North Elba Plain, where John Brown had attempted to settle a farming community of ex-slaves, provided Milne with some of his most beautiful subjects.

During the first year at Lake Placid, Milne's paintings and watercolors quickly began to fall out of step with each other. His watercolors failed to respond to the more fluid lines and open compositions of Lake Placid's winter subjects. Milne's watercolor technique, relatively unchanged since Dart's Lake, had become stale and tired. He stopped work in the medium in May 1925 for what would turn out to be a twelve-year hiatus. While his watercolors stagnated, his oil paintings were changing, briefly stumbling into a relatively decorative abstract mode before recovering into a more painterly, broadly rendered style. His painting style responded to the aesthetics of Lake Placid's landscape, but Milne needed a companion medium with which to form a dialogue.[12]

Throughout his career, and consciously since the Alander retreat, Milne needed a second medium whose separate aesthetic and technical demands would help propel his artistic development. Now was the time to take up the promise shown in those earlier experimental color drypoints. Lake Placid in winter was the perfect place to inspire color drypoints. Nowhere else did Milne seem to have been so taken by the brilliant colors he saw on the bright, snow-covered fields, valleys, and mountains around Lake Placid. He once described the colors of the North Elba Plain: farm buildings were blood red to burnt purple; the post office was lemon, scarlet, and lavender; and the road

was a streak of lemon yellow and orange. These are the very colors he would use in his first set of prints. But above all, Milne was captivated by the beautifully tinted skies of which he exclaimed: "If the Lord colors his skies for humans, he is wasting an awful lot of paint in North Elba."[13] By attempting to capture the colors of Lake Placid's skies, Milne would propel his color drypoints towards the most painterly prints imaginable.

In November 1925, six months after forsaking watercolor, Milne was asking Clarke to look for an etching press; it was not ordered until a full year later. Milne selected a tabletop Gorr Portable Etching Press. Clarke, who was acting as Milne's agent, could not find any colored printing inks with art suppliers in New York and sent instead some non-permanent inks for Milne to try. At this early stage Milne wanted to work with etching, but the post office understandably refused to allow acid to be sent in the mail. And because Milne was not sure if the locally available acids were of the correct strength, he decided to develop his prints as drypoints.[14] Borrowing upon the color woodcut technique, he would make a separate plate for each color in the design. As his guidebook, he used S. R. Koehler's translation of Maxime Lalanne's *A Treatise on Etching* (London, 1880) purchased many years earlier. The first subject he tried with his new equipment was the Big Moose subject, "Painting Place"; *Painting Place (Small Plate)* was created most likely in the first week of January 1927 at Lake Placid.

The prints made during the 1927 Lake Placid winter can best be described as experimental with Milne attempting to get the technique of his multiple plate color drypoints underway. He wrote of these first prints: "Merely process and the result painful to look at. . . . Made the mistake of breaking in [my] . . . new pants and the new press on the same day, succeeded with the pants all right."[15] None of Milne's prints during this winter of experimentation amounted to very much. However, he was solving some technical problems. His Winsor and Newton oil paints were good substitutes for colored printing inks, and his stock of watercolor paper worked well. Milne found controlling the needle to create line and burr in the correct amount and location comparable to learning to ski. With each color coming from a different plate, Milne was encountering difficulties with the registration; not only was the paper traveling in the press, it was also expanding and shrinking at different rates as it was dampened and then run through the press two or more times.

How to use and apply color became the most difficult problem to solve. Milne realized that replicating his now abandoned method of applying watercolor simply did not work. He began by searching out new methods of applying color. He attempted to create large, solidly colored areas, but these swamped the image. Finally, with the Big Moose subject *Boulders in the Bush (Second Version),* pulled sometime between August 1927 and 1928, Milne's printmaking began to emerge from the wilderness. He was starting to simplify and open up the design. The key plate provided the essential draw-

9.1. *Boulders in the Bush (Second Version),* ca. 1927–28. Color drypoint on wove paper, 87 x 125 mm (plate). National Gallery of Canada, Milne-Duncan Bequest, 1970.

ing while the second plate provided the defining color, which was kept to small pools that hugged the lines of the key plate. Milne was attempting to use the second color to facet the rocks and suggest the color of the ground. It is interesting to note that among the very earliest prints, the most successful were the Big Moose subjects. Perhaps this was owing to the less complex colors of the closed-in summer forest. It was far easier to develop a subject when the color scheme kept to such strong opaque colors as black, brown, and green.

Boulders in the Bush (Second Version) was consciously based on a 1927 painting of the same title. In fact, the redrawing of the print from the first version to the second was done in part to eliminate the image reversal, making the print read from left to right like the painting. However, such slavishness to make the print similar to the painting was not common. At times Milne would try out a subject first in drypoint, and then he would rework it in oil (and after 1937, watercolor), or it could appear within the middle of a series. Sometimes this simple act of reworking a subject would lead Milne to the final resolution of a compositional or technical problem.

The color drypoint, however, also greatly enhanced his painterly explorations. During the twenties, Milne was developing a system of working in subject series as a means of fully exploring its potential creative energy. Whereas reworking a subject in watercolor or oil could only offer a single variation, the drypoint offered many variations. Because of their "fixed" image, the subjects were easily repeated in various color schemes, allowing Milne to continue to investigate and exploit the full potential of a subject.

Throughout his career to date, Milne painted all his subjects on the spot and at one sitting. More often than not, he did the same when he reworked subjects in oil and watercolor. He aspired to capture and convey to the picture's viewer that thrilling moment when his attention was caught and held, when he was gripped by "aesthetic emotion."[16] As a result, he rarely worked up a subject in his studio where the emotional impact was just an elusive memory. At the outset, he hoped his work in drypoint would be as portable as his work in oil or watercolor. But the metal plates were too cold and awkward to handle in winter. He therefore sought out an alternative. On one occasion he prepared a sheet of gelatin according to Lalanne's instruction, but rather than using it as a means for transferring an image, he used it to make an on-the-spot sketch of Mt. Jo from Adirondack Loj, which he transferred to a copper plate.[17] While it was partially successful, he found the technique unsatisfactory because the gelatin tended to curl and get brittle in the cold and to dissolve when it got damp. Chance offered Milne an alternative. In 1929, after the annual ski jumping event on Lincoln's birthday, Milne found some exposed celluloid at the top of the ski jump. He took it back to his studio and scratched *Roofs of the Glenmore Hotel* after his painting of the same title. This technique worked better than the gelatin, but he could only make one decent print before the burr and line began to disappear. After these two experiments, Milne no longer looked to the print as a portable medium to provide him with original on-the-spot subjects. He would have to find other ways for his prints to sustain his excitement with the image and its creation. This need would be a driving force in his evolution as a printmaker.

The year 1928 was a particularly bleak one for Milne's painting or printmaking. All his thoughts

9.2. *Roofs, Glenmore Hotel,* February 1929. Color drypoint on celluloid, on wove paper, 90 x 135 mm (imp). National Gallery of Canada, Milne-Duncan Bequest, 1970.

and energies were focused on the cottage building project which he was bringing to completion. In late autumn the cottage finally sold for $6,500. By retaining the mortgage, Milne had the guaranteed income he had hoped for. Now he could seriously consider his return to Canada with the security of having the time to establish himself in the Canadian art world.

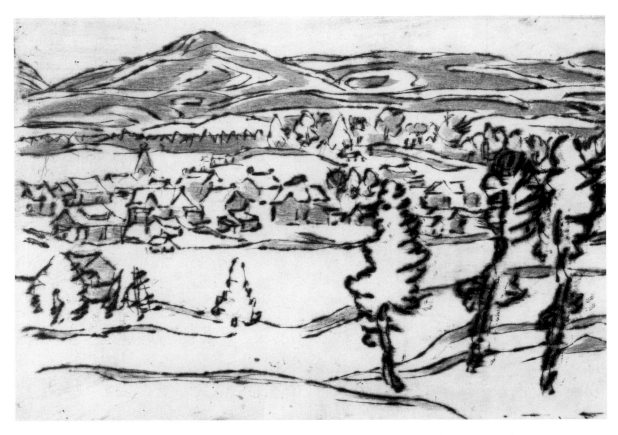

9.3. *Lake Placid (First Version),* 1929. Color drypoint on wove paper, 125 x 178 mm (plate, maximum). National Gallery of Canada, Milne-Duncan Bequest, 1970.

However, before he left for home, Milne returned to Lake Placid for one last season at Ski-T. It became something of a holiday—letters suggest Milne spent a lot of time teaching himself downhill skiing, and in this more relaxed climate, he devoted the remainder of his free time entirely to his drypoints. The prints made at Lake Placid that winter suggested several points of departure, which Milne pursued in the autumn of 1929 when he was reunited with his etching press at Weston, Ontario, near Toronto.

Lake Placid (First Version), one of the very rare subjects unique to his prints, recapitulated the technique of the earlier prints and began a new direction. Technically, Milne had successfully achieved

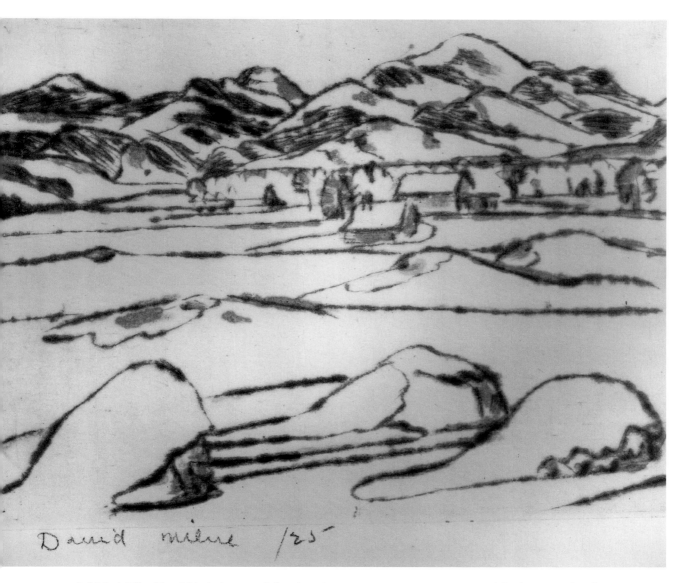

David milne /25

9.4 *North Elba (Fourth Version),* 1929. Color drypoint on wove paper, 133 x 176 mm (plate). National Gallery of Canada, Milne-Duncan Bequest, 1970.

the close registration and solid coloring attempted in 1927. Trying to simulate the blue-grey of the distant mountains, Milne introduced a new element into his technical repertoire—mixing his colors, in this case blue with zinc white, directly on the plate. Consequently, the blue-grey tonality differed from impression to impression. This technique would further expand the variables each subject could give him.

Although the solid color of *Lake Placid (First Version)* was executed with greater success than the 1927 efforts, it tended to deaden the composition. As a result, Milne gave up this approach entirely. With *North Elba (Fourth Version)* he defined and colored the mountains with splotches of color created by the burr but still closely registered to the key plate. These two prints demonstrated another problem to be resolved—the color of the key plate. Black was too opaque, suffocating the line. It also gave Milne technical problems: the black oil paint tended to clog the line and burr. Blue (i.e. French ultramarine) had the viscosity for responsive printing but lacked the opacity to give his key plate lines sufficient strength.

Lake Placid, Winter Sunset was a superior reworking of a 1926 canvas. (The canvas was cut down in the thirties to conform with the composition of the print.) The print represented the furthest advancement of Milne's printmaking efforts undertaken in the Adirondacks. There were two significant changes. In emulation of the region's much admired tinted winter skies, Milne deliberately used plate tone to create a clear tint (yellow or yellow ochre) which helped unify the colors and explain the composition. The plate tone added a new, less controllable element to Milne's prints but gave him the "kick" or creative energy he sought in his art and which sustained his enthusiasm through the technically dull and slow process of printing. The second change, a deliberate "misregistration" of the plate, evolved out of a mistake noticed in this print. Milne had erred in the placement of the second color which in some places had crossed over onto the lines from the key plate or left gaps between the color and the defining line. He liked the result of both accidents: the overlapping of lines gave them greater variety of colors while the wide play in registration of the plates allowed the spaces between the lines of color to perform as important a role as the lines of color themselves. Both registration "mistakes" helped animate the subject. From now they would be deliberately applied in prints like *Across the Lake (Second Version),* a Dart's Lake subject, made after a 1921 watercolor of the same title. This drypoint, completed at Weston, further explored the use of clear tint (red or blue) to unify the composition and the cross-over of line. Milne animated the print by adding the second color, in tiny flecks of blue colored burr, which he deliberately allowed to cross into the Chinese vermilion lines of the key plate. Milne loved the way the separate colors became black where they intersected; it added to the visual excitement of the subject and gave him another dimension to

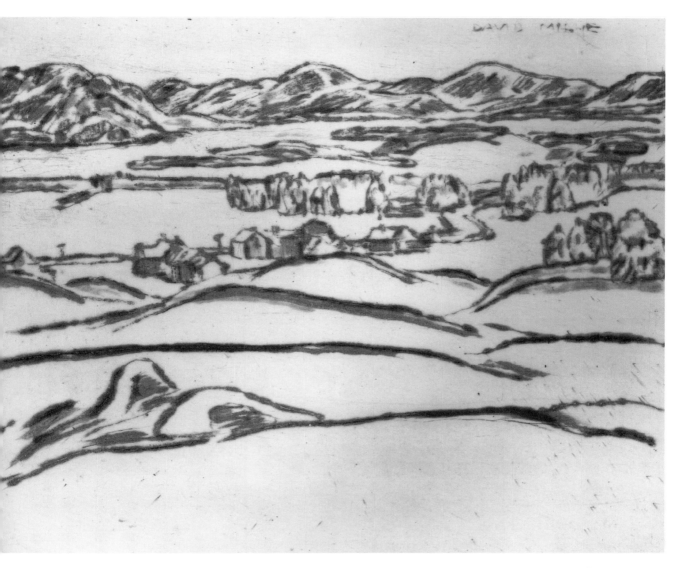

9.5. *Lake Placid, Winter Sunset,* 1929. Color drypoint on wove paper, 137 x 176 mm (plate). National Gallery of Canada, Milne-Duncan Bequest, 1970.

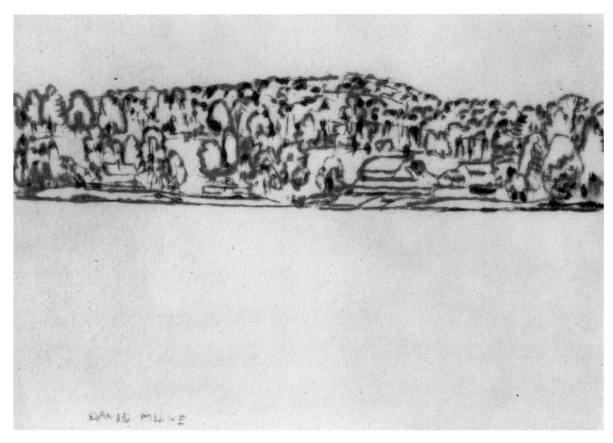

9.6. *Across the Lake* (Second Version), 1929–30. Color drypoint on wove paper, 136 x 175 mm (plate). National Gallery of Canada, Milne-Duncan Bequest, 1970.

the contrast between the open blank spaces and the busy, concentrated drawing. By bringing all these elements together, Milne had re-created the shimmering visual effect of a hot and sunny afternoon in the Adirondacks.

 Among the very last prints executed in 1929 was *Painting Place (Large Plate)*. This was the long sought after resolution of the Big Moose subject begun three years earlier and tried in four versions in oil and drypoint; the 1929 print became the model for the final canvas, thought to be Milne's masterpiece. Milne considered the print the best of his first drypoints. The confluence of all Milne's

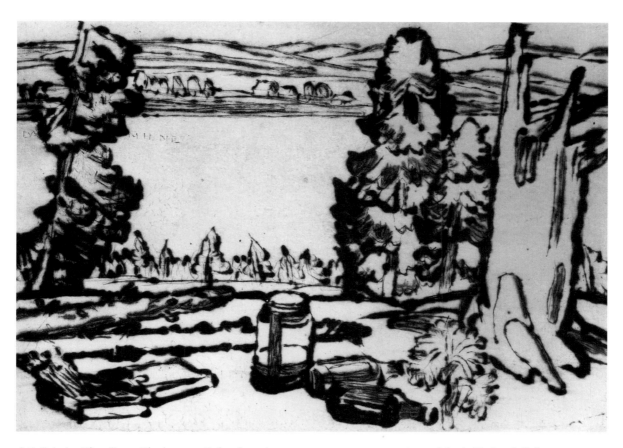

9.7. *Painting Place (Large Plate),* 1929. Color drypoint on wove paper, 123 x 176 mm (plate). National Gallery of Canada, Milne-Duncan Bequest, 1970.

experiments with color drypoint to date are seen: the control of line and burr, solid unifying tints, wide registration, and above all, mixing of colors on the plate (the important one being the combining of black with French ultramarine in the key plate). The print was the ideal marriage of subject (pine trees) and technique (drypoint burr). Milne resolved the subject so quickly in the Weston drypoint, he only pulled two impressions of the print, drawn in two states. There was no need for the artist to make more.[18]

In the summer of 1930 Milne moved to Palgrave in the Caledon Hills northwest of Toronto. At

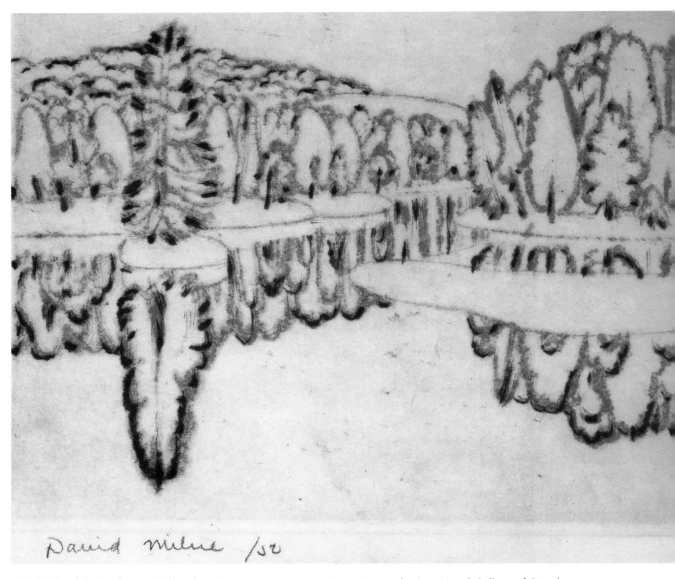

David Milne /50

9.8. *Outlet of the Pond,* 1930. Color drypoint on wove paper, 176 x 226 mm (plate). National Gallery of Canada, Milne-Duncan Bequest, 1970.

Palgrave Milne's art evolved into what many consider his classic style. It was a style derived from the color drypoint which by now had become his most progressive medium.

Despite having many strong local subjects from which to select, during his years at Palgrave, Milne chose to develop two further Adirondack subjects as prints. *Outlet of the Pond* was the sixth and last depiction of the reflections in the Squash Pond behind Big Moose Lake. His first attempt at this in drypoint a few years earlier had led nowhere, but now, in 1930, having mastered the technique, Milne felt confident to tackle the textural complexities of the mist shrouded autumn forest reflected in the still water. *Outlet of the Pond* marked the next major advance since *Painting Place (Large Plate)*. To achieve the subtlety of texture required by the subject, Milne tried wiping the plate with a rag rather than with the palm of his hand. Rag wiping drew out more ink from the lines, complementing the burr, and left behind a heavier, uneven film of color on the surface of the plate. The overall effect was to blur the detail, while emphasizing the sickle-shaped masses. By using rag wiping, Milne noted that he could develop three distinct characteristics to his prints—a dry granular texture; a very lively tint that reduced the contrast between heavily delineated areas and blank areas of the composition; and finally, a shifting, mottled, or misty look to both lines and tints. Further variations could be developed by altering the strength of the inks: heavy inkings produced boldly colored compositions and light inkings created soft shimmering impressions. Introducing such complex printing techniques and variables increased the element of chance. In the end, after seven states and countless proofs, just thirteen impressions from all the states were approved and signed. *Outlet of the Pond* marked Milne's start to consciously use the color drypoint as a means of exploring every possible aesthetic avenue the subject could give him. Once he had drained it of all its potential, he would stop, go back and select those works he liked, and call that the edition. No two prints were ever alike.

A 1928 canvas of Lake Placid's most famous site gave Milne the subject for one of his most technically complex and painterly prints, the breathtaking *John Brown's Farm*. The test for the print lay in Milne's desire to describe a twilight subject dominated by a tinted winter sunset sky without resorting to the easy solution of delineating clouds to give substance to the sunlight.

Working through eleven states, Milne pared down the drawing, searching for the effect of the waning evening light which dissolved the forms of the buildings and landscape. As the design was being reduced, he increased the complexity of the inking of lines and plate tone. The key plate was first inked in black and wiped clean, than inked in blue and rag wiped so that when printed, the blue and black not only printed as combined and separate colors but were allowed to stray from their designated locations. The final result not only animated the lines, it complemented Milne's ef-

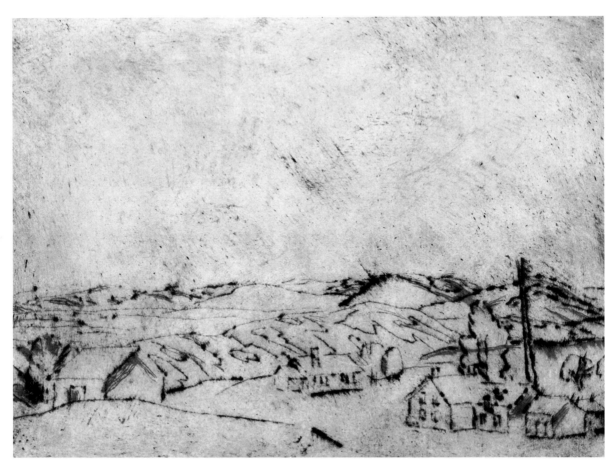

9.9. *John Brown's Farm*, 1931. Color drypoint on wove paper, 174 x 227 mm (plate). National Gallery of Canada, Milne-Duncan Bequest, 1970.

forts in the drawing to replicate the breaking up of form and color during twilight. To re-create the tinted skies and clouds of sunset, Milne resorted to printing techniques alone. An uneven transparent red tint, with a scattered speckled residue, was printed over a similarly uneven transparent speckled blue-black tint. (The speckling was probably achieved by tamping the paint smeared rag onto the plate.) Guided only by his experience and intuition, Milne achieved the effect he was seeking.

Rosemarie L. Tovell

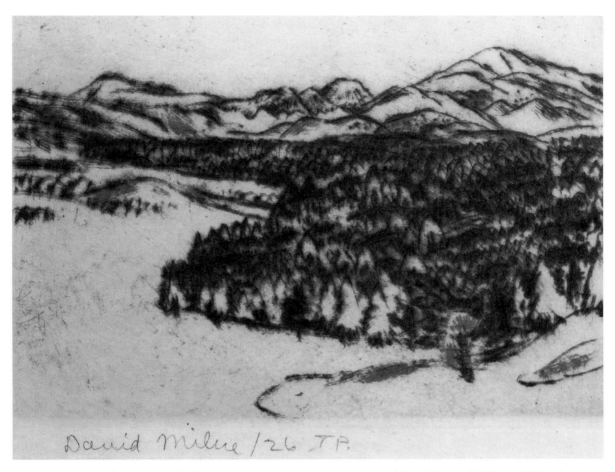

9.10. *Adirondack Valley,* 1941. Color drypoint on wove paper, 126 x 175 mm (plate). National Gallery of Canada, Milne-Duncan Bequest, 1970.

For the artist, the success of *John Brown's Farm* lay in its casual look and explosive, creative energy. He had turned printmaking into something as close to painting as was possible. These complex modes in the appearance of color applied in line and tint would become a basis for his evolving style in painting and watercolor until his death in 1953.

There was one further Adirondack subject that Milne had yet to conclude. He had tried the

view of the Ausable River valley from the ski jump in a 1929 drypoint at Lake Placid. But unable to capture either the "flesh colored skies" or the texture and hue of a forest in winter, Milne abandoned the subject after four states and at least six color schemes. He took it up again in 1941 with *Adirondack Valley*. With his acquired experience and confidence in the medium, Milne had little difficulty resolving the subject. For a change, Milne made no real effort to explore possible color variations or printing techniques. Douglas Duncan was now his dealer, and there was a market for the drypoints.[19] Duncan asked Milne to follow the standard practice of creating uniform editions, but *Adirondack Valley* is the only instance where Milne made an effort to comply.

The color drypoint *Adirondack Valley* brought to a conclusion Milne's use of Adirondack subjects for his art. This does not mean it brought an end to his Adirondack experience. In Canada he regularly sought painting places which allowed him to revisit the subjects made familiar by the forest interior and shoreline of Big Moose Lake or the crisp winter days and hills of Lake Placid. The region had introduced Milne to a way of life and a manner of seeing that remained with him always. In the natural world of the Adirondacks, Milne had not only recorded the appearance of its scenery, he had also absorbed its special aesthetic phenomena into his art.

Appendix

North American Print Conferences and Publications

A series of locally organized conferences held in the United States and Canada on subjects relating to the history of prints in North America.

1. *Prints in and of America to 1850.* March 19–21, 1970, Winterthur Museum, Winterthur, Del. Proceedings, edited by John D. Morse, published by University Press of Virginia, 1970.

2. *Boston Prints and Printmakers, 1670–1775.* April 1–2, 1971, Colonial Society of Massachusetts, Boston. Proceedings, edited by Walter Muir Whitehill and Sinclair Hitchings, published by Colonial Society of Massachusetts, 1973.

3. *American Printmaking before 1876: Fact, Fiction, and Fantasy.* June 12–13, 1972, Library of Congress, Washington, D.C. Proceedings published by Library of Congress, 1975.

4. *Philadelphia Printmaking: American Prints before 1860.* April 5–7, 1973, Free Library of Philadelphia, Historical Society of Pennsylvania, Library Company of Philadelphia, and Philadelphia Museum of Art. Proceedings, edited by Robert F. Looney, published by Tinicum Press, 1976.

5. *Eighteenth-Century Prints in Colonial America.* March 28–30, 1974, Colonial Williamsburg, Va. Proceedings, edited by Joan Dolmetsch, published by University Press of Virginia, 1979.

6. *Art and Commerce: American Prints of the Nineteenth Century.* May 8–10, 1975, Museum of Fine Arts, Boston, in association with other Boston institutions. Proceedings published by Museum of Fine Arts, Boston, 1978; distributed by University Press of Virginia.

7. *Prints of New England.* May 14–15, 1976, American Antiquarian Society and Worcester Art Museum, Worcester, Mass. Proceedings, edited by Georgia Brady Barnhill, published by American Antiquarian Society, 1981, distributed by University Press of Virginia.

8. *American Maritime Prints.* May 6–7, 1977, New Bedford Whaling Museum, New Bedford, Mass. Proceedings, edited by Elton W. Hall, published by Old Dartmouth Historical Society, 1985.

9. *Prints of the American West.* May 4–6, 1978, Amon Carter Museum, Fort Worth, Tex. Proceedings, edited by Ron Tyler, published by Amon Carter Museum, 1983.

10. *American Portrait Prints.* May 15–17, 1979, National Portrait Gallery, Smithsonian Institution, Washington, D.C. Proceedings, edited by Wendy Wick Reaves, published by University Press of Virginia 1984.

11. "Canada Viewed by the Printmakers." May 6–8, 1980, Royal Ontario Museum, Toronto.

12. *Prints and Printmakers of New York State, 1825–1940*. May 14–16, 1981, Syracuse University, Everson Museum of Art, and Erie Canal Museum. Proceedings, edited by David Tatham, published by Syracuse University Press, 1986.

13. "Mapping the Americas." October 15–17, 1981, Historical Society of Pennsylvania, Philadelphia.

14. *The American Illustrated Book in the Nineteenth Century*. April 8–9, 1982, Winterthur Museum, Winterthur, Del. Proceedings, edited by Gerald W.R. Ward, published by Winterthur Museum, distributed by University Press of Virginia, 1987.

15. "Images by and for Marylanders, 1680–1940." April 27–30, 1983, Maryland Historical Society, Baltimore, in association with other Baltimore institutions.

16. "The Graphic Arts in Canada after 1850." May 9–12, 1984, Public Archives of Canada and National Gallery of Canada in cooperation with National Library of Canada and Remington Art Museum, Ogdensburg, N.Y. Proceedings, edited by Jim Burant, forthcoming.

17. *Aspects of American Printmaking, 1800–1950*. April 25–27, 1985, Grace Slack McNeil Program in American Art, Wellesley College, and Museum of Our National Heritage, Lexington, Mass., in cooperation with Boston Athenaeum; Museum of Fine Arts, Boston; and Boston Public Library. Proceedings, edited by James F. O'Gorman, published by Syracuse University Press, 1988.

18. "Prints and Printmakers of New York City." April 10–12, 1986, New–York Historical Society, New York.

19. "Prints and Printmakers of New Orleans and the South." April 29–May 1, 1987, Historic New Orleans Collection, New Orleans, in cooperation with Louisiana State Museum and New Orleans Museum of Art. Proceedings, edited by Jessie Poesch, forthcoming.

20. *Prints and Printmaking of Texas*. November 9–12, 1988, Texas State Historical Association, Center for Studies in Texas History; Harry Ransom Humanities Research Center; Archer M. Huntington Art Gallery; Texas Memorial Museum of Texas at Austin. Proceedings, edited by Ron Tyler, published by Texas State Historical Association, 1997.

21. *Graphic Arts and the South*. March 14–17, 1990, High Museum of Art, Atlanta Historical Society, Clark Atlanta University, Emory University. Proceedings, edited by Judy L. Larson, published by University of Arkansas Press, 1993.

22. "A Celebration of North American Historical Prints." September 18–20, 1991, Boston Public Library; Boston Athenaeum; Museum of Fine Arts, Boston; Massachusetts Historical Society. Proceedings, edited by Sinclair Hitchings, forthcoming.

23. *Adirondack Prints and Printmakers: The Call of the Wild*. August 10–12, 1995, Adirondack Museum and Syracuse University. Proceedings, edited by Caroline M. Welsh, published by Adirondack Museum and Syracuse University Press, 1998.

24. "The Illustrating Traveller: Adventure and Illustration in North America and the Caribbean 1760–1890." March 29–30, 1996. Yale University, Beinecke Rare Book Room and Manuscript Library, Yale Center for British Art. Proceedings, edited by George Miles, forthcoming.

25. "Tools, Trades, and the Mechanical Arts in American Historical Prints." November 6–8, 1997, The Early American Industries Association and American Antiquarian Society in coorperation with Sturbridge Village and other Worcester organizations.

Notes

Introduction

1. Verplanck Colvin, *Seventh Annual Report on the Progress of the Topographical Survey of the Adirondack Region of New York, to the Year 1879, Containing the Condensed Reports for the Years 1874–75–76–77 and '78* (Assembly Document No. 87, 1879; Albany: Weed, Parsons, 1880), 67.

2. In 1869 William H. H. Murray, a Boston clergyman, published a guidebook entitled *Adventures in the Wilderness; or, Camp-Life in the Adirondacks* (Boston: Fields, Osgood & Co., 1869; reprint, Blue Mountain Lake, N.Y.: The Adirondack Museum; Syracuse, N.Y.: Syracuse Univ. Press, 1989). This volume's immense popularity provoked a rush to the wilderness by hordes of tourists dubbed "Murray's Fools."

3. *Appleton's Journal* 182 (Sept. 21, 1872): 323–24.

4. Ebenezer Emmons, New York State Natural History Survey Report, 1838. Quoted in Frank Graham, Jr., *The Adirondack Park: A Political History* (New York: Alfred A. Knopf, 1978), 12.

5. William M. Ivins, Jr., *Prints and Visual Communication* (Cambridge: Harvard Univ. Press, 1953), 180.

1. When Men and Mountains Meet: Mapping the Adirondacks

1. Bruce G. Trigger, *The Children of Aataentsic: A History of the Huron People to 1660* (Montreal: McGill-Queen's Univ. Press, 1976), 1: 247–56.

2. Alfred L. Donaldson, *A History of the Adirondacks* (New York: Century, 1921; reprint, Fleischmanns, N.Y.: Purple Mountain Press, 1992), 1: 9.

3. Samuel de Champlain, *Carte de Nouvelle France . . .* (1632), in H. P. Biggar, *The Works of Samuel de Champlain in Six Volumes . . .* (Toronto: The Champlain Society, 1922; reprint, Toronto: Univ. of Toronto Press, 1971), plate x.

4. Seymour I. Schwartz and Ralph E. Ehrenberg, *The Mapping of America* (New York: Harry N. Abrams, 1980), 163.

5. Paul G. Bourcier, *History in the Mapping: Four Centuries of Adirondack Cartography* (Blue Mountain Lake, N.Y.: The Adirondack Museum, 1986), 7.

6. Schwartz and Ehrenberg, *The Mapping of America,* 190.

7. Ibid., 153.

8. Donaldson, *A History of the Adirondacks,* 1: 51–61.

9. *A Plan of the Lands Purchased for the Benefit of Joseph Totten & Stephen Crossfield . . .* (1772), in New York State Engineer, *Certified Copies of Ancient Field Notes and Maps* (Albany: J. B. Lyon, 1903).

10. J. Theodore Cross (untitled paper presented at the annual meeting of the Oneida County Historical Society, Utica, N.Y., 1955).

11. Amo Lay, *Map of the Northern Part of the State of New York* (Newark, N.J.: P. Maverick, 1812).

12. George Marshall, "Dr. Ely and His Adirondack Map," *New York History,* 35 (Jan. 1954): 32–48.

13. Donaldson, *A History of the Adirondacks,* 2: 129.

14. Schwartz and Ehrenberg, *The Mapping of America,* 235.

15. John H. Eddy, *The State of New York with Part of the Adjacent States* (New York: James Eastburn & Co., 1818).

16. H. C. Carey, *Geographical, Statistical, and Historical Map of New York* (Philadelphia: Carey & Lea, 1823).

17. New York State Legislature, *Laws of the State of New York Passed at the Fifty-ninth Session of the Legislature . . .* (Albany: E. Croswell, 1836), 195.

18. Graham, *The Adirondack Park,* 12.

19. William L. Marcy, *Communication from the Governor, Relative to the Geological Survey of the State* (New York State Assembly Document 200, Feb. 20, 1838), 242.

20. *Geological Map of the State of New York, by Legislative Authority* (New York: George E. Sherman & John Calvin Smith, 1842).

21. A. F. Edwards, *Map of the Sacketts Harbor and Saratoga Railroad Routes . . .* (Albany: R. H. Pease, 1853).

22. Craig Gilborn, *Durant: The Fortunes and Woodland Camps of a Family in the Adirondacks* (Sylvan Beach, N.Y.: North Country Books, 1981; reprint, Blue Mountain Lake, N.Y.: The Adirondack Museum, 1986), 9–10.

23. Harold K. Hochschild, *Township 34: A History with Digressions . . .* (New York: privately printed, 1952), 288.

24. Harvey H. Kaiser, *Great Camps of the Adirondacks* (Boston: David R. Godine, 1982), 2.

25. Gilborn, *Durant,* 140–43.

26. Farrand N. Benedict, (untitled survey of a railroad and steamboat route from Lake Champlain to the County of Oneida) in New York State Senate, *Memorial of George A. Simmons and six other gentlemen stating the results of a survey . . .* (New York State Senate Document 73, 1846).

27. Hochschild, *Township 34,* 252.

28. Farrand N. Benedict, *Report on a Survey of the Waters of the Upper Hudson and Raquette Rivers . . .* (n.p., 1874).

29. Warder Cadbury, introduction to *Long Lake,* by John Todd (Pittsfield, Mass.: E. P. Little, 1845; reprint, Harrison, N.Y.: Harbor Hill Books, 1983), vi.

30. Gilborn, *Durant,* 12.

31. Paul G. Bourcier, "The Earliest Adirondack Tourist Maps," *Adirondac* 52 (Dec. 1988): 6–7.

32. E. A. Merritt, *Maps of the Racket River and Its Head Waters with Descriptions of the Several Routes to the Principal Bodies of Water* (Albany: Weed, Parsons and Company, 1860).

33. Bourcier, *History in the Mapping,* 33.

34. Homer D. L. Sweet, *Twilight Hours in the Adirondacks . . .* (Syracuse, N.Y.: Wynkoops & Leonard, 1870).

35. George Marshall, "Dr. Ely and His Adirondack Map," 32–48.

36. Cadbury, introduction to *Adventures in the Wilderness,* 40.

37. William Crowley, *Seneca Ray Stoddard: Adirondack Illustrator* (Blue Mountain Lake, N.Y.: The Adirondack Museum, 1982), 5.

38. Verplanck Colvin, *Report on a Topographical Survey of the Adirondack Wilderness of New York* (Albany: The Argus Co., 1873), 21.

39. Norman J. Van Valkenburgh, introduction to *Report of the Superintendent of the State Land Survey of the State of New York for the Year 1898* (Schenectady, N.Y.: Association for the Protection of the Adirondacks, 1989).

40. Barbara McMartin, *The Great Forest of the Adirondacks* (Utica, N.Y.: North Country Books, 1994), 66–68.

41. Gilborn, *Durant,* 10–11.

42. McMartin, *The Great Forest of the Adirondacks,* 90–91.

43. Graham, *The Adirondack Park,* 96.

44. New York State Engineer and Surveyor, *Lakes and Reservoirs Headwaters Moose and Black Rivers Showing Present and Proposed Feeders to Black River Canal* (Albany: Comstock & Cassidy, 1862).

45. Graham, *The Adirondack Park,* 197–207.

46. Norman J. Van Valkenburgh, "The Creation of the Forest Preserve," *The Conservationist* 39 (May–June 1985): 10–15.

47. New York State Forest Commission, *Special Report of the New York Forest Commission on the Establishment of An Adirondack State Park,* in *Annual Report of the New York Forest Commission for the Year Ending Dec. 31, 1890* (Albany: James Lyon, 1891), 110.

48. McMartin, *The Great Forest of the Adirondacks,* 90–91.

49. New York State Conservation Commission, *Fourteenth Annual Report* (Albany: J. B. Lyon, 1925), 132.

50. Graham, *The Adirondack Park,* 219–21.

51. John Booth, *Looking at Old Maps* (Westbury, Wiltshire, U.K.: Cambridge House Books, 1979), vii.

2. Two Great Illustrated Books about the Hudson River: William Guy Wall's *Hudson River Port Folio* and Jacques Gérard Milbert's *Itinéraire pittoresque du fleuve Hudson*

1. William Guy Wall, *The Hudson River Port Folio* (New York: H. I. Megarey and W. B. Gilley; Charleston: John Mill, 1821–25).

2. Jacques Gérard Milbert, *Itinéraire pittoresque du fleuve Hudson . . . ,* 3 vols. (Paris: Henry Gaugin et Cie., 1818–29).

3. J. Milbert, *Picturesque Itinerary of the Hudson River and the Peripheral Parts of North America. . . .* Translated from the French and annotated by Constance D. Sherman (Ridgewood, N.J.: Gregg Press, 1968) with a portfolio of facsimiles of the plates.

4. Library of Congress Prints and Photographs Division, *The John Rubens Smith Collection: A Life Portrait of the Young Republic* (Washington, D.C.: Library of Congress, 1993); Kenneth Myers, *The Catskills: Painters, Writers, and Tourists in the Mountains, 1820–1895* (Yonkers, N.Y.: The Hudson River Museum of Westchester, 1987); Edward J.

Nygren with Bruce Robertson, *Views and Visions: American Landscape Before 1830* (Washington, D.C.: The Corcoran Gallery of Art, 1986); Edward S. Smith, "John Rubens Smith: An Anglo-American Artist," *Connoisseur* 85, no. 345 (May 1930): 300–302, 305–7.

5. Richard J. Koke, *A Checklist of the American Engravings of John Hill (1770–1850) Master of Aquatint* . . . (New York: The New-York Historical Society, 1961); Richard J. Koke, "John Hill, Master of Aquatint 1770–1850," *The New-York Historical Society Quarterly* 43, no. 1 (Jan. 1959): 51–117; Frank Weitenkampf, "John Hill and American Landscapes in Aquatint," *American Collector* 17, no. 6 (July 1948): 6–8.

6. Anne Crookshank and the Knight of Glin, *Irish Watercolors and Drawings, Works on Paper c. 1600–1914* (New York: Harry N. Abrams, [1995]); John K. Howat, "A Picturesque Site in the Catskills: The Kaaterskill Falls as Painted by William Guy Wall," *Honolulu Academy of Arts Journal* 1 (1974): 16–29; Darrell Welch, "The Hudson River Portfolio," *The Conservationist* 26 (Apr.–May 1972): 18–25; James T. Callow, *Kindred Spirits, Knickerbocker Writers and American Artists, 1807–1855* (Chapel Hill: Univ. of North Carolina Press, [1967]); Donald A. Shelley, "William Guy Wall and His Watercolors for the Historic *Hudson River Portfolio,*" *The New-York Historical Society Quarterly* 31 (Jan. 1947): 25–45; [Helen Comstock] "The Water-Colours of William Guy Wall," *The Connoisseur* 120 (Sept. 1947): 42–43; "The Hudson River Portfolio," *The Old Printshop Portfolio* 3, no. 1 (Sept. 1943): [2]–5; [Helen Comstock] "The Hudson River Portfolio," *The Connoisseur* 107 (Mar. 1941): 120–21.

7. Manuscript note in the margin of the original drawing of this view in the Prints and Photographs Division of the Library of Congress.

8. Edward S. Smith, "John Rubens Smith," [1930] typescript in the Print Collection, Miriam and Ira D. Wallach Division of Art, Prints and Photographs, New York Public Library, Astor, Lenox and Tilden Foundations, quoted by permission of the Office of Special Collections. The original watercolor painting of New York City is now in the Library of Congress, and it is entitled, "View of N. York from Brooklyn"—not the Jersey Shore. The penciled note concludes, "In gratitude J. R. S. Painted about 1825 to 28."

9. Koke, "John Hill, Master of Aquatint 1770–1850," 51–117.

10. Koke, *A Checklist of the American Engravings of John Hill (1770–1850).*

11. Nygren, *Views and Visions,* 54.

12. "The Diorama at the Bowery Theatre," *The Critic,* 1 (Dec. 13, 1828): 104; see also "Bowery Theatre," *New-York Mirror* 6 (Dec. 6, 1828): 171 and Lee Parry, "Landscape Theater in America," *Art in America* 59 (Nov.–Dec. 1971): 52–61.

13. L. Earle Rowe, "William Guy Wall," *Antiques* 4, no. 1 (July 1923): 18–22. See also Jane Boicourt, "Some Staffordshire Views of the Upper Hudson," *Antiques* 60, no. 1 (July 1951): 52–53; Ada Walker Camehl, *The Blue-China Book, Early American Scenes and History Pictured in the Pottery of the Time* (New York: Haleyon House, [1916]); R. T. Haines Halsey, *Pictures of Early New York on Dark Blue Staffordshire Pottery* (1899; reprint, New York: Dover Publications [1974]); Gregor Norman Humphreys, "Clews' 'Picturesque Views,'" *Antiques* 16, no. 6 (Dec. 1929): 483–86; Ellouise Baker Larsen, *American Historical Views on Staffordshire China,* new revised and enlarged edition (Garden City, N.Y.: Doubleday and Company, 1950); Julia D. Sophronia Snow, "Delineators of the Adams-Jackson American Views, Part V. *William Guy Wall,*" *Antiques* 38, no. 3 (Sept. 1940): 112–15; and Frank Stefano, Jr., "Andrew Stevenson, Staffordshire Potter in New York," *Antiques* 108, no. 4 (Oct. 1975): 708–11.

14. David Karel, ed., *Dictionnaire des Artistes de Langue Française en Amérique du Nord* (Québec: Musée du Québec; Les Presses de l'Université Laval [1992]); Gwendolyn Owens, *Visions of Nature: Artists and the Environment* (Albany: Albany Institute of History and Art [1991]); Constance D. Sherman, "A French Explorer in the Hudson River Valley," *The New-York Historical Society Quarterly* 45, no. 3 (July 1961): 255–80.

15. Jacques Gérard Milbert, *Voyage pittoresque à l'Île-de-France, au Cap de Bonne-Espérance, et a l'Île de Ténériffe,* 2 vols. (Paris: Nepveu, 1812).

16. An advertisement for the academy was published in the *New York Evening Post,* May 1, 1816, p. [3], col. 1 and the *Commercial Advertiser* of the same date, p. 2, col. 5.

17. I. N. Phelps Stokes, *The Iconography of Manhattan Island,* 6 vols. (New York: Robert H. Dodd, 1915–38). See vol. 3, 568–69 and Pl. 87-b; I. N. Phelps Stokes and Daniel C. Haskell, *American Historical Prints, Early Views of American Cities, Etc. from the Phelps Stokes and Other Collections* (New York: The New York Public Library, 1932), 103–4.

18. Charles Mason Dow, *Anthology and Bibliography of Niagara Falls,* 2 vols. (Albany: The State of New York, 1921). The most complete list of Milbert's publications is in Jean Adhémar, "Les Lithographies de Paysage en France a l'Époque Romantique," *Archives de l'Art Français,* sér. 4, 19 (1938): [189]–377, where the views of Niagara Falls are item no. 237.

19. See note 3.

20. A slightly different view of the sawmill in Brownville, New York, was probably drawn on stone by Milbert himself. It was printed at the press of Barnet and Doolittle in New York perhaps before November 10, 1821, and was certainly one of the first lithographs printed in America. This print was featured in Wendy Shadwell's exhibition of rare prints from the collection of the New-York Historical Society that was mounted on the occasion of the 1986 North American Print Conference. Ms. Shadwell described it in her catalogue, "Prized Prints: Rare American Prints Before 1860 in the Collection of The New-York Historical Society," *Imprint* 11, no. 1 (Spring 1986): 1–26; see item no. 17, pp. 14–15. All of Milbert's views of the Black River area are discussed in George S. Sturtz and Helen D. Sturtz, "Milbert in the North Country," *Bulletin of the Jefferson County Historical Society* 10, no. 3 (July 1969): 3–14.

21. "Voyages," *Le Moniteur Universel,* no. 258 (Sept. 14, 1828): 1454.

22. Gordon N. Ray, *The Art of the French Illustrated Book 1700 to 1914* ([New York]: The Pierpont Morgan Library [1982]), 1: 170–71. Milbert's collection of views of Niagara Falls was actually his third publication. Ray seems to have been unaware of Milbert's *Series of Picturesque Views of America.*

23. Gloria Gilda Deak, *William James Bennett, Master of the Aquatint View* ([New York]: The New York Public Library, 1988), 27.

3. Illustrations of the Adirondacks in the Popular Press

1. This observation was made by Marjorie B. Cohn in her essay in David P. Becker, *Collecting Gifts for a College* (Brunswick, Maine: Bowdoin College Museum of Art, 1995), 16.

2. Sarah Burns, *Pastoral Inventions: Rural Life in Nineteenth-Century American Art and Culture* (Philadelphia: Temple Univ. Press, 1989), 7.

3. Karol Ann Peard Lawson in "An Inexhaustible Abundance: The National Landscape Depicted in American Magazines, 1780–1820," *Journal of the Early Republic* 12 ([Fall 1992]) provides an excellent survey of these illustrations.

4. *The Columbian Magazine* 1 (Mar. 1787): 306.

5. *The New York Magazine* 5 (Dec. 1794): 717.

6. Preface, *The New York Magazine* 5 (1794): iv.

7. *The Port Folio* 1 (June 1813): 532.

8. Horatio Gates Spafford, *Gazetteer of the State of New York* (Albany: H. C. Southwick, 1813), 200.

9. William Meade, *An Experimental Enquiry into the Chemical Properties and Medicinal Qualities of the Principal Mineral Waters of Ballston and Saratoga in the State of New York* (Philadelphia: Harrison Hall, 1817), xiv.

10. Benjamin Silliman, *Remarks Made on a Short Tour, between Hartford and Quebec in the Autumn of 1819* (New Haven: S. Converse, 1820) and Timothy Dwight, *Travels; in New-England and New-York* (New Haven: Timothy Dwight, 1821–22).

11. Silliman, *Remarks Made on a Short Tour,* 4.

12. Timothy Dwight, *Travels in New England and New York,* ed. Barbara Miller Solomon (Cambridge: Belknap Press of Harvard Univ. Press, 1969), 3: 247.

13. This painting, *The Great Adirondack Pass, Painted on the Spot, 1837,* is in the Adirondack Museum collection (66.114.1).

14. See their works for *The Hudson River Port Folio* and *Itinéraire pittoresque du fleuve Hudson,* respectively.

15. Ebenezer Emmons, *Geology of New-York. Part II* (Albany: Printed by W. & A. White & J. Visscher, 1842), 218. This volume contained the three views by John William Hill, lithographed by George Endicott of New York. The views by Ingham were published in the *New York State Geological Report for 1837* (Albany, 1838 and 1840). Those prints were lithographed by John H. Bufford in New York.

16. An excellent description of Colvin's work is in Philip Terrie's *Forever Wild: A Cultural History of Wilderness in the Adirondacks* (1985; reprint, Syracuse: Syracuse Univ. Press, 1994), 77–91.

17. Donaldson, *A History of the Adirondacks,* 2: 164.

18. Donaldson, *A History of the Adirondacks,* 2: 165–67.

19. Nathaniel P. Willis, *American Scenery* (London: George Virtue, 1840), iii.

20. Joel T. Headley, *The Adirondack; or, Life in the Woods* (New York: Baker and Scribner, 1849), i.

21. Headley, *The Adirondack,* 21.

22. Burns, *Pastoral Inventions,* 7.

23. Sue Rainey, *Creating Picturesque America: Monument to the Natural and Cultural Landscape* (Nashville and London: Vanderbilt Univ. Press, 1994), 274 and 357.

24. Prints of the photographs are in the Adirondack Museum's historic photograph collection.

25. *Harper's Weekly* 12 (Sept. 26, 1868): 612.

26. *Harper's Weekly* 12 (Oct. 24, 1868): 679.

27. *Harper's Weekly* 12 (Nov. 21, 1868): 742.

28. This illustration appears in the May 15, 1869, issue of an unidentified periodical.

29. For information on Davis's activities, see Robert Taft, *Artists and Illustrators of the Old West 1850–1900* (1953; reprint, Princeton: Princeton Univ. Press, 1982), 62–71. The Harper firm sent him to the West on several occasions.

30. *Harper's Weekly* 27 (Nov. 17, 1883): 731.

31. *Harper's Weekly* 26 (Nov. 18, 1882): 726.

32. *Harper's Weekly* 28 (Oct. 4, 1884): 658.

33. Ibid.

34. *Harper's Weekly* 29 (Feb. 28, 1885): 139.

35. *Harper's Weekly* 27 (Aug. 25, 1883): 535.

36. This history is provided in detail by Philip G. Terrie in *Wildlife and Wilderness: A History of Adirondack Mammals* (Fleischmanns, N.Y.: Purple Mountain Press, 1993).

37. *Harper's Weekly* 28 (Dec. 6, 1884): 805.

38. *Harper's Weekly* 29 (Jan. 24, 1885): 58.

4. The Adirondack Chromolithographs of Robert D. Wilkie

1. "Letters from the Sporting Grounds," *The Spirit of the Times* 18 (1848): 272, 295, 307–8, 321, 328–29, 352, 376–77, 416, and 427.

2. See my "Alfred Jacob Miller's Chromolithographs" in *Alfred Jacob Miller, Artist on the Oregon Trail,* ed. Ron Tyler (Fort Worth: Amon Carter Museum, 1982), 447–49. Webber's book, and its illustrations, have a complicated bibliographical history.

3. Peter C. Marzio, *The Democratic Art* (Boston: David R. Godine; Fort Worth: Amon Carter Museum, 1979), 35.

4. Katharine M. McClinton, *The Chromolithographs of Louis Prang* (New York: Clarkson N. Potter, 1973), 2.

5. Unless otherwise noted, the quotations from Tait, Prang, and the press are documented in Warder H. Cadbury, *Arthur Fitzwilliam Tait: Artist in the Adirondacks* (Newark, Del.: The American Art Journal/Univ. of Delaware Press, 1986), Ch. 6.

6. McClinton, *The Chromolithographs of Louis Prang,* 204.

7. Larry Freeman, *Louis Prang: Color Lithography* (Watkins Glen, N.Y.: Century House, 1971), 37.

8. Robert Jay, *The Trade Card in Nineteenth Century America* (Columbia, Mo.: Univ. of Missouri Press, 1987), 28.

9. Ruth Kimball Wilkie, "Robert D. Wilkie, Artist (1827–1903): His Work and Times," (Adirondack Museum Library, n.d., typescript).

5. "Nature's Forest Volume": *The Aldine,* the Adirondacks, and the Sylvan Landscape

1. For a succinct discussion of the history of *The Aldine* see Frank Luther Mott, *A History of American Magazines 1865–1885* (Cambridge, Mass.: Harvard Univ. Press, 1957), 410–12; see 181–91 passim for the journal's role in art education.

2. Back wrapper, part 1 of *Picturesque America.* For an excellent history and analysis of the making of *Picturesque America* and its competition with illustrated periodicals like *The Aldine,* see Sue Rainey, *Creating Picturesque America.*

3. George Henry Smillie's *Adirondack Scenery—Morning on the Ausable* was first published in *The Aldine* 5 (Feb. 1872): 95, and then used as the cover of *Illustrated Christian Weekly* 9 (Oct. 18, 1879).

4. These words flank the logo of the Sutton publishing house, which is a variation of the crest for Aldus Manutius, the fifteenth-century typographer for whom the journal is named. This logo and declaration headline *The Aldine's* prospectus for 1872 featured on the back page of *The Aldine Dinner Supplement* of March 1, 1872. The banquet included representatives from the major newspapers and magazines of the Northeast, key literary figures including speakers Bayard Taylor and Mark Twain, and such prominent artists as William Hart, Thomas Moran, and architect Richard Morris Hunt.

5. At the banquet Schuyler Colfax, who presided, introduced this ambitious declaration with the following: "the young lady," that is, *The Aldine*, "has proved herself during the last year to be a reigning belle—her admirers nearly doubling" and "as her charms will develop with age" she then will "emphatically say, 'The whole boundless continent is ours.'" See *The Aldine Dinner Supplement*, 1. The publishers and editor then incorporated this declaration in their introduction to the seventh bound volume. In addition, they elaborated on Colfax's discussion of Aldus Manutius. See, "Introduction," *The Aldine* 7 (1874–75).

6. Ibid.

7. Reverend T. DeWitt Talmage included these words in his oration on the importance of pictures during the banquet. See *The Aldine Dinner Supplement*, 2.

8. "Introduction."

9. Prospectus for 1872, *The Aldine* 4 (Dec. 1871): 203.

10. Ibid.

11. Stoddard wrote a poem celebrating the restorative powers of McEntee's art, especially for the urban dweller. See "To Jervis McEntee, Artist," from "The Book of the East" in *The Poems of Richard Henry Stoddard, Complete Edition* (New York: Charles Scribner's Sons, 1880), 322.

12. *Dictionary of American Biography* (New York: 1936), 18: 57–59. See also, A. R. Macdonough, "Richard Henry Stoddard," *Scribner's Magazine* 20, no. 5 (Sept. 1880): 686–94.

13. "Introduction."

14. This view was commonly voiced in art and literary criticism beginning in the late 1840s; the English critic John Ruskin and America's cultural minister, Henry Ward Beecher, established a tradition that others followed. The antebellum art periodical *The Crayon* (1855–61) provided one of the most impassioned arguments for the reformative powers of a nature-inspired art. See Janice Simon, "*The Crayon* 1855–1861: The Voice of Nature in Criticism, Poetry, and the Fine Arts," (Ph.D. diss., Univ. of Michigan, 1990). *The Aldine* advanced the interrelationship between art, nature, education, aesthetic taste, and morality in the editorial "Art," *The Aldine* 4 (Jan. 1871): 18–19.

15. "Introduction."

16. Frederick Jackson Turner first delivered "The Significance of the Frontier in American History," at the meeting of the American Historical Association in Chicago, July 12, 1893. Although Stoddard, devoted to Northeastern culture, cannot be accredited with a frontier mindset equal to Turner's, *The Aldine's* cultural rhetoric and nature references do partake of Turner's environmental determinism. Ray Allen Billington points out that theories linking American democracy and ambition to the physical attributes of the continent were voiced as early as the 1860s. See *The Genesis of the Frontier Thesis: A Study in Historical Creativity* (San Marino, Calif.: The Huntington Library, 1971).

17. In commentary on this picture, Stoddard assails the stubborn ignorance of those who criticize without the writer's or painter's extended knowledge of nature. Only those who diligently study the subjects of their creation truly know what is "real." See "The Critics," *The Aldine* 6 (Jan. 1873): 15.

18. Elizabeth Stoddard, "Nature's Forest Volume," *The Aldine* 6 (Aug. 1873): 161.

19. Sometimes the editor added poetry below an illustration to spark a response or foster an anthropomorphic mindset in the reader. The following poetic lines embellished the rather dark, atmospheric wetland scene that appeared in the middle of page 314, a page whose text was about a romance set during the American Revolution:

> How many centuries of change and chance
> Those gnarled gray trunks have sentineled, calm and still,
> Above the pool where slanting sunbeams glance
> And the grave heron wets his tawny bill!
> How many more will pass with all they bear
> Of human toil, of struggles lost and won
> Ere man's decay these brookside monarchs share,
> And on the sylvan nook unbroken shines the sun!

Such references to the cycles of life and death were a commonplace in forest imagery, whether visual or written. Celebrated poet and *Post* editor William Cullen Bryant codified the type in his "A Forest Hymn" of 1825; it was incessantly invoked throughout the century. In *The Aldine*'s illustration, the sense of foreboding is further accentuated by the gnarled, labyrinthine branches that block out much of the distant light. See *The Aldine* 7 (Apr. 1875): 314.

20. Elizabeth Stoddard, "Nature's Forest Volume," 161–62.

21. The poem "The Forest Spring" by W. W. Bailey opened with the lines:

> TALL, arching birches toward the sky
> Their leafy branches rear on high;
> They roof me o'er with living green,
> With rifts of azure in between,
> Where fleecy clouds in quiet lie.

The Aldine 6 (Oct. 1873): 193. The two pictures are essentially full-page engravings produced for the journal—Worthington Whittredge's "A Catskill Brook" and John Hows's "White Birches of the Saranac"—each accompanied by a short article on the virtues of the birch tree. See discussion that follows as well as notes 21 and 22. Although volume 5 of 1872 includes many references to the forest, volume 6 of 1873 contains an extraordinary amount, so much so that it truly seems to be "Nature's Forest Volume."

22. The article, directed at assigning character traits to the birches in Worthington Whittredge's *A Catskill Brook* engraved on the same page, discussed the variety of birches common to New England and New York. The author, probably Richard Stoddard, praised Whittredge for his "feeling for Nature," which "is as tender as his knowledge is accurate." "A Catskill Brook," *The Aldine* 6 (Apr. 1873): 82.

23. "White Birches of the Saranac," *The Aldine* 6 (Mar. 1873): 58.

24. For an extended analysis of the complex responses by male writers to American nature as alternately a virginal and a maternal space, see Annette Kolodny, *The Lay of the Land: Metaphor as Experience and History in American Life and Letters* (Chapel Hill: Univ. of North Carolina Press, 1975).

25. *The Aldine* referred to Taine periodically, including his *Philosophy of Art,* translated by John Durand. See Fuller-Walker, "Wilhelm Von Kaulbach," *The Aldine* 7 (1874): 114.

26. In the closing paragraphs of her essay, Elizabeth Stoddard admonishes Americans for their irresponsible alteration of the environment to the point of the outright destruction and extermination of species. She promotes conservationist policies and an ecological understanding of species and habitat. In fact, Stoddard even hints at the interdependence of human welfare and the natural environment. See Stoddard, "Nature's Forest Volume," 163.

27. Stoddard actually claims that during the rainy season "language cannot describe the appearance of these forests" and that "the landscape takes a physiognomy which the pencil of a painter would be unable to express." Ibid., 162–63.

28. "A Tropic Forest" from *Montgomery's Pelican Island* in *The Aldine* 5 (Jan. 1872): 20.

29. "Flights Through Florida," *The Aldine* 7 (May 1874): 93–95. *The Aldine* pointed out the difficult and even dangerous swampy channel of the Ocklawaha River. It is this passage that equally informs Woodward's hummock image. For visual evidence of competition between Appleton's projects and *The Aldine,* compare Woodward's frontispiece, *Moonlight on the Coast of Florida* (p. 90) and *Silver Springs, Florida* (p. 94) to Harry Fenn's steel engraving and illustrations for *Picturesque America* (New York: Appleton's, 1872): 1, 17–30. Fenn's earlier versions first appeared in *Appleton's* 4 (Nov. 12, 1870): 577–84.

30. "Isles of the Amazons," *The Aldine* 8, no. 7 (1876–77): 223.

31. "Scene in Venezuela," *The Aldine* 8, no. 11 (1876–77): 349.

32. As Professor James Orton declared, "The exuberance of nature displayed in these million square acres of tangled, impenetrable forest offers a bar to civilization nearly as great as its sterility in the African deserts. . . . The reckless competition among both small and great adds to the solemnity and gloom of a tropical forest." *The Andes and the Amazon; or, Across the Continent of South America,* 3rd ed. (New York: Harper & Brothers, 1876), 287. For an excellent overview of American artists' fascination with the tropics, see Katherine Emma Manthorne, *Tropical Renaissance: North American Artists Exploring Latin America, 1839–1879* (Washington and London: Smithsonian Institution Press, 1989). For an extensive analysis of the iconology of the swamp and jungle in American culture, see David C. Miller, *Dark Eden: The Swamp in Nineteenth-Century American Culture* (Cambridge: Cambridge Univ. Press, 1989).

33. John Hows's, *Kettle Run, Altoona* appeared in *The Aldine* 7, no. 7 (1874–75): 134. Worthington Whittredge's *A Catskill Brook* illustrated a discussion of the wonders of the White Birch, *The Aldine* 6 (Apr. 1873): 82.

34. See "The Yellowstone Region," *The Aldine* 6 (Apr. 1873): 74–75; "Colorado Scenery," *The Aldine* 6 (Sept. 1873): 174–75; "Utah Scenery," *The Aldine* 7, no. 1 (1874–75): 14–15.

35. The rhetoric continues to elevate the American artist as heroic interpreter of nature's grandeur: "With genius equal to any; with the requisite knowledge; with a determination to overcome all obstacles; with the pluck

to undertake laborious and costly expeditions, by sea and land, to paint equatorial mountain chains of Arctic ice-fields, the American landscapist has placed himself at the head of all others." The other illustration is a smaller, port-hole and bird's eye view of mountainous coast-line. "Midsummer Art," *The Aldine* 9 (1878–79): 204.

36. "The Adirondacks," *The Aldine* 6 (Aug. 1873): 154–55. For an extended history of responses to the Adirondacks see Terrie, *Forever Wild*.

37. "The Heart of the Adirondacks," *The Aldine* 5 (Oct. 1872): 194–96.

38. Grey, in effect, turns the picture into a paraphrase of William Cullen Bryant's poem, "A Forest Hymn." Sidney Grey, "The Adirondacks," *The Aldine* 9 (1878–79): 18–19.

39. During the last quarter of the nineteenth century, Americans defined masculinity in terms that blurred distinctions between the civilized, the primitive, and the animalistic. Virility, savagery, and struggle became synonymous. See E. Anthony Rotundo, *American Manhood: Transformations in Masculinity from the Revolution to the Modern Era* (New York: Basic Books, 1993): 222–32.

40. Two additional examples by John S. Davis are *A Bear Hunt, The Aldine* 8, no. 1 (1876–77): 37 and *Swan Shooting on the Red River, The Aldine* 8, no. 6 (1876–77): 190.

41. "The Pine Marten," *The Aldine* 6 (May 1873): 102. A discussion of the weasel, "the imp of the forest, the cruel and sly enemy of the birds," shies away even less from outright brutality: "The weasel is a great lover of fresh, warm blood, and will often attack animals much larger than itself, fastening about the throat and sucking the blood until the animal becomes exhausted." "The Weasel," *The Aldine* 4 (Oct. 1871): 153.

6. The Hermit of Phantom Island: John Henry Hill's Etchings of Lake George

1. Seneca Ray Stoddard, *Lake George: A Book of Today* (Albany: Van Benthuysen Steam Printing House, 1875), 96.

2. Milbert, *Itinéraire pittoresque,* plate 24.

3. Charlotte Julie Bonaparte, Comtesse de Survilliers, *Vues pittoresques de l'Amérique dessinées par la Comtesse Charlotte De Survillier* [*sic*] (Paris? 1824). The lithographs are by Joubert, after the countess's drawings.

4. David McNeely Stauffer, *American Engravers upon Copper and Steel* (New York: Grolier Club, 1907), part 2, no. 2243. Stauffer 2244 is another view of Lake George.

5. James Fenimore Cooper, *The Last of the Mohicans* (New York: Dodd, Mead & Company [1951]), 243n.

6. James K. Kettlewell, "Landscape Painting and Lake George in the 19th Century" in *Artists of Lake George, 1776–1976* (Glens Falls, N.Y.: The Hyde Collection, 1976), 9–13.

7. *Currier & Ives: A Catalogue Raisonné: A Comprehensive Catalogue of the Lithographs of Nathaniel Currier, James Merritt Ives and Charles Currier, Including Ephemera Associated with the Firm, 1834–1907* (Detroit, Mich.: Gale Research Company, 1984), 2: no. 3675. Nos. 3676 and 3677 are also Lake George views and are also undated.

8. On the life and work of John Hill, see Koke, "John Hill, Master of Aquatint, 1770–1850," 51–117; Koke, *A Checklist of the American Engravings of John Hill (1770–1850)* and Tobin Andrews Sparling, *American Scenery: The Art of John & John William Hill* ([New York]: The New York Public Library, 1985).

9. Sparling, *American Scenery.*

10. Emmons, *Geology of New-York.* Hill's views are plates XIII, XIV, and XV.

11. Headley, *The Adirondack,* opp. 20l.

12. See Linda S. Ferber and William H. Gerdts, *The New Path: Ruskin and the American Pre-Raphaelites* (New York: The Brooklyn Museum/Schocken Books Inc., 1985). The work of both Hills, father and son, is discussed at great length, including a watercolor by John Henry Hill, *Evening at Lake George,* dated October 1869.

13. The best reference on these artists is still Allen Staley, *The Pre-Raphaelite Landscape* (Oxford: Oxford Univ. Press, 1973).

14. A. L. S. to S. R. Koelher, June 3, 1880. S. R. Koehler Papers, Archives of American Art.

15. Murray, *Adventures in the Wilderness.*

16. This visit is documented in the watercolor *Evening at Lake George,* dated Oct. 1869, which was included in the exhibition *The New Path: Ruskin and the American Pre-Raphaelites,* no. 24.

17. Note in artist's file, the Adirondack Museum, Blue Mountain Lake, N.Y..

18. Diary. Unless otherwise noted, the following account of Hill's stay on Phantom Island is drawn exclusively from his diary in the Adirondack Museum Library.

19. Diary.

20. See Diary (Dec. 30, 1870, Jan. 7, 1871, and Jan. 19, 1871). On Jan. 19, "Mr. Taylor" from Bolton Landing helped Hill take the press to the island on a "hand sleigh," crossing a "couple of cracks with considerable difficulty."

21. Philip Gilbert Hamerton, *Etching and Etchers* (London: MacMillan Co., 1868), 312–15.

22. For example, Hill's friend and fellow pre-Raphaelite Henry Farrer constructed the press used by the New York Etching Club. See Maureen C. O'Brien and Patricia C. F. Mandel, *The American Painter-Etcher Movement* (Southampton, N.Y.: The Parrish Art Museum, 1984), 9. Letters from Hill to Farrer are in the Gordon L. Ford Collection, New York Public Library.

23. Hill's involvement with the American etching revival is discussed in some detail by Rona Schneider in "The Birth of American Painter-Etching, 1866–1882" (master's thesis, Queens College, City University of New York, 1978), 159–61. Schneider minimized Hill's involvement with the movement, presumably because he never joined the New York Etching Club, but it is clear Hill's contemporaries were well aware of his work. He was represented by no less than seven works in the important exhibition of American etchings held at the Museum of Fine Arts, Boston, in 1881; in addition, variant proofs of one of his etchings, *Crossing the River at Farmington* (see below), were exhibited in a separate room demonstrating the technique.

24. Diary (Apr. 20, 1871).

25. Diary (Dec. 23, 1871). This is presumably the watercolor of Little Falls now in the New-York Historical Society. See Richard J. Koke, *American Landscape and Genre Painting in The New-York Historical Society* (New York: New-York Historical Society; Boston: G. K. Hall & Co., 1982), 2: no. 1210.

26. Diary (Sept. 12, 1871). Present location unknown.

27. Hill sent copies of those prints he considered his most successful to Sylvester Koehler, who included a list in his essay on Hill in *The American Art Review* I (1880): 429–30. Hill's letter to Koehler, referring to these prints, is dated May 17, 1880, and is in the S. R. Koehler Papers, Archives of American Art.

28. Seneca Ray Stoddard, *Lake George: A Book of Today* (Albany: Weed, Parsons & Co., 1873), 84: "Alighting where a noisy brook tumbles in . . . and following up a little way, you will be rewarded by the sight of a perfect little gem called Shelving Rock Falls."

29. Benjamin Franklin da Costa, *Lake George: Its Scenes and Characteristics,* 59.

30. *Nelson's Guide to Lake George and Lake Champlain* (London: T. Nelson and Sons, 1868), 15.

31. Diary (Apr. 22, 1871).

32. Diary (Feb. 21–25, 1871).

33. Diary (Nov. 6, 1871): "Cold and windy. Chopped some wood and etched on map of the island[s?]."

34. Hill also identified Turtle, Phelps, Flora, Perch, and Fourteen Mile Islands on his map. Of these, only Turtle Island and Fourteen Mile Island retain the same names today. Phelps is now known as Mohican Island, Flora as Oahau Island, Perch as Bass Island. I have not been able to ascertain the current name, if any, for the group of rocks Hill called "Gull Rocks" on his map.

35. Diary (Oct. 30, 1873).

36. According to Seneca Ray Stoddard, *Saratoga Springs . . .* (Glens Falls, N.Y.: S. R. Stoddard Publisher, 1881), 97, these events took place in 1876. A note in the artist's file in the Adirondack Museum places them in 1877. In the absence of other evidence, I am inclined to believe Stoddard's date is correct.

37. Thomas Reeves Lord, *Stories of Lake George Fact and Fancy* (Pemberton, N.J.: Pinelands Press, 1989), 89.

38. John Scott, "The Hill Family of Clarksville," *South of the Mountains* 19, no. 1 (Jan.–Mar. 1975): 12.

7. Winslow Homer's Adirondack Prints

1. The essential critical biography of Homer remains Lloyd Goodrich, *Winslow Homer* (New York: Macmillan, 1944). An important recent study, incorporating new information about the artist and his work, is Nicolai Cikovsky and Franklin Kelly, *Winslow Homer* (Washington: National Gallery of Art, 1995). For Homer's visits to the Adirondacks, see David Tatham, *Winslow Homer in the Adirondacks* (Syracuse: Syracuse Univ. Press, 1996).

2. For a chronology of Homer's visits to the Adirondacks, see Tatham, *Homer,* 137.

3. The photograph is reproduced in Tatham, *Homer,* 63.

4. All of the oil paintings mentioned in this essay are reproduced in Tatham, *Homer.*

5. For reproductions of most of these wood engravings, see Philip C. Beam, *Winslow Homer's Magazine Engravings* (New York: Harper & Row, 1979).

6. Leila Fosburgh Wilson, *One Hundred Years in the Adirondack Wilderness: The North Woods Club, 1886–1986* (Minerva, N.Y.: privately printed, 1986) 7–10.

7. Tatham, *Homer,* 38–39.

8. Stephanie Loeb Stepanek, *Winslow Homer* (Boston: Museum of Fine Arts, 1977), 21.

9. *Lake Shore* is reproduced in *Winslow Homer in the Adirondacks,* exhibition catalogue (Blue Mountain Lake, N.Y.: The Adirondack Museum, 1959), 37.

10. Bibby received *Prospect Rock,* reproduced in *Winslow Homer in the Adirondacks* (1959), 80.

11. North Woods Club register, Adirondack Museum.

12. North Woods Club minute book, vol. 4, entry for Oct. 27, 1910.

13. For Homer's etchings, see Lloyd Goodrich, *The Graphic Art of Winslow Homer* (New York: The Museum of Graphic Art, 1968), 13–19.

14. Ibid., fig 101.

15. Goodrich, *Homer* (1944), 117–22.

16. Reproduced in Beam, *Magazine Engravings,* 196.

17. Ibid., 176.

18. Biographies and biographical sketches of Homer long maintained that the artist's last visit to the Adirondacks occurred in 1908, but examination of the North Woods Club register shows without question that he spent ten days at the clearing in 1910. His presence in 1910 was reported by the present author in a paper read at the National Gallery of Art in 1986 and later published as "Winslow Homer at the North Woods Club," in Nicolai Cikovsky, ed. *Winslow Homer: A Symposium* (Washington, D.C.: National Gallery of Art, 1990), 114–30.

8. "A Passion for Fishing and Tramping": The Adirondacks Etched by Arpad G. Gerster, M.D.

1. Arpad G. C. Gerster, *Recollections of a New York City Surgeon* (New York: Paul B. Hoeber, 1917), 316.

2. See Elton W. Hall, "R. Swain Gifford and the New York Etching Club," in *Prints and Printmakers of New York State, 1825–1940,* ed. David Tatham (Syracuse: Syracuse Univ. Press, 1986), 183–212.

3. Dr. William Mayo to Arpad G. C. Gerster, Mar. 4, 1897, Adirondack Museum Library.

4. E. P., "Gerster, Arpad Geyza Charles," *Dictionary of American Biography* (New York: Scribners 1959), 3: 228–29.

5. Arpad G. C. Gerster, "Etching as a Diversion," *The Medical Pickwick* (Oct. 1916): 365.

6. Ibid., 363.

7. Ibid., 367.

8. See Frank Weitenkampf, *American Graphic Art* (1924; reprint, New York and London: Johnson Reprint Corp., 1970) for discussion of painter-etchers and etchers and etching clubs.

9. Rona Schneider, "The Career of James David Smillie (1833–1909) as Revealed in His Diaries," *The American Art Journal* 16, no. 1 (Winter 1984): 4–33.

10. Gerster, *Recollections,* 315–16.

11. Pauline Goldmark, "Keene Valley Artists," (Keene Valley Library, Keene Valley, N.Y., 1940, typescript).

12. Gerster, *Recollections,* 317.

13. Ibid., 318 and Schneider, "The Career of James David Smillie," 33.

14. Gerster, *Recollections,* 318.

15. E. S. Lumsden, *The Art of Etching* (New York: Dover Publications, 1963), 63–65.

16. Gerster, *Recollections,* 320.

17. Diary (Aug. 12, 1896), "Notes Collected in the Adirondacks," 1895–98, Adirondack Museum Library.

18. Gerster, *Recollections,* 278.

19. Gerster, *Recollections,* 283. Also Diary (Sept. 8, 1895), "An Excursion to Saranac Lake."

20. Diary (Sept. 24, 1896), "Early Facts about Raquette Lake."

21. Gerster, *Recollections,* 281.

22. Ibid., 276.

23. Gerster, "Etching as a Diversion," 367.

24. Ibid., 367.

25. Gerster, *Recollections,* 320–21.

26. Ibid., 312–14.

27. P10034, caption by John C. A. Gerster, Adirondack Museum Collection.

28. Diary (May 26, 1897).

29. Throughout Dr. Gerster's Diary he makes many references to making sick calls and treating his friends and neighbors.

30. Gerster, *Recollections,* 283.

31. Gerster, "Etching as a Diversion," 368.

32. Bernard Sachs, "Dr. Gerster: As Man and Scholar," reprinted from proceedings of the Charaka Club, vol. 5., Adirondack Museum Library.

9. Responding to Nature: David Milne's Adirondack Prints

1. David Milne to James Clarke, Nov. 13, 1927, Milne Papers, National Archives of Canada.

2. For more information on Milne's development at this time, see John O'Brian, *David Milne: The New York Years 1903–1916* (Edmonton: Edmonton Art Gallery, 1981). For further reading on Milne's entire career, see Ian M. Thom, ed., *David Milne* (Vancouver: Douglas & McIntyre, 1991).

3. Rosemarie L. Tovell, *Reflections in a Quiet Pool: The Prints of David Milne* (Ottawa: The National Gallery of Canada, 1980), nos. 1–22.

4. Maria Tippet, *Art at the Service of War: Canada, Art and the Great War* (Toronto, Buffalo, London: Univ. of Toronto Press, 1984). The Canadian scheme, established in 1916, was the first of its kind. It was so successful as a propaganda tool, the British formed their own the following year.

5. James Alfred Clarke (1886–1969) was a commercial artist who worked under the pseudonym of René Clarke. He was employed by the advertising firm of Calkins & Holden and rose to the top of his profession. Clarke not only purchased Milne's art, he organized small exhibitions in the firm's offices from which fellow workers and clients made purchases. Clarke and Milne had a special rapport, and their correspondence on matters of art and life often was Milne's sole outlet for dialogue on his work. This especially rich correspondence can be found with the Milne Papers at the National Archives of Canada in Ottawa.

6. The Milne letters to Clarke written during the Adirondack years are recommended for the beautiful and affectionate descriptions of the local people, flora, and fauna Milne encountered. They give a fascinating account of the everyday world of the Adirondacks, without the glitter of the region's well-to-do tourist and summer residents. In the forties Milne wrote a chapter on his summer at Dart's Lake for his unpublished autobiography. The manuscript remains with the Milne estate.

7. Milne to Clarke, June 1923, Milne Papers.

8. The building took its shape from the topography of the lot, which rose in a series of steep climbs to a clifftop. The house was built with its back close to the hillside, and the pitches of the several rooflines from the second story at the back to the porch at the front replicated the contours of the hill. Milne also went to a great deal of trouble with the decorative interior detail: deer were carved into the newel post; a large stone fireplace was made with

rocks split to create reverse patterning; and the plaster walls were tinted in several shades of green found in the local vegetation.

9. Milne to Clarke, Sept. 24 and Oct. 1, 1926, Milne Papers. The road around the lake was made by the local residents. To ensure the road did not come too close to his house, Milne helped with its construction.

10. Rosemarie L. Tovell, *David Milne, Painting Place* (Ottawa: National Gallery of Canada, 1976).

11. Milne to Clarke, Apr. 11 and 25, 1926, Milne Papers.

12. Milne to Clarke, Nov. 30, 1925, Milne Papers.

13. Milne to Clarke, Jan. 10, 1927, Milne Papers.

14. Milne's previous work in etching was limited. He had simply prepared the ground and scratched the plates, which were etched and printed by the master printer Peter J. Platt at his printshop in Lower Manhattan.

15. Milne to Clarke, Jan. 7, 1927, Milne Papers.

16. The concept of "aesthetic emotion," a cornerstone of Milne's art theory, was borrowed from Clive Bell's *Art* (London: Chatto & Windus, 1914). Milne began reading Clive Bell in 1920. But his use of Bell's ideas and terminology were not expressed in his writings until the early thirties, when Milne had fully developed his very personal theoretical apparatus.

17. Tovell, *Reflections in a Quiet Pool*, 40.

18. In 1930 Milne received a commission for *Painting Place (Large Plate)* from *The Colophon*. To print the large edition of 3,000, Milne went through at least six pairs of steel faced plates and simplified the inking to black and green. The print was included in the March 1931 issue.

19. Duncan ran a small art rental dealership in Toronto known as the Picture Loan Society. When he first met Milne in 1935, he wanted to sign Milne on, but Milne's existing commitment to another dealer for his paintings and watercolors meant Duncan could only handle Milne's prints. From 1935, when Duncan purchased his first group of color drypoints, he began to form a complete collection of all the prints in all their states and color schemes. Milne donated many to this collection, which was being formed for the National Gallery of Canada. The prints entered the Gallery's collection following Duncan's death in 1968.

Duncan eventually was able to handle all of Milne's work and he became Milne's principal patron. At least one example of Milne's art from his vast collection was deposited with every public art collection in Canada.

Selected Bibliography

REFERENCES TO THE ADIRONDACKS as subject in written and visual form are numerous and date from the eighteenth century. Literature mentioning the Adirondacks incidentally is vast and primarily takes the forms of gazetteers, state documents, advertising, annual reports, newspaper articles, geographies, and fiction. Books and articles devoted exclusively to the Adirondacks, while less numerous, are growing in number. Major repositories of primary and secondary resources on Adirondack history and culture reside within the region. They include the Adirondack Museum, both in its library and in the research files of the Curatorial Department in Blue Mountain Lake; the Adirondack Research Center of the Association for the Protection of the Adirondacks in Schenectady; the Adirondack Room of the Saranac Lake Free Library in Saranac Lake; the Loomis Collection and related collections at the Keene Valley Public Library, Keene Valley; the Adirondack Book Collection at the Sherman Free Library, Port Henry; the historical collection at the Crandall Library, Glens Falls; and the special collection in the New York State Room at SUNY Plattsburgh.

In addition to primary and secondary sources on the Adirondacks, the Adirondack Museum library and curatorial collections encompass manuscripts, diaries, periodicals, newspapers, ephemera, auction records, travelogues and guidebooks, government reports, and a unique assemblage of research notes on artists at work in the Adirondacks compiled by Margaret Goodwin O'Brien. The regional focus of this extensive file is an invaluable resource to museum staff and researchers in the field of American art.

Basic to the study of an Adirondack subject are the *Adirondack Bibliography* (Gabriels, N.Y.: Adirondack Mountain Club, 1958) and the *Adirondack Bibliography Supplement, 1956–1965* (Blue Mountain Lake, N.Y.: The Adirondack Museum, 1973), both compiled by Dorothy A. Plum. Thousands of entries are organized by subject—travel and exploration, recreation, conservation, art and literature, natural history, etc.—and date. The highly informative introduction to the *Supplement* by the late William K. Verner, former curator of the Adirondack Museum, discusses works devoted to Adirondack history and Adirondack writings in seven time periods beginning with the colonial period. Useful references to works that are primarily illustrations, such as *Every Saturday* and *The Aldine,* provide resources for visual and art historians.

For a complete list of all works and articles cited in these essays the reader should consult the end notes. The following list enumerates works that provide scholarly, informative, and sometimes entertaining insights to Adirondack history, art, and culture.

Ackerman, David H., ed. *Placid Lake: A Centennial History, 1893–1993.* Lake Placid, N.Y.: The Shore Owners Association of Lake Placid, Inc., 1993.

Aber, Ted, and Stella King. *History of Hamilton County.* Lake Pleasant, N.Y.: Great Wilderness Books, 1965.

Barnhill, Georgia B. *Wild Impressions: The Adirondacks on Paper.* Blue Mountain Lake, N.Y.: The Adirondack Museum; Boston: David R. Godine, 1995.

Bellico, Russell P. *Chronicles of Lake George: Journeys in War and Peace.* Fleischmanns, N.Y.: Purple Mountain Press, 1995.

Cadbury, Warder H., and Henry P. Marsh. *Arthur Fitzwilliam Tait: Artist in the Adirondacks.* Newark, Del.: American Art Journal/University of Delaware Press, 1986.

Colvin, Verplanck. Reports for New York State Adirondack Land Survey conducted between 1873 and 1900, published as Assembly Documents. Albany: Weed, Parsons.

Donaldson, Alfred L. *A History of the Adirondacks.* 2 vols. Harrison, N.Y.: Harbor Hill Books, 1977.

Emerson, Ralph Waldo. "The Adirondacs, A Journal," in *Poems.* Boston: Houghton Mifflin and Co.; Cambridge, Mass.: The Riverside Press, 1892.

Emmons, Ebenezer. *Documents of the Assembly of the State of New York.* Albany: published 1837–1841.

Gilborn, Craig. *Adirondack Furniture and the Rustic Tradition.* New York: Harry N. Abrams, 1987.

Graham, Frank Jr. *The Adirondack Park: A Political History.* New York: Alfred A. Knopf, 1978.

Hammond, Samuel H. *Hills, Lakes, and Forest Streams; or, A Tramp in the Chateaugay Woods.* New York: J. C. Derby, 1854.

————. *Wild Northern Scenes; or, Sporting Adventures with the Rifle and the Rod.* Philadelphia: John E. Potter, 1863.

Headley, Joel Tyler. *The Adirondack; or, Life in the Woods,* 1849. Reprint, with an introduction by Philip G. Terrie, Harrison, N.Y.: Harbor Hill Books, 1982.

Hochschild, Harold K. *Township 34: A History with Digressions on an Adirondack Township in Hamilton County in the State of New York.* New York: privately printed, 1952.

Hoffman, Charles Fenno. *Wild Scenes in the Forest and Prairie.* New York: W. H. Colyer, 1843.

Jamieson, Paul, ed. *The Adirondack Reader.* Glens Falls, N.Y.: The Adirondack Mountain Club, Inc., 1982.

Jones, Barbara. *Nature Staged: The Landscape and Still Life Paintings of Levi Wells Prentice.* Blue Mountain Lake, N.Y.: The Adirondack Museum, 1993.

Kaiser, Harvey H. *Great Camps of the Adirondacks.* Boston: David R. Godine, 1982.

Mandel, Patricia C. F. *Fair Wilderness: American Paintings in the Collection of the Adirondack Museum.* Blue Mountain Lake, N.Y.: The Adirondack Museum, 1990.

McGrath, Robert L. *Scenes of Placid Lake.* Lake Placid, N.Y.: Thorner Press, 1993.

————. *A Wild Sort of Beauty: Public Places and Private Visions.* Blue Mountain Lake, N.Y.: The Adirondack Museum, 1992.

Murray, William Henry Harrison. *Adventures in the Wilderness; or, Camp-Life in the Adirondacks.* 1869. Reprint, with preface by William K. Verner and introduction and notes by Warder H. Cadbury, Blue Mountain Lake, N.Y.: The Adirondack Museum; Syracuse: Syracuse Univ. Press, 1970.

Pell, Robin. *Keene Valley: The Landscape and Its Artists.* New York: Gerald Peters Gallery, 1994.

Pilcher, Edith. *Up the Lake Road: The First Hundred Years of the Adirondack Mountain Reserve.* Keene Valley, N.Y.: The Adirondack Mountain Reserve, 1987.

Street, Alfred Billings. *Woods and Waters; or, The Saranacs and Racket.* New York: M. Doolady, 1860.

———. *The Indian Pass.* New York: Hurd and Houghton, 1869.

Tatham, David. *Prints and Printmakers of New York State, 1825–1940.* Syracuse: Syracuse Univ. Press, 1986.

———. *Winslow Homer in the Adirondacks.* Syracuse: Syracuse Univ. Press, 1996.

Terrie, Philip G. *Contested Terrain: A New History of Nature and People in the Adirondacks.* Blue Mountain Lake, N.Y.: The Adirondack Museum; Syracuse: Syracuse Univ. Press, 1997.

———. *Forever Wild: Environmental Aesthetics and the Adirondack Forest Preserve.* Philadelphia: Temple Univ. Press, 1985; reprint as *Forever Wild: A Cultural History of Wilderness in the Adirondacks.* Syracuse: Syracuse Univ. Press, 1994.

Todd, John. *Long Lake.* Pittsfield, Mass.: E. P. Little, 1845.

Verner, William K. "Adirondack Park: A Painterly Celebration of the First Wilderness Preserve," *Wilderness* 48, no. 169 (Summer 1985).

———. "Art and the Adirondacks," *The Magazine Antiques* 100, no. 1 (July 1971).

Warner, Charles Dudley. *In the Wilderness.* 1878. Reprint with an introduction by Alice Wolf Gilborn, Blue Mountain Lake, N.Y.: The Adirondack Museum; Syracuse: Syracuse Univ. Press, 1990.

Welsh, Caroline Mastin "Masterworks of the Adirondacks." *American Art Review* 9, no. 4 (August 1997).

———. "The Most Beautiful Water Ever Seen: The Art of Celebrating Lake George." *Adirondack Life.* 28, no. 5 (August 1997).

———. "Paintings of the Adirondack Mountains," *The Magazine Antiques* 152, no. 1 (July 1997).

White, William Chapman. *Adirondack Country.* New York: Alfred A. Knopf, 1954.

Ausable River Valley, 11, 163, 178
AutoRoad Map of the Adirondacks (Stoddard), 23
Avalanche Lake (Vance), 98

Bailey, W. W., 191n. 21
Baker, Eunice, 128, 133, 134
Ballou, Maturin M., 72, 73
Ballou's Pictorial (magazine), 73
Ballston Spa, 47
Bartlett, William Henry, 51–52, *53,* 107
Bartram, John, 2
Bates, Wesley, 152, 154
Beard, Daniel Carter, 62, *65,* 66
Beaver Mountain, 132
Beecher, Henry, 190n. 14
"Bee Hunting in the Adirondacks" (Davis), 56
Bell, Clive, 160, 198n. 16
Benedict, Farrand N., 11–12, *12*
Bennett, Ed, 148
Bibby, Jennie and Robert, 134
Bichebois: lithographs for Milbert, 40; "Rapids on the Hudson at Adley's," *34;* "Saw-Mill near Luzerne," *32*
Big Moose Lake, 161–62
billboards, 23
Billington, Ray Allen, 191n. 16
Billy's Bald Spot, 162
birch trees, 91
Birmingham Falls, 77
Bitter, Karl, 149
"Black-Bass Fishing in the Adirondacks" (Zogbaum), 58, *59*
Black Mountain, 58, 107
Black Mountain from Caldwell Island (Hill), 113–14, *113,* 122, 124
Black River Canal, 11, 20–21
Blake, William, 24
Blodgett, Samuel, 2, 107
Blue Line, 21, 22
Blue Mountain Lake, 6, 8, 11, 14, 108
Bolton, 121–22
Boulders in the Bush (Second Version) (Milne), 164–66, *165*
Brassier, William, 2
Brazilian Forest (Heade), 92
Bricher, Alfred Thompson, 70, 107
Brodhead, Charles, 6
Brown, John, 11, 56, *74,* 163, 175, *176*
Brownville, 38, *39, 40,* 187n. 20
Bryant, William Cullen: "A Forest Hymn," 191n. 19, 193n. 38; *Picturesque America,* xxi, 51, *52,* 54; and Stoddard, 86

Bufford, John H.: lithographs of Ingham's views, 188n. 15; "View of the Indian Pass," *49*
Burns, Sarah, 45
Burt, Charles, 53
Butler, B. C., 19, 21

Calamity Pond (Vance), 98
Caldwell, 26, *78,* 107
Campfire (Homer), 126
camping, 56–58, 60
"Camping out as a Fine Art" (Rogers), 60
Camping Out in the Adirondack Mountains (Homer), 132, *133*
"Canoeing in the North Woods—A Carry" (Rogers), 58
Carey and Ley, 7, *7*
Carvill, G. & C. & H., 33, 34, 36
Cary, William de la Montagne, 58
Casilear, John W., 107
Catlin Lake, 11, *12*
Catskill Brook, A (Whittredge), 98, 192nn. 21, 22, 193n. 33
Cedar River, 8, 108
Champlain, Samuel de, 1
Champlain-Hudson Canal, 37
Charaka Club, 157
chromolithographs: Cook's criticism of, 71; of Currier and Ives, 71; demise of, 82; given to subscribers by *The Aldine,* 85; Prang's publication of, xxiii, 70–72
Clarke, James Alfred, 160, 162, 164, 198n. 5
Clews, Ralph and James, 37
Clinton, DeWitt, 6
Cohn, Marjorie B., 188n. 1
Cole, Thomas, 54, 107, 157
Cole, Timothy, 85
Colfax, Schuyler, 190n. 5
Collas, Louis Antoine, 37
color drypoint, xxiv–xxv, 159, 161, 163–66
color lithographs. *See* chromolithographs
Columbian Magazine, 46
Colvin, Verplanck: on an Adirondack Park, 48; on the Adirondacks as mysterious, xix; illustrations of, 51; as secretary to Adirondack Forest Commission, 21; survey of the Adirondacks, xix, 17, 19, *20, 51*
Cook, Clarence, 71
Cooper, James Fenimore, 107
Corinth, 33
Cozy Corner at Camp Oteetiwi (Gerster), 154, *155*
Cozzens, Frederick Schiller, 60
Crayon, The (periodical), 190n. 14
"Critics, The" (Moran), 87–88, *87*

Forked Lake, 6, 11
Fort Ticonderoga: Hill's *Fort Ticonderoga*, 122; Prior's "View of the Ruins of Fort Ticonderoga," *53*
Fort William Henry, 2, 107
Foundery on Jones's Creek Near Baltimore (Wall), 38
Frank Leslie's Illustrated Newspaper, 58, 60, *61, 65,* 73
Franklin, L. M., 85
French and Indian War, 2, *3*
Frontier Thesis, 87, 191n. 16
Frost, Arthur B., 62, 64
Fry, Roger, 160
Fuechsel, Hermann, xxiii, 72

Gamble's Cliff, 162
game wardens, 64
Gazetteer of the State of New York (Spafford), 47
General Map of the Middle North American Colonies in America, A (Evans), 2–4
Geographical, Statistical, and Historical Map of New York (Carey), 7, *7*
Geological Map of the State of New York, by Legislative Authority (1842), 8
Gerster, Anna Barnard Wynne, 140, 145
Gerster, Dr. Arpad G. C.: Adirondack images of, xxiv; *Alvah Dunning, 153,* 154; in Association for the Protection of the Adirondacks, 147; avocations of, 142; biography, 140, 142; in Charaka Club, 157; *Cozy Corner at Camp Oteetiwi,* 154, *155; Dawn in the Adirondacks,* 145, *146;* diary of, 147; "The Duo," *141,* 142; *The End of the Carry, 150;* on etching, 139, 142–43; *Lake and Mountains, 147;* at Long Lake, 145, 149; *My Camp at Carry Pond,* 156, *156;* North Creek, 149, 151, *151; A Northwoods Island,* 143, *143; Oteetiwi and Dandy, 148,* 149; as portraitist, 152; at Raquette Lake, 145, 148–49; *Recollections of a New York City Surgeon,* 142; *Rules of Aseptic and Antiseptic Surgery,* 140, 142; Sachs on, 157; self-portrait, *140;* and Smillie, 144–45; *Sumner Lake,* 151, *152;* Thoreau as influence on, 145; and Yale, 144, 155
Gerster, Dr. John C. A., 140, 145, 154
Gifford, Sanford R., 107
Gignoux, Regis François, 53
Gleason, Frederick, 72–73
Glen, The (Vance), *99,* 100
Glenmore Hotel, 161, 166, *167*
Glens Falls: Milbert's "Hudson Fall at the village of Gleens," 40, *41, 42;* and Wall's *Hudson River Port Folio,* 26
"Glens Falls" (Hill), 35
Goering, A., *96, 97*

Gore Mountain, 5
Great Adirondack Pass, The, Painted on the Spot (Ingham), xxii
Great Camps, 10
Great Camp style, 10, 162
Great Windfall of 1845, 14
Grey, Sidney, 100, 193n. 38
guidebooks: Ely's *Map of the New York Wilderness* in, 17; Headley's *The Adirondack; or, Life in the Woods,* 53–54, 108; and Merritt's work as first true guide, 14; Murray's *Adventures in the Wilderness,* xxi, 17, 56, 149, 183n. 2; *Nelson's Guide to Lake George and Lake Champlain,* 117; picturing the Adirondacks for people, xxi; Stoddard's *Lake George: A Book of Today,* 105, *106,* 123; Stoddard's *Lake George Illustrated,* 17; Stoddard's *The Adirondacks Illustrated,* 17
guides, 58, 64, 152, 154

"Hadley Falls" (Smith and Hill), 34–35, *35,* 108
Hall, Harrison, 47
Hamerton, Philip Gilbert, 111
Harper's New Monthly Magazine, 12–13
Harper's Weekly (magazine): Adirondack prints in, xxi, 56–68; "Adventures in Gorilla Land" article, 84; Homer's *Camping Out in the Adirondack Mountains,* 132, *133;* Homer's *Waiting for a Bite,* 131–32, *131;* illustrations as adjuncts to editorials, 64; Rix's "Destruction of Forests in the Adirondacks," *67,* 68; Rogers's "Lawing in the North Woods," 63, *64;* subscribers to, 54; Zogbaum's "Black-Bass Fishing in the Adirondacks," 58, *59*
Hart, James M., xxiii, 71–72
Heade, Martin Johnson, 92, 107
Headley, Joel T., xxi, 53–54, 108
Hill, Ann, 35
Hill, Caroline, 35
Hill, Charles, 109
Hill, David B., 21
Hill, George, 109, 118, 121
Hill, John: aquatints for Meade's *An Experimental Enquiry,* 47; aquatints for Shaw's *Picturesque Views of American Scenery,* 28, 108; "Glens Falls," 35; and grandson John Henry Hill, 108; "Hadley Falls," 34–35, *35;* "Junction of the Sacandaga and Hudson Rivers," 30–31, 33, 108; "Little Falls at Luzerne," 30, *31,* 108; in prospectus for *Hudson River Port Folio,* 28; "Rapids above Hadley's Falls," 33–34, *33;* "View near Jessup's Landing," 33, 108
Hill, John Henry: and American etching revival, 123, 194n. 23; "Artist's Retreat" on Phantom Island, 109, *110; Black Mountain from Caldwell Island,* 113–14, *113,* 122, 124;

Crossing the Stream, Farmington, Connecticut, 112, 122,
124; diary of, 106, 110, 123; etching press of, 111;
Evening at Lake George, 194nn. 12, 16; father's influence
on, 108–9; first visit to the Adirondacks of, 109; Fort
Ticonderoga, 122; and grandfather John Hill, 108; The
Island Pines, 114–16, 114, 120, 122; The Island Pines, Lake
George, 115–16, 115; The Island Stones, 118, 119, 120,
122; in King expedition, 109, 111; and Koehler, 123–24,
195n. 27; last years on Phantom Island of, 123; Map of
the Narrows, 111, 112, 118, 120–21, 121, 122; as pre-
Raphaelite, 109; residing in the Adirondacks, 54; and
Ruskin, 109; Sabbath Day Point, 122; sales by, 122;
Shelving Rock Falls views, 116–18; Sketches from Nature,
109, 111; and Stoddard, 105–6, 110–11, 122, 123, 195n.
36; Study on Lake George, 116, 120, 122; temporary in-
sanity of, 123; as third generation artist, xxiv, 105, 108–9;
on Thoreau, 116; and Turner, 109; Upper Cascades of
Shelving Rock, 117–18, 117; View from Bolton, Lake
George, 121–22; White Mountains from Gorham, N.H.,
112, 122
Hill, John William: in American pre-Raphaelite movement,
109; "Crossing the Stream, Farmington, Connecticut,"
112; with Emmons's survey, 48, 108, 188n. 15; Headley
publishing engravings after, 53, 108; "Lake Catharine,
Hamilton Co.," 50, 108; son John Henry Hill influenced
by, 108–9
History of the Adirondacks (Donaldson), 154
Holster Atlas (American Military Atlas), 2
Homer, Winslow: Adirondack journeys, 125; in Adirondack
Preservation Association (North Woods Club), 133, 134,
137; Adirondack prints of, xxiv, 126, 127, 137; aquatint
used by, 136; Campfire, 126; Camping Out in the
Adirondack Mountains, 132, 133; Deer-Stalking in the
Adirondacks in Winter, 128–29, 129; Eastern Shore, 82;
etchings of, 134–36; Fly Fishing, Saranac Lake, 135–36,
136; In the Mountains, 126; at Keene Valley, 125–26, 127,
136; Lake Shore, 132, 196n. 9; last Adirondack visit, 137,
196n. 18; Lumbering in Winter, 129, 130, 131; at Minerva,
125, 126, 127–28, 137; Netting the Fish, 134–36; The
North Woods, 82; On the Road to Lake George, 136–37; A
Quiet Day in the Woods, 136; The Trapper, Adirondack Lake,
126; Trapping in the Adirondacks, 127, 128; The Two
Guides, 126; Waiting for a Bite, 131–32, 131; and Wallace,
128; wood engravings of, 126–27, 136
Howitt, Mary, 103
Hows, John A.: Kettle Run, Altoona, 98, 193n. 33; Pines of the
Racquette, 88, 89, 91, 98; White Birches of the Saranac, 88,
90, 91, 192n. 21

Hubbard, Richard William, 48, 52, 54
"Hudson Fall at the village of Gleens" (Milbert), 40, 42
Hudson River Port Folio, The (Wall), xxii; arrangement of
plates in, 26; Carvills reissuing, 36; "Glens Falls," 35;
"Hadley Falls," 34–35, 35, 108; "Junction of the
Sacandaga and Hudson Rivers," 30–31, 33, 108; "Little
Falls at Luzerne," 30, 31, 108; and Milbert's Itinéraire pit-
toresque du fleuve Hudson, 25, 38, 44; models for, 28;
number of complete sets of original, 36; original water-
colors for, 37; prospectus for, 27; "Rapids above Hadley's
Falls," 33–34, 33; Smith's role in, 28, 29–31; in
Staffordshire pottery, 37; "View near Jessup's Landing,"
33, 108; waterfalls in, 41
Hudson River School: Cole, 54, 107, 157; Durand, 53, 54,
55; Lake George as subject of, 107; and Wall's Hudson
River Port Folio, 26; Whittredge, 98, 192nn. 21, 22, 193n.
33
Hulett's Landing, 60, 61
Hummock, Florida, A (Woodward), 92, 94
hunting, 56, 62–66
Huntington, Collis P., 11

Illustrated Christian Weekly, 84
Indian Lake, 4, 5
Indian Pass: Davis on, 57; Ingham's depictions of, 48; The
Source of the Hudson, in Indian Pass, 60; "View of the
Indian Pass," 49
"Indian Pass, The" (Palmer), 51, 51
Ingham, Charles Cromwell: accompanying Emmons's sur-
vey, xxii, 48, 188n. 15; The Great Adirondack Pass, Painted
on the Spot, xxii; Headley including engraving after, 53;
"View of the Indian Pass," 49
In the Mountains (Homer), 126
Island Pines, The (Hill), 114–16, 114, 120, 122
Island Pines, Lake George, The (Hill), 115–16, 115
Island Stones, The (Hill), 118, 119, 120, 122
Isles of the Amazons (Nemo), 95, 96
Itinéraire pittoresque du fleuve Hudson (Milbert), xxii; arrange-
ment of plates in, 26; "Extremity of Adley's Falls," 36;
Foundery on Jones's Creek Near Baltimore, 38; in French il-
lustrated book exhibition, 42–43; geographical range of
lithographs, 38; "Hudson Fall at the village of Gleens,"
40, 41, 42; issuance of, 39; Lake George view, 107;
Machine for Portage on the Susquehanna, 38; "Mills on the
Black River," 38, 39; Moniteur Universel review of,
41–42; "Rapids on the Hudson at Adley's," 34; "Saw-
Mill near Luzerne," 32; Smith's illustrations for, 38; sub-
title of, 38; and Wall's Hudson River Port Folio, 25, 38, 44;

"Little Falls at Luzerne," 30, *31*, 108; John Henry Hill's watercolor of Little Falls, 112, 195n. 25

Machine for Portage on the Susquehanna (Wall), 38
Macomb, Alexander, 6
Manutius, Aldus, 190n. 4
Map of Lake George (Stoddard), *106*
Map of the Adirondack Forest and Adjoining Territory (Koetteritz), 21–22
Map of the Adirondack Wilderness (Stoddard), 17, *18*
Map of the Narrows (Hill), 111, *112*, 118, 120–21, *121*, 122
Map of the New York Wilderness (Ely), *16*, 17
Map of the Northern Part of the State of New York (Lay), 6
Map of the Province of New York, A (Sauthier), 4–6
Maps of the Racket River and Its Headwaters (Merritt), 14, *15*
Marcy, William, 8
Marion River Carry railroad, 149
Martin, Homer Dodge, 85, 86, 149
Marzio, Peter, 69
Maternal Love (Tait), 71
Maverick, Peter, 47, 107
Mayo, William J. and Charles H., 142
McEntree, Jervis, 85, 86, 190n. 11
McGuire, Mike, 154
Meade, William, 47
Megarey, Henry J., 28, 30, 36
Merritt, Edwin A., 14–17, *15*
Milbert, Jacques Gérard, 37–43; as acquainted with Wall, 26; Adirondack wash drawings, xxii, 25; biography of, 37–38; Brownville sawmill drawing, *40*, 187n. 20; "Hudson Fall at the village of Gleens," 40, *41*; travels in North America of, 38. *See also Itinéraire pittoresque du fleuve Hudson*
Miller, Alfred Jacob, 70
Miller, William Rickarby, 54
"Mills on the Black River" (Sabatier), 38, *39*
Milne, David: *Across the Lake (Second Version)*, 170, *172*; *Adirondack Valley*, *177*, 178; Adirondack years, 161; on aesthetic emotion, 166, 198n. 16; Bell's influence on, 160, 198n. 16; at Big Moose Lake, 161–62; *Boulders in the Bush (Second Version)*, 164–66, *165*; and Clarke, 160, 162, 198n. 5; and cottage on Big Moose Lake, 162, 167, 198n. 8; cross-country skiing, 163; at Dart's Lake, 161, 198n. 6; Duncan as dealer for, 178, 199n. 19; early life of, 159–60; etchings, 164, 198n. 14; floral still-lifes of, 163; *John Brown's Farm*, 175–77, *176*; at Lake Placid, 163–64, 168; *Lake Placid (First Version)*, 168, *168*, 170; *Lake Placid, Winter Sunset*, 170, *171*; and The Little Tea House,

161–62; and multiple plate color drypoint, xxiv–xxv, 159, 161, 163–66; *North Elba (Fourth Version)*, *169*, 170; *Outlet of the Pond*, 174, *175*; "Outlet of the Pond" series, 162; *Painting Place (Large Plate)*, 172–73, *173*, 199n. 18; *Painting Place (Small Plate)*, 164; "Painting Place" series, 162; to Palgrave, Ontario, 173, 175; registration mistakes exploited by, 170; returns to Canada, 162; *Roofs of the Glenmore Hotel*, 166, *167*; Thoreau as influence on, 160; as war artist, 160
Milne, Patsy, 161
Minerva, 125, 126, 127–28, 133, 137
Mink Pond, 128, 132, 136
"Miss Diana in the Adirondacks—A Shot Across the Lake" (Rogers), 66
Moore's Rural New Yorker (newspaper), 13–14, *13*
Moran, Mary Nimmo, 95, *96*
Moran, Peter, 87–88, *87*
Moran, Thomas, 85, 98
Morning in the Adirondacks (Davis), 100, *101*, 103
Mountain Ramble, A (Currier and Ives), 51
Mount Marcy, 8, 163
Mount Seward, 149
multiple plate color drypoint, xxiv–xxv, 159, 161, 163–66
Murray, William H. H., xxi, 17, 56, 149, 183n. 2
"Murray's Fools," xxi, 17, 183n. 2
My Camp at Carry Pond (Gerster), 156, *156*

Narrows, the, 107, 111, *112*, 118, 120–21, *121*
Nast, Thomas, 54
"Nature's Forest Volume" (Stoddard), 83, 88, 91–92, 192n. 26
"Near Skeensborough on Lake Champlain" (engraving), 46–47
Nelson's Guide to Lake George and Lake Champlain, 117
Nemo, Mary, 95, *96*
Netting the Fish (Homer), 134–36
New and Accurate Map of the Present War in North America (Seal), 2, *3*
New Map of Northern New York Including the Adirondack Region (Lloyd), 14
New York Etching Club, 144, 195n. 23
New York Magazine, 46
New York State Geological Report for 1837 (Emmons), xxii, *49*
New York Wilderness Hamilton County and Adjoining Territory (Butler), 19
North American Print Conference (1995), xv
North Creek (Gerster), 149, 151, *151*
North Elba, 56